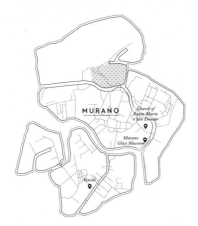

MURANO

Church of Santa Maria e San Donato

Murano Glass Museum

Venini

MW00997493

UIDE

VENICE

|————————| 250 m

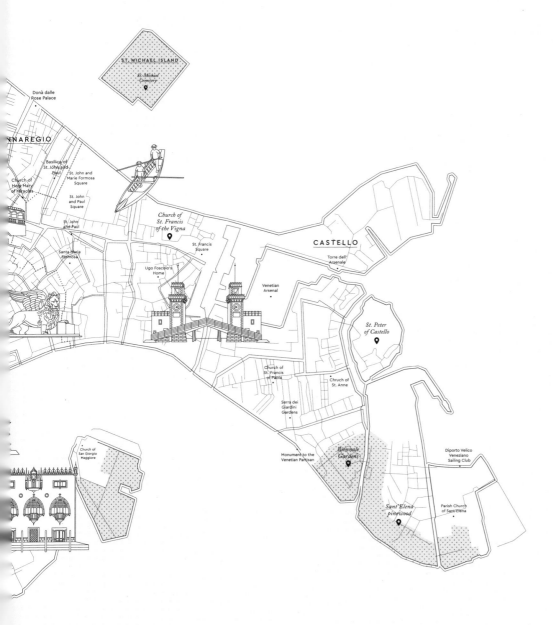

ST. MICHAEL ISLAND

St. Michael Cemetery

Donà dalle Rose Palace

NNAREGIO

Basilica of St. John and Paul

Church of Holy Mary of Miracles

St. John and Marie Formosa Square

St. John and Paul Square

St. John and Paul

Santa Maria Formosa

Church of St. Francis of the Vigna

St. Francis Square

CASTELLO

Torre dell' Arsenale

Ugo Foscolo's Home

Venetian Arsenal

St. Peter of Castello

Church of St. Francis of Paola

Chruch of St. Anne

Serra dei Giardini Gardens

Church of San Giorgio Maggiore

Monument to the Venetian Partisan

Biennale Gardens

Diporto Velico Veneziano Sailing Club

Sant'Elena pinewood

Parish Church of Sant'Elena

MAGICAL VENICE

THE HEDONIST'S GUIDES

+ THE HEDONIST'S GUIDE +

MAGICAL
VENICE

LUCIE TOURNEBIZE | GUILLAUME DUTREIX

EXCEPTIONAL PLACES | HISTORIC FIGURES

ESSENTIAL SITES | CURATED ITINERARIES

HARPER DESIGN
An Imprint of HarperCollins Publishers

INTRODUCTION

THE LAGOON

SAN MARCO

DORSODURO

SAN POLO

SANTA CROCE

CANNAREGIO

CASTELLO

GIUDECCA
AND SAN GIORGIO

For some, the soul of Venice is found by wandering its narrow pathways, passing the bricks of its salt-soaked facades; others find it through the eyes of a Carnival mask, or perhaps within one of the city's small squares; while still others find it through the mist of a foggy January day. Each of us has in mind a particular image of Venice, made up of snippets we glean from movies, art, or literature. And when we travel there to experience our mythical Venice in person, stepping on its cobblestone streets and touching its marbled walls, we are motivated even more to discover what makes up this rather strange city unlike any other.

In the beginning, there was the lagoon, a salty wetland through which meandered the bed of an ancient river whose sediment formed a network of small islands floating just at sea level. And on these barely dry lands, people have lived since ancient times, evidence of which archaeologists have traced to the beginning of the Byzantine Empire. Torcello, at that time, was the most populated of the islands. Legend, however, pinpoints the birth of Venice to March 25, 421, when the first Venetians decided to settle on the high banks, the *rivus altus* in Latin, of what is today Rialto. Two centuries later, in 697, the first doge was elected for life, establishing what would be the Most Serene Republic of Venice (*La Serenissima*).

In the ninth century, the city built its first monuments whose names are now inscribed in the collective imagination. The foundations were laid for the construction of the first bell tower, the Doge's Palace, and Saint Mark's Basilica, where the remains of Saint Mark, brought back from Egypt by two merchants, Buono and Rustico, are held. Destroyed several times by fire, these structures were rebuilt, enlarged, and embellished over the centuries, but their locations have remained the same. Venice eventually built Saint Mark's Square, from which the city's energy now radiates.

Near Saint Mark's, a second vital area of the city was on the rise. The Rialto, still associated today with commerce, became the city's center for all trade. As early as the eleventh century, this trading hub allowed Venice to prosper through the exchange of goods originating beyond the islands. From the city's complex of shipyards, the Arsenale, emerged fearsome warships that allowed Venice to establish itself as a sea and land power throughout the Mediterranean. From as far away as Constantinople, Venetians brought back precious marbles as well as the Horses of Saint Mark after pillaging the city in 1204.

The city's history is a succession of battles, plagues, fires, and episodes of *acqua alta*. Perched on waters that both protect and seek to destroy it, Venice nevertheless became enriched with sumptuous palaces and glorious churches. Architects from the mainland arrived to build its precious buildings: the Lombard Mauro Codussi, Andrea Palladio from Padua, and Jacopo Sansovino from Rome. From great engineering feats rose gothic spires and baroque arches on the *caranto*, the lagoon's original silt deposits. Painters from the Venetian schools adorned them with frescoes. Now gone, these frescoes embellished the facades of homes owned by patrician families along the Grand Canal. Bellini, Carpaccio, Giorgione, Titian, Tintoretto, Veronese, Giambattista Tiepolo, Canaletto, and Guardi are among the most famous of these painters whose works can still be seen inside churches and museums, or in the *scuole grandi*, which conserve them.

Venice thrived by developing trade, handicrafts, and the arts. Even today, the *botteghe*, or workshops, of the city's many artisans bear witness to the know-how that developed over the centuries. Among many of these specialties are glasswork, weaving precious fabrics, marbleized paper printing, and mask making. Within its maze of narrow streets, which the Venetians call *calle* (pronounced "kah-lay"), can be found these workshops where craftsmen continue the art of hammering gold, sculpting glass, or cutting fabrics.

What remains of past glories of Venice as a proud republic reigning over the seas? The fall of the Serenissima in 1797 marked the beginning of a troubled time. The Napoleonic and Austro-Hungarian occupations profoundly changed the city. Amid the destruction of churches, prohibition of Carnival, burying of canals, and creation of new routes, Venice modernized and, most important, opened itself up to the world. The real change occurred in 1846 with the construction of the railway bridge that opened the island and made it accessible by train. Vehicles followed in 1933 when the artificial island of Piazzale Roma was constructed, serving as a bus station and the final stop for cars and the tramway. Now connected to the rest of the world, Venice became an international scene where artists and architects could find exposure during the Biennale.

It is impossible to approach Venice today without being reminded of mass tourism or dreading the crowds that invade Piazza San Marco (Saint Mark's Square) or the Ponte di Rialto (Rialto Bridge). This is a reality that Venetians come face-to-face with every day, but this should not discourage you, because this situation can be avoided. A visitor can appreciate Venice by taking time and remaining curious. By going beyond the iconic monuments to explore off the beaten paths, you can find pockets of calm and silence where the absence of noise from cars allows only the sound of lapping water to fill the ears; where, through the humid air, you may follow an inviting aroma escaping through a nearby kitchen window and discover a quiet alley leading to a small *campo*, as the Venetians call their squares, where you find yourself sitting down at a small café to taste the flavors of the sea and spices in the local cuisine.

In Venice, every door opened and every path explored can be a passage leading to something surprising and unexpected: baroque ballrooms, marbled palaces, workshops of gilded mosaics, hidden treasures in churches, votive altars nestled in passageways, secret rooftop terraces . . . it is necessary to seek out, to get lost, to follow pathways, to accept unexpected dead ends, and to cross an infinite number of bridges to fully appreciate Venice and to fill the eyes and soul with its elusive yet perpetual beauty.

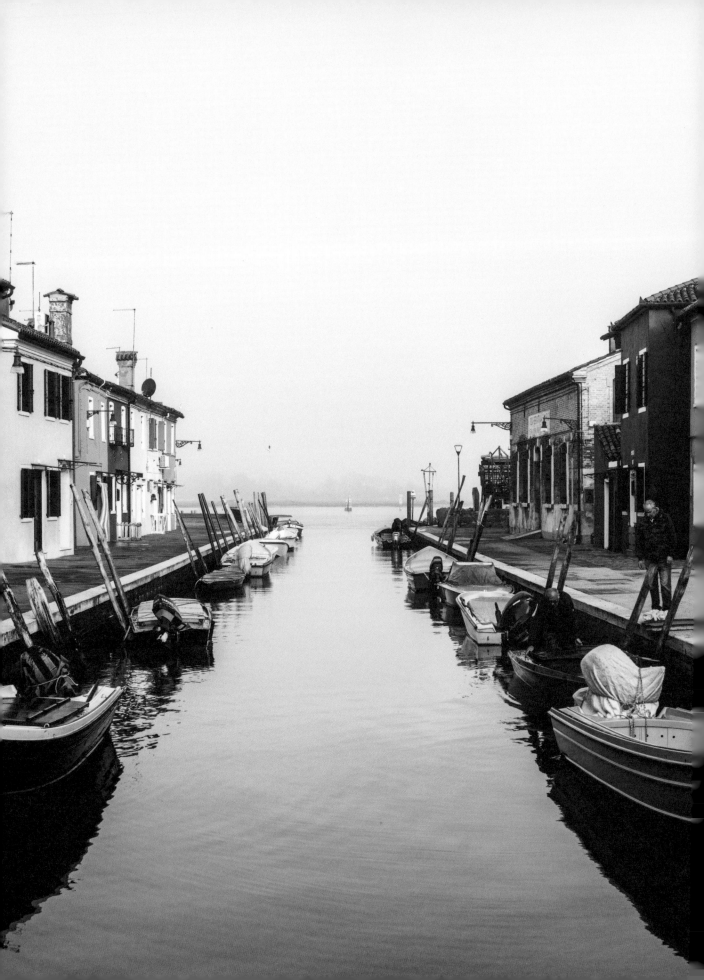

THE LAGOON

Its waters are like a mirror, reflecting the nuanced colors
of the sky. From the pale pink of dawn to the deep orange of
sunset, the lagoon is the single constant in Venice. As you travel
its waters from island to island, its rich history slowly unfolds.

From morning to evening, the surface of the lagoon is covered with boats of all kinds: lacquered wooden taxis connecting the city to the airport, *vaporetti* leaving for Burano, long transport boats, boats carrying firefighters, garbage collectors, and deliverymen, and small, quiet boats propelled by lone rowers. It is in the midst of these shallow waters, spread over more than one hundred small islands, where Venice exists. The lagoon is the city's raison d'être. To protect themselves from invading barbarians, the first inhabitants of the lagoon fled here starting in the fifth century. The lagoon has always been Venice's primary space: its first condition that must be faced before entering the city. To explore and study the lagoon is to understand the Venetian ecosystem, with its smells of the sea, its typical products, and its history.

The lagoon is studded with treasures. Inhabited, abandoned, sometimes tiny, its islands define its identity. From the workshops on the island of Murano emerge glass beads, jewelry, and objects of design. On the small, colorful island of Burano, lace-makers perpetuate the art of weaving threads into delicate fabrics. In Sant'Erasmo, the fields and vineyards yield vegetables and wines with slight briny flavors of the sea that can be tasted at Venetian tables.

The lagoon is also an endless collection of small, abandoned islands, which visitors pass in *vaporetti*, the public water buses. These isolated places housed convents, lazarettos, and psychiatric hospitals. Some islands have been purchased by large resorts, such as San Clemente, where you can now enjoy a spa overlooking Venice.

Finally, the lagoon reshapes the contours of the city, causing the land to emerge or disappear according to its tides, an inevitable fate for a city floating in delicate balance on the water's surface.

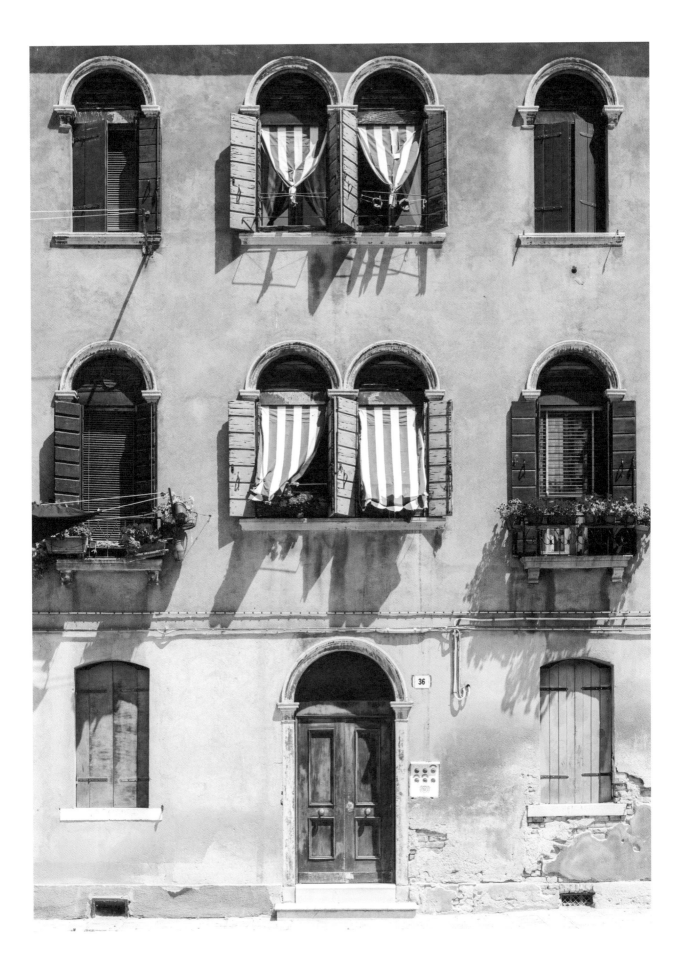

THE ESSENTIALS

01

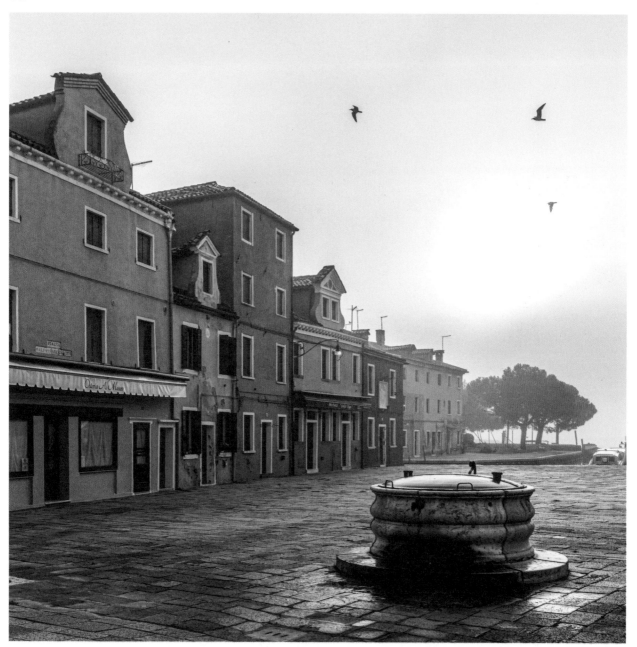

BURANO

The island of Burano and its colorful houses invite photography
lovers to stroll among its pastel tones and bright pops of color.

O2

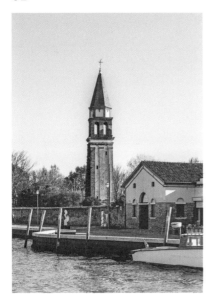

MAZZORBO

Mazzorbo is a peaceful neighbor of Burano nestled between vineyards and *case popolare* by architect Giancarlo De Carlo.

O3

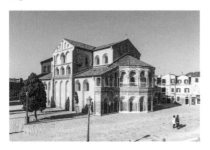

BASILICA DEI SANTI MARIA E DONATO

The Basilica dei Santi Maria e Donato is the main church on the island of Murano.

O4

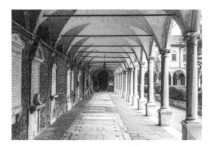

SAN MICHELE

Contemplation and quiet can be found on the cemetery island of San Michele, which also has two beautiful churches.

O5

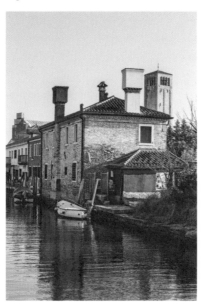

TORCELLO

Torcello maintains a rural atmosphere, situated between canals and marshes.

O6

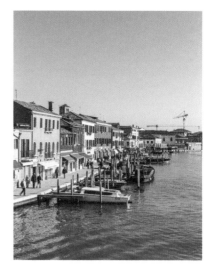

MURANO

On this small island with its spacious streets is a mingling of famous glassmakers and residents.

O7

SANT'ERASMO

Sant'Erasmo is a collection of fields and vineyards just a few steps away from the water.

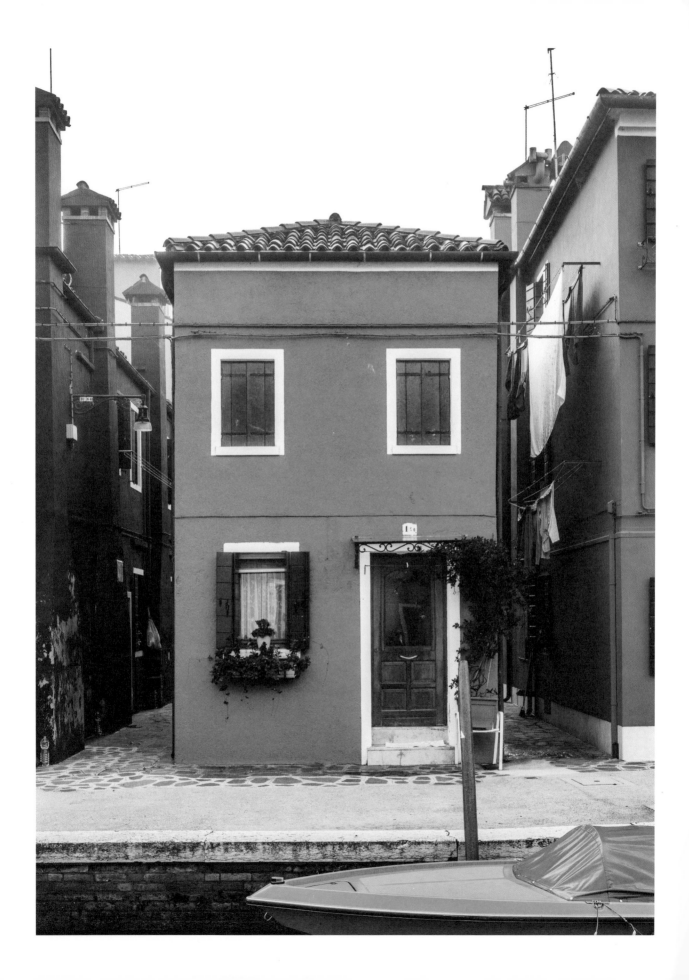

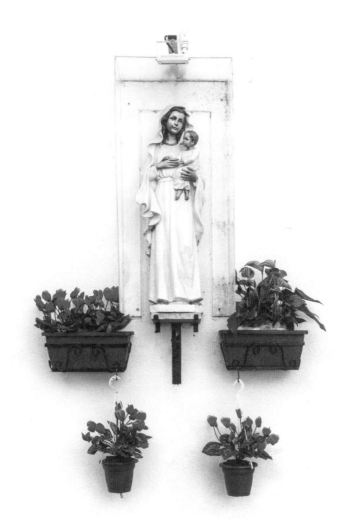

ABOVE

In Venice, just as throughout Italy, many symbols of faith
are found in public spaces.

LEFT

In Burano, it is said that the colors of the houses allowed fishermen to spot them
through the thick fog common from November to February.

FOLLOWING SPREAD

At dawn, silence settles over Burano with merely the sound of the water present.
The island wakes up slowly before welcoming the many tourists.

PROFILE

PHILIPPE STARCK

THE BURANELIAN

For forty-five years, Philippe Starck has lived on the island of Burano as a true Buranelian. On this colorful island, a "model of the ideal society," he makes his home and carries out his daily routines among its markets and cafés.

In front of his red ochre *casa*, his *topetta*—a traditional boat—is anchored. Like any Venetian, he uses it "to explore the lagoon." Venice is perhaps, for him, the ultimate mystery, a city he defines as "ultramodern before its time, it knew how to be the mastermind of Europe, a utopia built in an inhospitable world." Threatened with becoming a sort of amusement park, it needed creative initiatives to regain its place in the world. This is a vision Starck has put into practice among the iconic spots of the city, on the Piazza San Marco, and along the Grand Canal.

In 2009, he built his first hotel in Italy, the Palazzina Grassi, housed in a sixteenth-century palace across from Ca' Rezzonico. There he installed more than two hundred mirrors made by craftsmen of the Barbini family, who use glass from Murano by the artist Aristide Najean.

But Starck believes that "in Venice, you can't change everything." There is a form of respect in his work based on the know-how of Venetian craftsmen, as seen in his restoration of Caffè

Quadri, originally opened in 1775 on Piazza San Marco. For the ground floor of the café, he envisioned furniture with feet of raw brass, a metal that stands up to the frequent rise of the waters to which the café is often exposed. Upstairs reflects his dreamlike and humorous style where he has hidden spaceships and weapons as well as portraits of restaurateurs the Alajmo brothers within the traditional motifs of wall tapestries woven in the Venetian workshops of Bevilacqua. Everywhere there are "rich surprises," such as the stuffed winged animals, a nod to the lion of the evangelist Saint Mark, the symbol of Venice.

A spirit of subversion and play can be found in the heart of Fondaco dei Tedeschi, a former merchant warehouse restored with splendor by architects Rem Koolhaas and Jamie Fobert. In this setting, Starck designed the café AMO, a charming place where the sofas are inspired by the shape of gondolas and the wall frescoes reflect the fantasies of Carnival—all arranged in the scene of a Venetian theater. This is the spirit of Venice as seen by Starck.

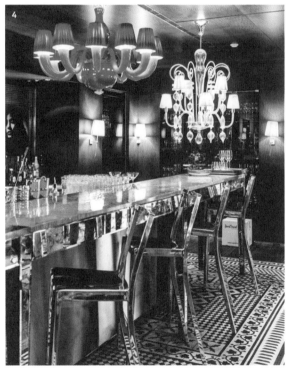

1. AMO

In the heart of Fondaco dei Tedeschi, Starck renewed the idea of Michelin-starred dining in Venice.

2. QUADRI

In Saint Mark's Square, this centuries-old café was completely renovated by the French designer in 2018.

3. THE ART OF DETAIL

At Quadri, every detail has been considered, even in case of rising waters.

4. PALAZZINA GRASSI

Along the Grand Canal, this luxury hotel by Starck occupies a sixteenth-century building.

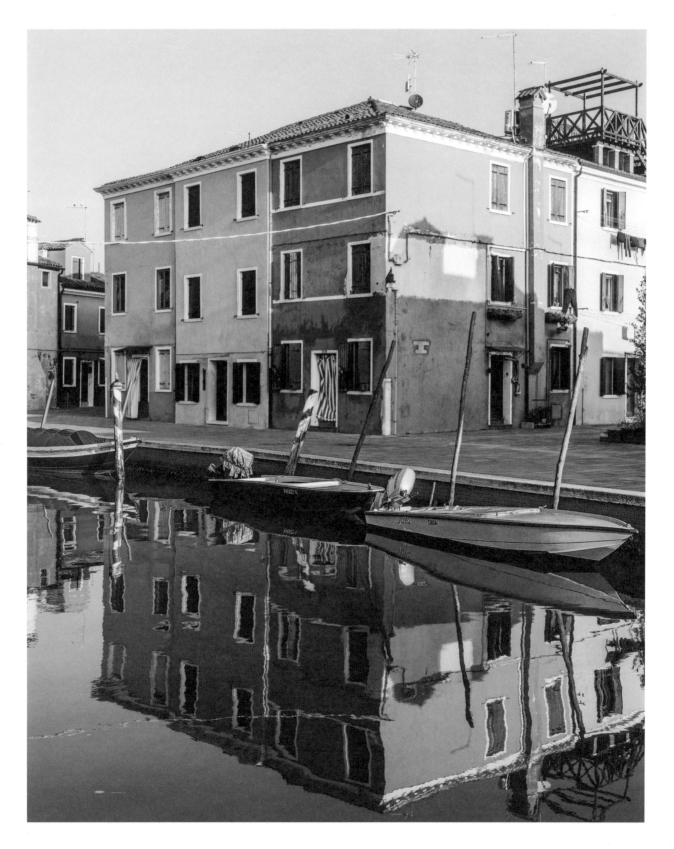

A fondamenta *is what Venetians call a pedestrian path that runs along a* rio *or a canal.*
You can walk it by foot or anchor your boat at the edge.

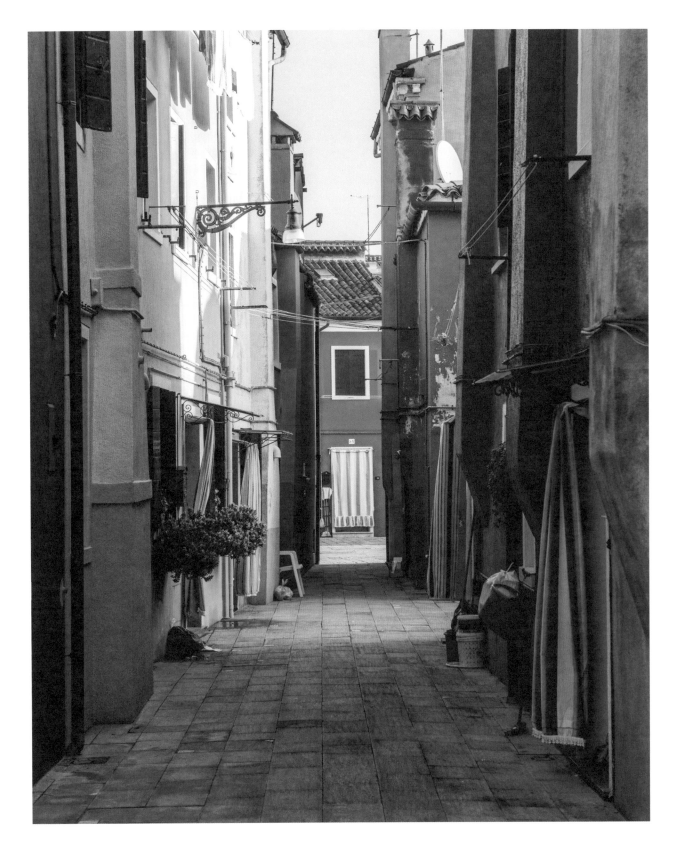

Burano is famous for its small houses painted in bright colors. Today, residents must respect the color of their facade when renovating.

ABOVE

*The atmosphere of Murano is of a village in the center of the lagoon.
In the air, the scent of laundry mixes with the
aromas of food cooking in a nearby house or restaurant.*

RIGHT

*Venice may be situated in a salty lagoon, but the Venetians
used their imagination to find their drinking water.*

THE HOUSE OF VENINI

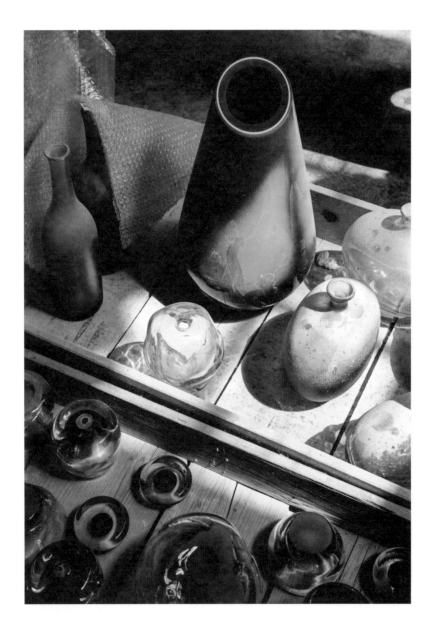

A CONTEMPORARY GLASSMAKER IN MURANO

Illustrious glassmaker Venini collaborates with designers and architects
to create unique objects produced in small quantities.

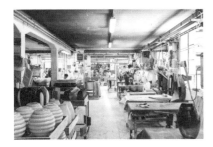

IN THE WORKSHOP

Once cooled, the glass is taken to the workshop for finishing.

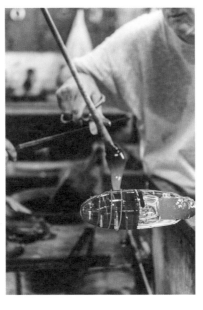

BLOWING THE GLASS

Before blowing the glass, adornments are applied while hot.

PRECISE WORK

The finishing work eliminates the slightest imperfections in the glass.

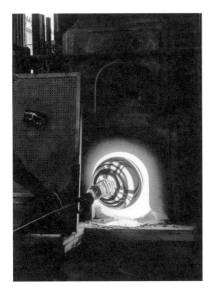

IN THE OVEN

The temperature rises to more than 2,700°F (1,500°C) to melt the glass.

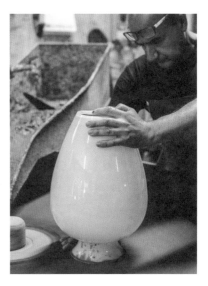

FINISHING

The edges of the glass are polished with a rotating disk.

A KNOW-HOW

Before they can work alone, glassmakers must be a master's apprentice for many years.

TOOLS

A very manual task, glasswork requires great precision with handling tools.

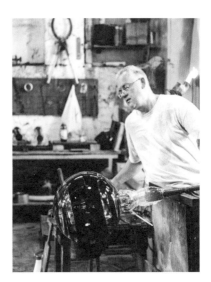

JUST OUT OF THE OVEN

The glass is cooled quickly to a temperature of 1,100°F (600°C) to be worked.

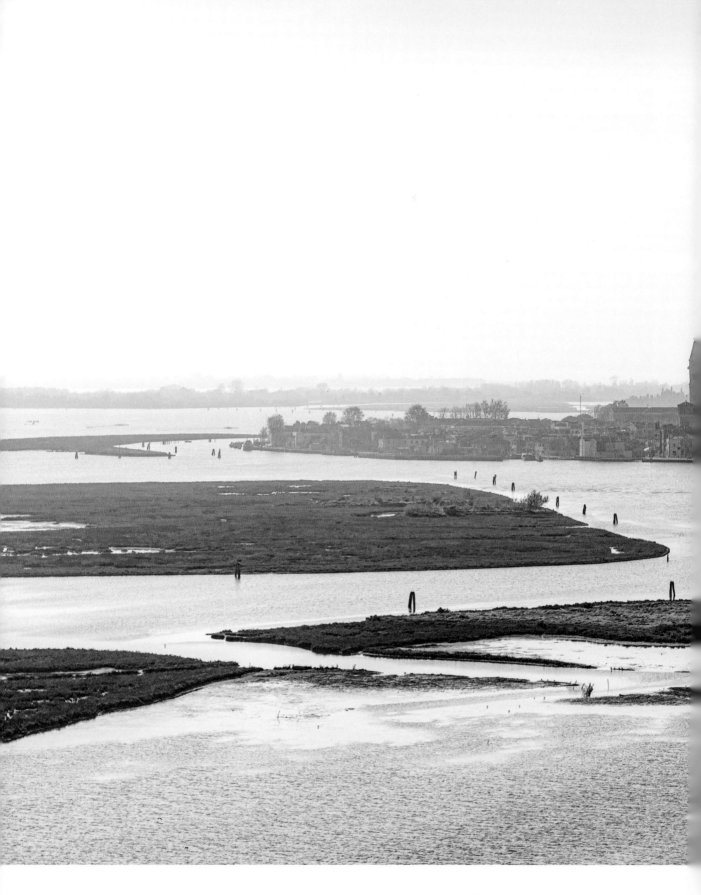

Built during the expansion of the Basilica di Santa Maria Assunta, the bell tower of Torcello has been watching over the lagoon since the eleventh century. From its summit, you can see the nearby island of Burano.

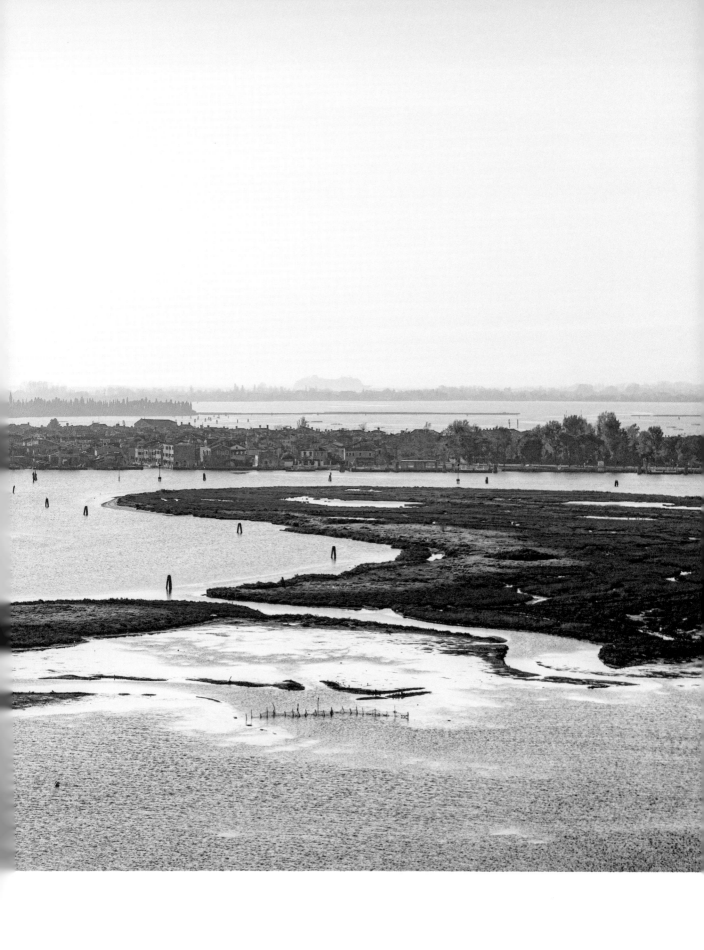

VISITING

SANT'ERASMO

VENICE'S VEGETABLE GARDEN

To find new land to cultivate, Venetians searched where they could among
the islands of their lagoon, where every piece of land counted. On Sant'Erasmo,
inhabitants have been working the fields for more than four hundred years.

Just northeast of the Lido lies Sant'Erasmo. From the *vaporetto*, about a thirty-minute ride, you can see monasteries and lazarettos now overtaken by vegetation. However, once you step off onto the pier, the well-organized fields of the island come into view. As you venture farther in, you will discover a Venice with a rural character. In the air lingers the smell of the sea, which lies just two miles (three kilometers) beyond the protective strip of the Lido. On its sandbanks grows cropped vegetation, serving as an area of exploration for wild cats as well as bees that produce an incredible honey, *miele di barena*.

The landscape quickly gives way to a rigorous arrangement of fields and vineyards. On the island of Sant'Erasmo, vegetables grow in clay soil, taking on a unique flavor thanks to the brininess of the sea and to sediments brought by rivers from the Dolomites. For a long time, Venice's supplies remained dependent on the tide: deliveries to the Rialto market stalls were timed to the currents, which change every six hours. Venetians today no

longer face these obstacles but instead use an app on their phones to order their vegetables and pick them up at one of the anchoring points of the motorized delivery boats.

Recently, the cultivation of wine grapes has been added to Venice's list of handcrafted products, started up by several of the island's wine enthusiasts. Among them is Michel Thoulouze, who set out to make Sant'Erasmo an excellent wine-growing terroir. As a Frenchman who was in love with Venice and in search of tranquility, he surrounded himself with winemaking specialists to help select the best grape varietals: Malvasia Istriana, Vermentino, and Fiano.

Each year, Thoulouze produces a white wine vinified on the island then shipped to France or Italy, about fifteen thousand bottles with odd limestone grooves created by the salt water from the lagoon: because there are no underground wine cellars in Sant'Erasmo, the wine is aged underwater, away from light and air.

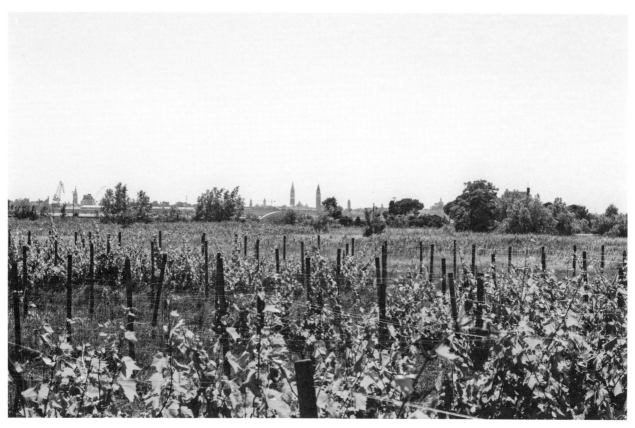

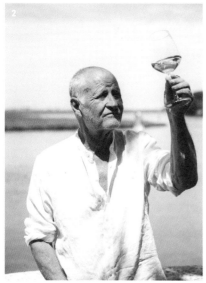

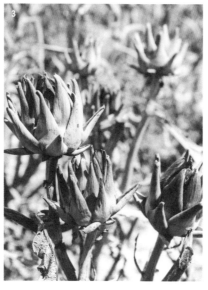

1. THE VINES

From the vineyards of Sant'Erasmo, the silhouette of Venice is never far away.

2. MICHEL THOULOUZE

He has revived the Venetian wine business, dormant since the seventeenth century.

3. THE *CASTRAURE*

Sant'Erasmo baby artichokes derive their unique flavor from the clay fields in which they grow. They are in season from April to June and are enjoyed raw, fried, or boiled. When accompanied by *schie*, tiny lagoon shrimps, they are a delight.

4. TRADITIONAL HOUSES

Just over two and a half miles (four kilometers) long, Sant'Erasmo is dotted with traditional houses and farms, which have been providing food to Venice since the sixteenth century.

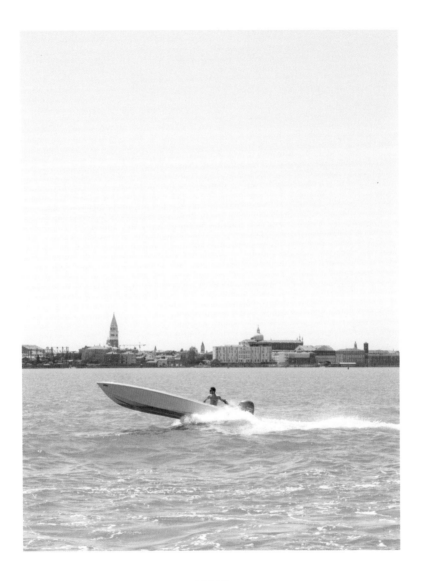

ABOVE

*Many Venetians have their own boat
for crossing the lagoon.*

LEFT

To reach the islands, Venetians and tourists take one of the many vaporetti,
Venice's only available public means of transport.

1. MONTHLY DISTRIBUTION OF TIDES
EXCEEDING 2 FT 7 IN (80 CM) FROM 1872 TO 2014

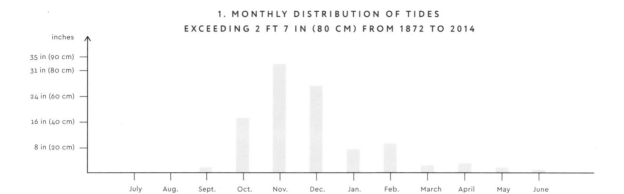

2. EXCEPTIONAL TIDES FROM 1936 TO 2018			
APRIL 16, 1936	+4 FT 10 IN (147 CM)	FEBRUARY 1, 1986	+5 FT 2 IN (158 CM)
NOVEMBER 12, 1951	+4 FT 11 IN (151 CM)	NOVEMBER 6, 2000	+4 FT 9 IN (144 CM)
OCTOBER 15, 1960	+4 FT 9 IN (145 CM)	NOVEMBER 16, 2002	+4 FT 10 IN (147 CM)
NOVEMBER 4, 1966	+6 FT 4 IN (194 CM)	DECEMBER 1, 2008	+5 FT 1 IN (156 CM)
NOVEMBER 3, 1968	+4 FT 9 IN (144 CM)	DECEMBER 25, 2009	+4 FT 9 IN (145 CM)
FEBRUARY 17, 1979	+4 FT 7 IN (140 CM)	NOVEMBER 11, 2012	+4 FT 11 IN (149 CM)
DECEMBER 22, 1979	+5 FT 5 IN (166 CM)	OCTOBER 29, 2018	+5 FT 1 IN (156 CM)

3. PERCENTAGE OF FLOODED SURFACE
ACCORDING TO SEA LEVEL

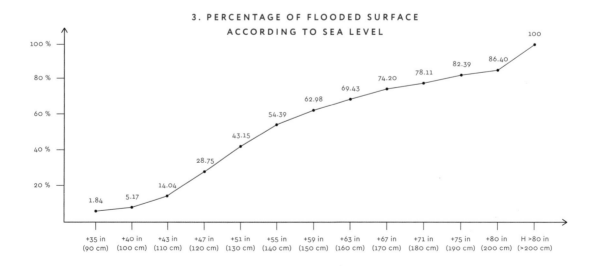

The tide measurement made in 1897 at the Punta della Salute
is the level 0 reference for the rise of the sea level in Venice.

UNDERSTANDING

A LAGOON ECOSYSTEM

Venice is a world of stone, bricks, and marble built at sea level, surrounded by salt water, seaweed, and untamed small islands. The land spans 141,000 acres (57,000 hectares), and its borders change throughout the day.

Measuring thirty-four miles (fifty-five kilometers) on the north-south axis and five to nine miles (eight to fourteen kilometers) across, Venice's lagoon is a vast, delicately balanced universe of flora fluctuating between water and land and bird fauna venturing up to the Grand Canal. If you look closely, you may see a little egret or a gray heron resting in a small, tranquil canal.

A city without ramparts and defended only by the waters, Venice has always battled to avoid the sands of the lagoon, not hesitating to divert the course of the Brenta River, which carries sediment. Because its environment is fragile—with a depth sometimes less than three feet four inches (one meter)—the lagoon is often bare. Some areas called *barene* and *velme* alternately flood then become dry. Small flowers will grow in the area, foraged by bees that produce *barena* honey.

Today, the opposite is now a challenge: Venice fears invasion from its waters, referred to as the *acqua alta*. The tides, barely noticeable in the Mediterranean, are clearly visible in Venice, which is built

between approximately two and a half to three and a half feet (seventy to one hundred centimeters) above sea level. Every day, the water enters through three inlets of Chioggia, Lido, and Malamocco. The crossing of the currents can be seen by observing the canals. The water then recedes and flows back into the sea. Depending on the atmospheric pressure, the amount of water flowing into the lagoon will vary. When unusually high—called *acqua alta*: above three feet (ninety centimeters) of tide—it enters the docks and squares, starting with the Piazza San Marco, the lowest point. The Venetians then walk around wearing boots or on elevated wooden walkways installed from November to April when this phenomenon is most prevalent.

To counter this, a huge project has been initiated called the MOSE system, designed as a barrier to isolate the lagoon from high tides. An enormous project with exorbitant costs (more than five million euros), the MOSE project has been strongly criticized by various organizations and experts who are awaiting its results once the work is completed, scheduled for 2020.

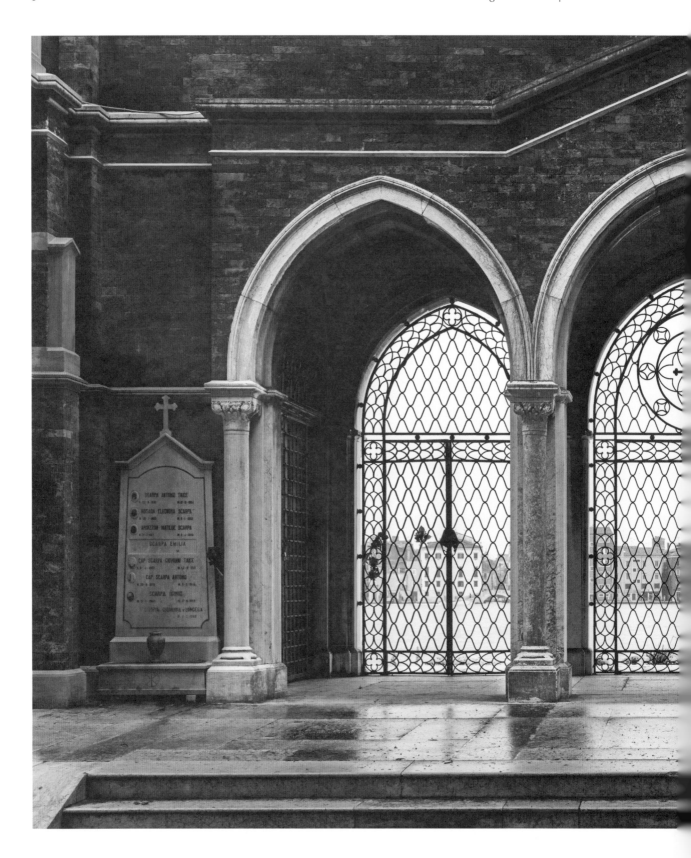

*Located halfway to the island of Murano, the cemetery island of San Michele
has served as the last resting place for many Venetians since 1837.*

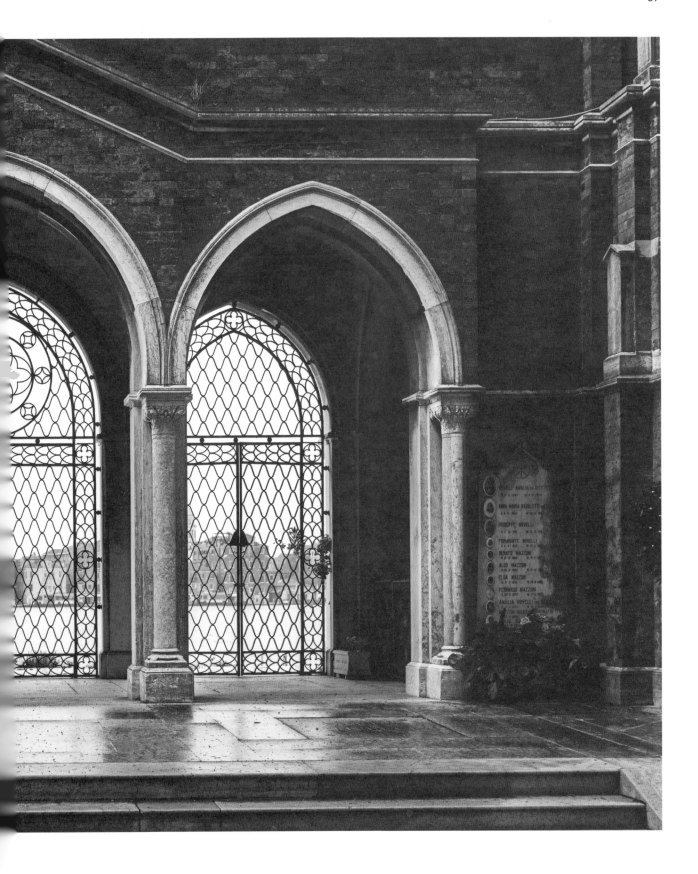

ABOVE

A sense of abandonment reigns on the island of Torcello,
where vegetation invades old houses.

RIGHT

Torcello's main canal is lined with several rustic restaurants where
diners can spend a quiet Sunday over a casual lunch.

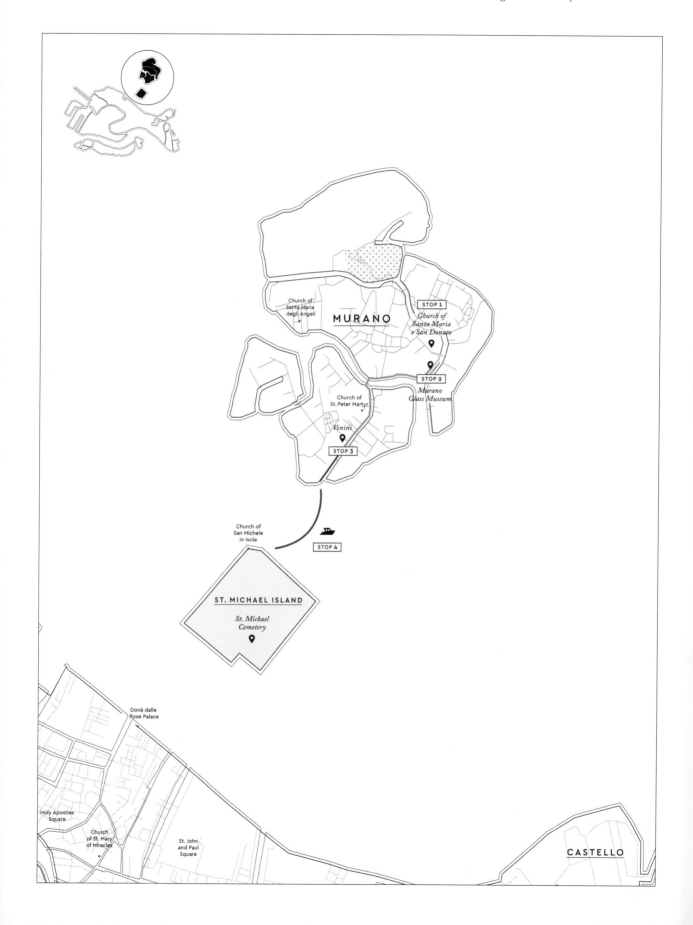

Church of Santa Maria degli Angeli

MURANO

STOP 1
Church of Santa Maria e San Donato

STOP 2
Murano Glass Museum

Church of St. Peter Martyr

Venini

STOP 3

Church of San Michele in Isola

STOP 4

ST. MICHAEL ISLAND

St. Michael Cemetery

Donà dalle Rose Palace

Holy Apostles Square

Church of St. Mary of Miracles

St. John and Paul Square

CASTELLO

A WALK ALONG MOSAIC GLASS

Since the thirteenth century, the *fornace* of the island of Murano have produced a glass renowned throughout the world for its purity. Although it has developed a rather kitsch image in recent decades, it continues to seduce designers who recognize the excellence of this Muranian craftsmanship. Follow this walking tour through the ages of Venetian glassmaking.

STOP 1: AROUND THE BASILICA DEI SANTI MARIA E DONATO

This part of the island of Murano has a peaceful atmosphere, far from the main pier. From the *museo* to the basilica, elegant shop windows replace bargain shops. The church, rebuilt in the twelfth century but in existence since the seventh century, first appears as a reflection on the canal, revealing its apse of brick and marble. A red-and-brown brick facade hides its vast nave from outside gazes, but inside, a world of mosaics is revealed. The floor, covered with bits of marble pieced together, depicts animals and geometric patterns, while the altar captures the eye with thousands of glittering gold tiles surrounding the figure of the Virgin. The splendor of these unique adornments is thanks to the mastery of the art of glassmaking and mosaics Venetians developed starting from the twelfth century, when the church's floor and the dome were constructed.

STOP 2: THE MUSEO DEL VETRO

Just a few steps away from the basilica, the Palazzo dei Vescovi di Torcello opens its doors to visitors searching to broaden their knowledge of the history of Murano's artisan glassworks.

The halls of this palace lead to a journey back through time. On the ground floor, the creations of contemporary artists are displayed in white rooms, while upstairs, tapestries cover the walls surrounding jewelry, dishware, mirrors, and fashionable objects from the fourteenth to nineteenth century. The history of glassware can be traced from the invention of the technique in Mesopotamia to its arrival in the lagoon, where it was perfected and enriched. Following several centuries of European popularity and then eventually stiffer competition with other glassmaking centers such as Bohemia, Murano glass witnessed a rebirth in the nineteenth century when new *fornace* were invented that would enhance the ancestral techniques.

STOP 3: MODERNIZATION OF GLASS AT VENINI

Over the course of the twentieth century, glassmaking headed toward a more contemporary direction. To follow in its footsteps, head to the Fondamenta dei Vetrai, located in the south of the archipelago, to the Venini showroom. In 1921, this was the first glassmaker on the island to have an art director. Vittorio Zecchin, a native of Murano, inspired by the artists he met at the budding Biennale, envisioned modern vases, the first of their kind. This is an approach Venini has maintained, collaborating with artists and architects who are invited to create unique pieces in close collaboration with its master glassmakers. In the showroom, objects by Tadao Ando, Carlo Scarpa, and Ron Arad highlight the contemporary style of this glassmaker.

STOP 4: LAST DETOUR TO SAN MICHELE

The *vaporetto* returning to Venice makes a final stop on your tour of glass and mosaics. On the cemetery island of San Michele, the mosaicist Salviati built a private chapel in 1915 decorated entirely with a mosaic of glass and marble. In the heart of the island, among the silence of the tombs, the Church of San Cristoforo contains the colorful mosaics of Antonio Castamer, a pupil of Salviati who would become founder of a house of master mosaicists in Tuscany. This is a place of solitude and calm to look out in the distance toward Venice before returning to the land of the living.

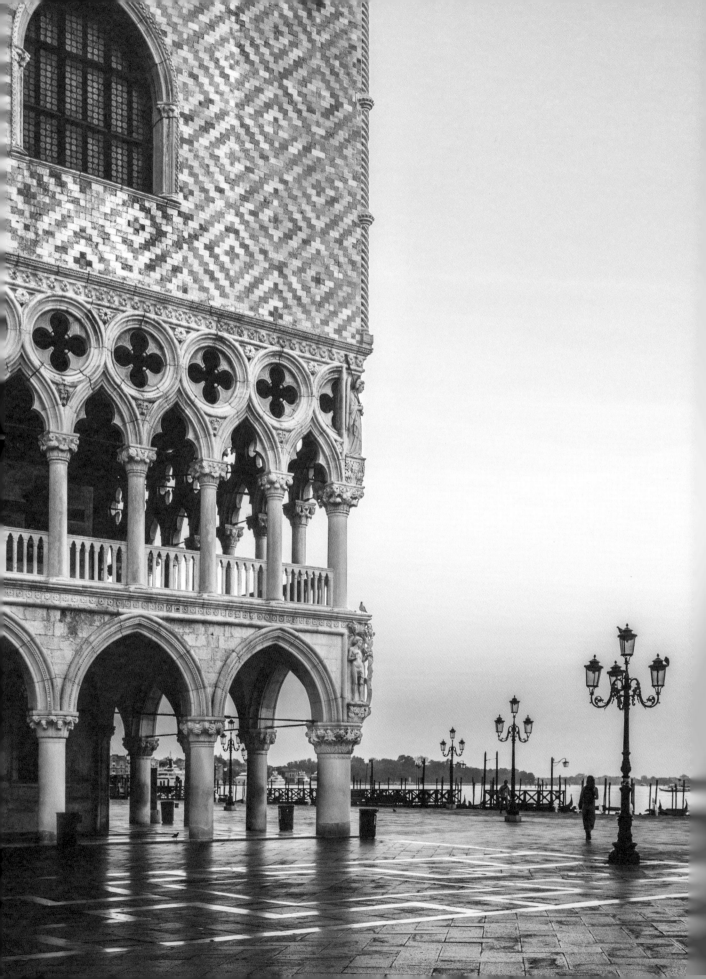

SAN MARCO

Venice is divided into six districts (or neighborhoods)
called *sestieri*. The district of San Marco is the heart
and best embodies the collective imagination of the Serenissima.
Until the nineteenth century, it was through San Marco
that visitors entered the city.

P. 42

*The Doge's Palace, a symbol of the power of the Republic of Venice,
sits atop two floors of delicate columns.*

RIGHT

*From the Bridge of Sighs, which connects the Doge's Palace to the old prisons, onlookers can gaze
out upon the small Ponte della Paglia and the island of San Giorgio in the distance.*

In Venice, the layout of the houses and the juxtaposition of the subdivisions with the parishes invites you to follow a particular path, passing one jewel of the city after the other. But rather than follow the directions of the *nizioleti,* the panels whose arrows urge visitors toward Piazza San Marco, you might instead head down a *calle,* what the Venetians call streets. To get to know San Marco, considered the emblem and soul of Venice, in more detail, it is best to feel your way along.

Whether you're entering the district by way of the Rialto or the Accademia, the two bridges that connect San Marco to the neighboring *sestieri,* the path forward is the same. Walking down the alleyways, you will cross a series of open squares where you can stop near a water well to admire the stones and canals. The privacy of these spaces, such as the *campi* Sant'Angelo, San Maurizio, and Santa Maria del Giglio, invites calm before your steps lead you to the district's most famous public square. At this point, all the open squares you encounter take the name of *campo,* meaning "field," recalling the days when vegetables were grown in these spots. From here, however, it is time to discover the one space that most deserves the name *piazza*: Piazza San Marco.

Entering Piazza San Marco is like walking out onto a grand stage from behind the scenes, accessed through one of the arches running under the Museo Correr. From this direction, Saint Mark's Basilica, flanked by the bell tower, rises straight in front of you. The nearby terraces of the Florian and Quadri cafés add to the scene with their symphonies of alternating stone, gold, and mosaics. Along the sides, the Procuraties (the old procurators' offices), with their porticoes lined with elegant windows, enclose the space, yet the square nevertheless remains miraculously gigantic. After the basilica, it is the Doge's Palace that surprises with the lightness of its structure resting on two floors of marble pillars, topped with gothic floral designs.

In all weather and at all hours, the square amazes. In autumn, it doubles its splendor by reflecting itself in the puddles created by the *acqua alta.* In the early mornings of summer, the dawn awakens it with golden reflections. The mists of winter give it a magical charm. All year round, the square invites us into a daydream as we stand surrounded by stone and water, gazing out toward the lagoon, past the sea, and into the horizon of Venice.

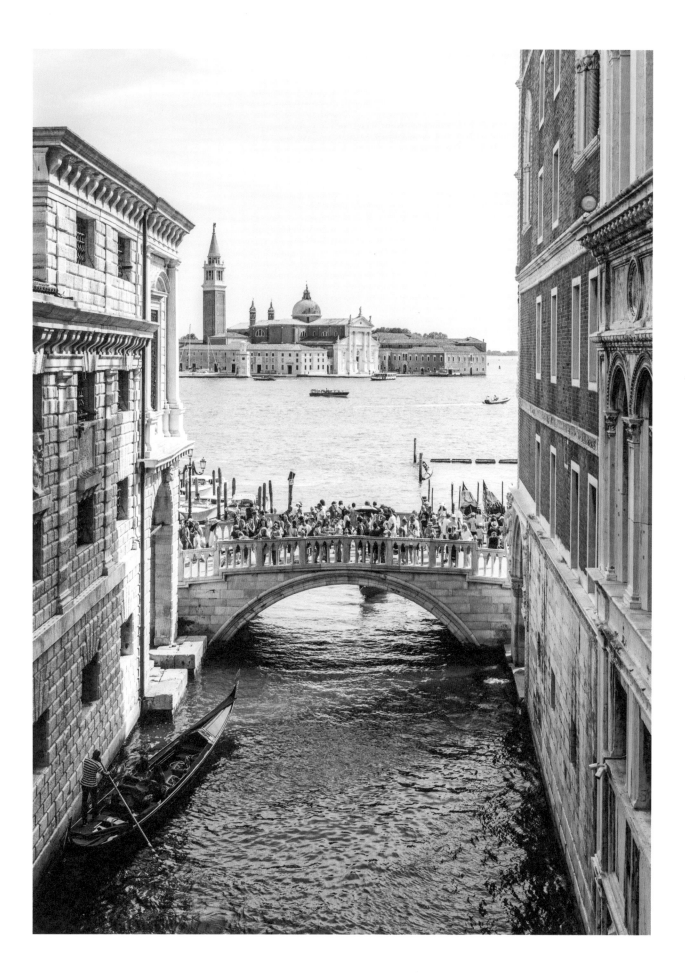

THE ESSENTIALS

08

LA FENICE

A phoenix rises, reborn out of a fire. In 1996, Aldo Rossi rebuilt this opera house after it was destroyed by fire.

09

CAMPO SANTO STEFANO

Bordered by palaces, Campo Santo Stefano is a favorite spot for Venetians to enjoy ice cream on the terrace.

10

FONDACO DEI TEDESCHI

The Fondaco dei Tedeschi, today a temple to luxury fashion, was an important merchant warehouse situated on the Grand Canal.

11

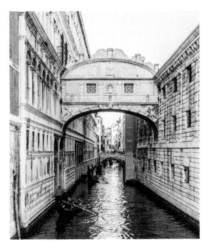

PONTE DEI SOSPIRI

Closed off to prevent escapes, the Ponte dei Sospiri (Bridge of Sighs) leads to what were the dreaded prisons within the Doge's Palace.

12

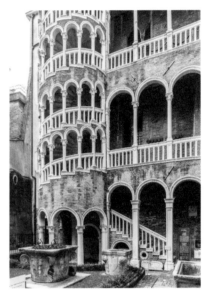

PALAZZO CONTARINI DEL BOVOLO

At the back of a dead end down a narrow alley, the Palazzo Contarini del Bovolo surprises with its incredible open staircase.

13

PALAZZO GRASSI

The last palace of the Republic of Venice built on the Grand Canal, Palazzo Grassi today houses contemporary art exhibits.

14

CAMPANILE SAN MARCO

The view of Venice from Saint Mark's bell tower is sublime.

15

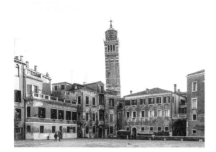

CAMPO SANT'ANGELO

An open-air space within the neighborhood, Campo Sant'Angelo has an atmosphere that invites daydreaming.

16

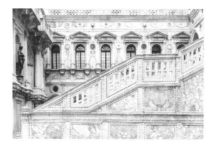

PALAZZO DUCALE

The Doge's Palace is a concentration of works of art and an architectural marvel.

17

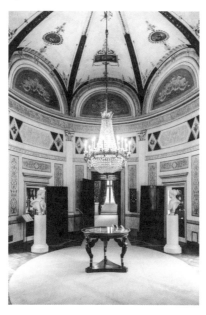

MUSEO CORRER

The Museo Correr, located in the Napoleonic Wing, is decorated in a grand, imperial style.

18

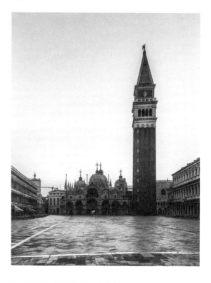

PIAZZA SAN MARCO

Saint Mark's Square offers a unique and sublime landscape any time of day.

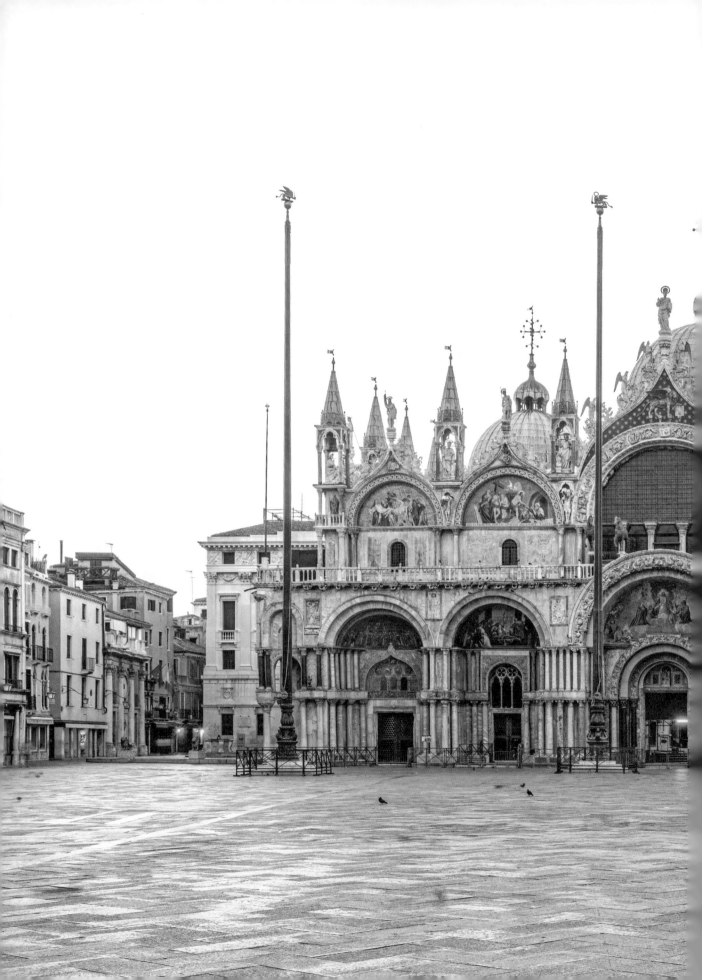

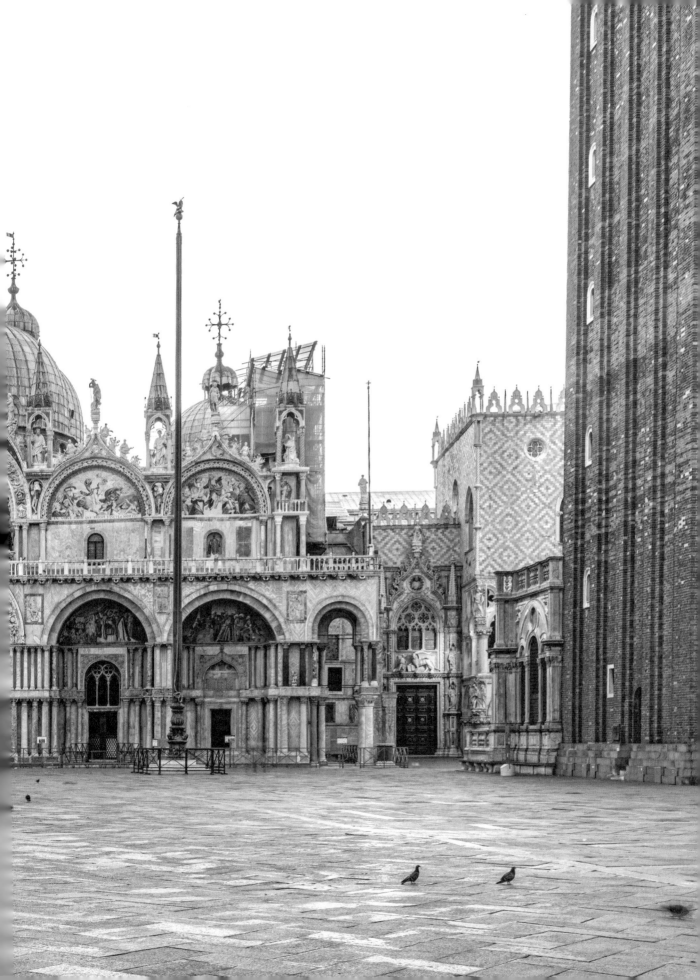

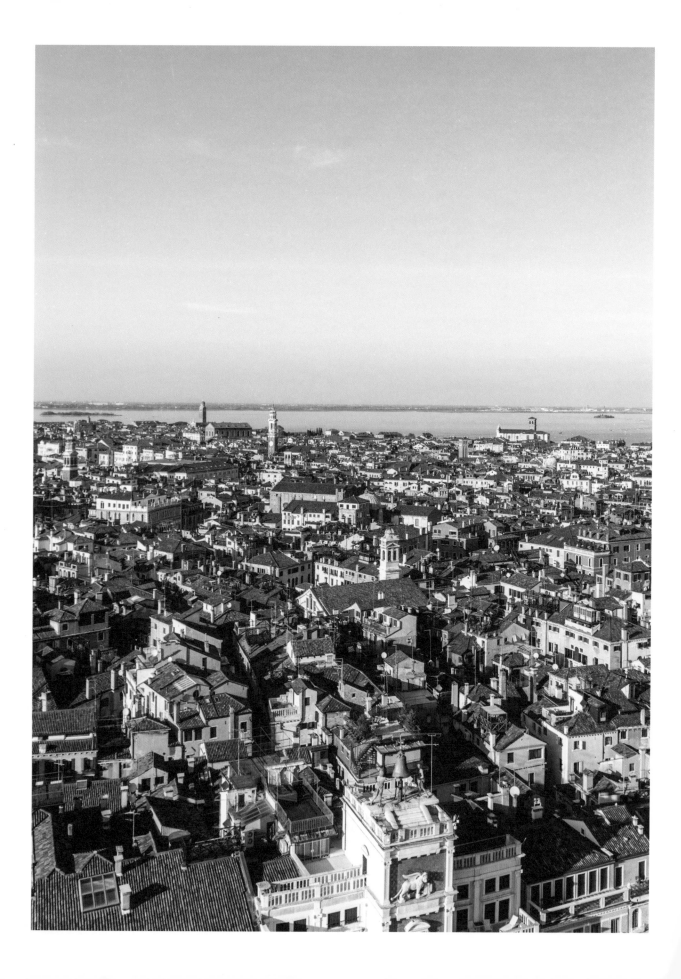

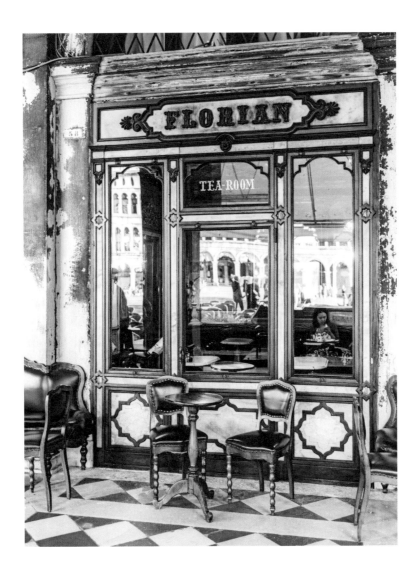

*In the early morning hours Saint Mark's Basilica, enriched with works of art
dating to the ninth century, can be admired without the crowds.*

ABOVE

*In front of Caffè Florian, Venice's most famous café, an orchestra plays continually
during summer months, adding to its magical charm.*

LEFT

Venice reveals its size and watery surroundings from the top of Saint Mark's bell tower.

UNDERSTANDING

VENETIAN COFFEE-OLOGY

Italians love coffee, and the Venetians are no exception. The drink spread throughout Europe starting in the sixteenth century thanks to Venetian merchants.

Saint Mark's Square, which the emperor Napoleon referred to as "the most elegant salon in Europe," is an ideal setting to relax over an espresso or cappuccino. A medicinal drink at first, coffee enjoyed in public places was popularized with the opening in 1775 of the first café, Caffè Quadri. Along with Caffè Florian, Quadri remains forever associated with the square, which today has just a small number of the thirty-four cafés found there at the end of the eighteenth century.

To experience the culture of coffee like Venetians today, head toward a coffee bar in the early morning hours for a *colazione*. As everywhere in Italy, the day starts by standing at the counter with a coffee in one hand and a brioche in the other. It's at the counter where Venetians order croissants filled with honey, jam, or chocolate. Occasionally, but more rarely, they may sit down to drink their coffee over a conversation or for a work meeting. Taking time to admire the gold of the basilica while the orchestra is playing is a rare way to experience the culture of the cafés, usually reserved for more important moments. For the rest of the time, coffee culture is a bar culture, where everyone stands elbow-to-elbow at the counter.

Here is a short list of coffees to know to keep you from getting lost in the crowd while ordering at Venetian cafés.

CAFFÈ LISCIO

This is what Venetians call espresso,
a common way to drink very strong coffee.

RISTRETTO

A very small serving of
a very strong coffee.

MACCHIATO CALDO

A coffee literally "stained" with a splash of milk,
topped with foam.

AMERICANO

Enjoyed mostly by tourists,
an Americano is composed of an espresso
diluted with about sixty percent water.

MACCHIATONE

Served only in the Venice region, this coffee
is the large version of the macchiato.

LUNGO

The Italians' "long" coffee, an espresso brewed
with more water, resulting in a larger serving.

CAPPUCCINO

An espresso served in a large cup with milk,
topped with foam. For Italians, this is
exclusively for breakfast!

CAFFÈ SHAKERATO

An espresso shaken with ice cubes,
served cold and sweet,
enjoyed especially in summer.

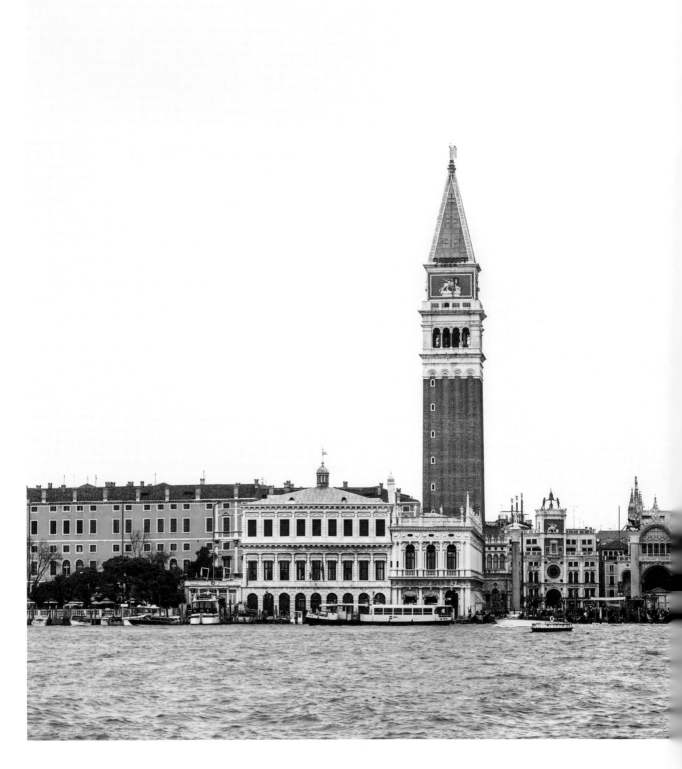

Viewed from a vaporetto, *Saint Mark's Square is a concentration of monuments stretching from the Marciana Library (left) to the Doge's Palace (right).*

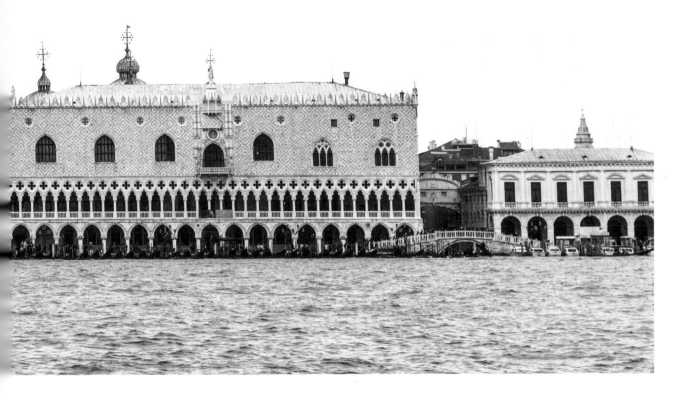

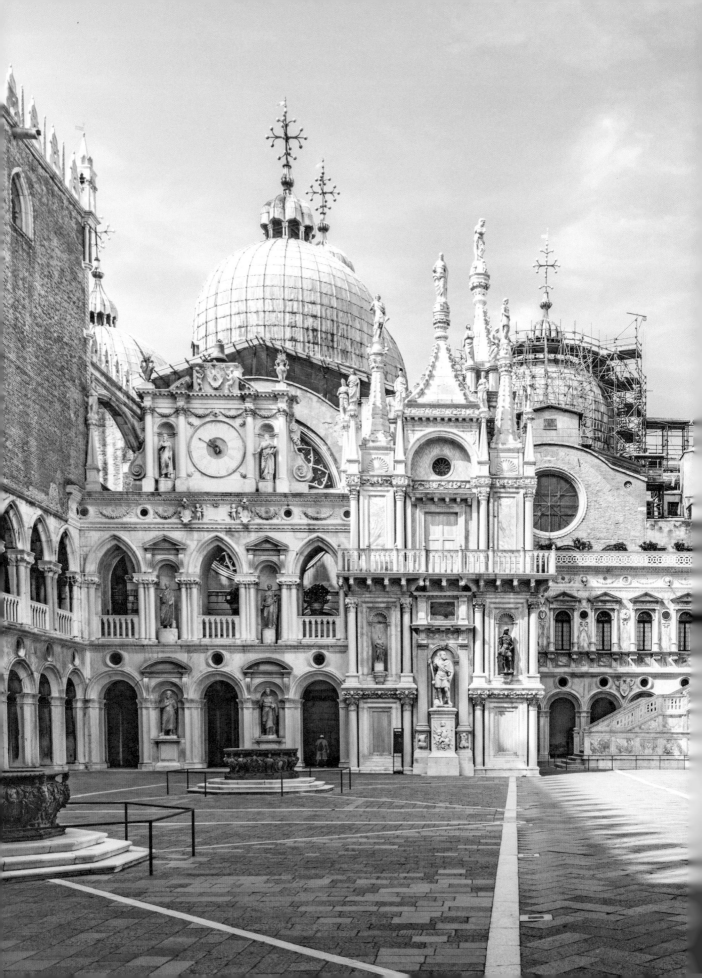

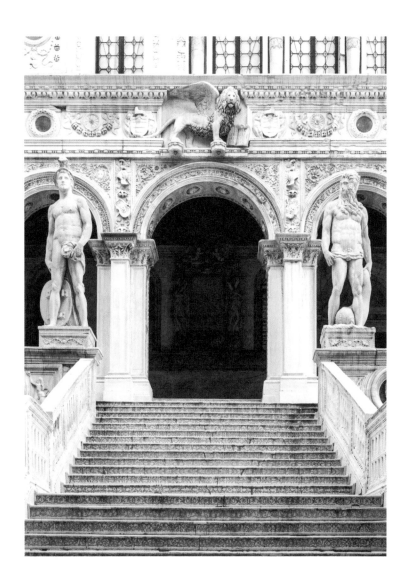

*Behind the Porta della Carta, where scribes would sit, the Giants' Staircase
serves as a monumental entrance to the Doge's Palace.*

*Unlike the uniform exterior facades, the courtyard of the Doge's Palace
presents a mixture of architectural styles.*

DESIGN

CARLO SCARPA

AN ARCHITECT FOR OLIVETTI

Piazza San Marco contains many surprises. Nestled between a grand café and a Murano glassmaker, Olivetti's displays vintage typewriters and calculators in its elegant showroom.

Under the arcades of the Procuratie Vecchie, just a few steps from the basilica, is a showroom designed by Carlo Scarpa for the famous Olivetti company. In the early 1950s, Piazza San Marco was frequented by the artists and architects of the Biennale as well as by tycoons of American industry. The big names of "made in Italy" occupied the square's shop windows; you might have met Liz Taylor or Grace Kelly coming out of Roberta di Camerino with a shopping bag in hand. For Adriano Olivetti, who inherited his father's burgeoning business, this was the perfect place to be seen. In 1956, he asked Carlo Scarpa, who had already been awarded the Olivetti Prize in design, to create a space capable of expressing the modernity of the brand. Today, the showroom is no longer a boutique but instead a "calling card" for displaying beautiful Olivetti objects to the world passing through the square.

The original space was cramped and divided in two by a partition limiting incoming light, as is usually the case on the ground floor of Venetian buildings. Scarpa focused his efforts on creating more light within the space. Four windows were installed, and the partition was removed. In the center of the room, the staircase divides the space with its seemingly floating steps with their irregular widths suggestively mimicking a typewriter carriage. A Venetian by birth, Scarpa had a style that includes elements borrowed from local artisans. Thus, the floor is decorated with an inset of pieces of Murano glass within a more modern material, concrete. The upper floor completes the ensemble by offering a warmer atmosphere consisting of a mixture of teakwood and rosewood.

Thanks to the renovation work in 2009, passersby can still see from the square the shiny calculators in their boxes, presented as jewels of modernity, before entering to visit the Negozio Olivetti, where exhibits are also organized.

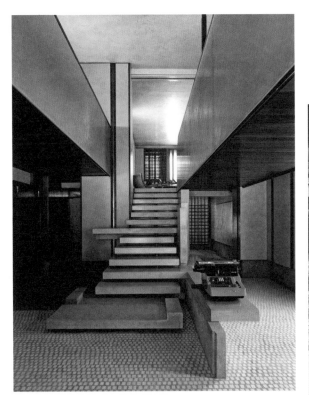

The care taken in the creation of the windows
testifies to the originality of the architect,
who invented his own style.

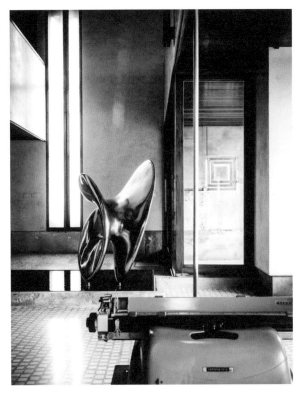

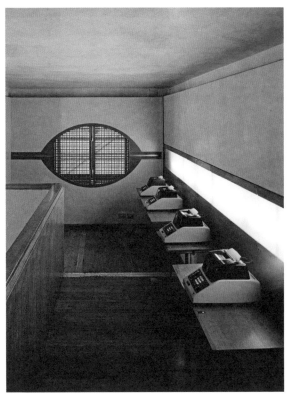

A DIALOGUE OF THE ARTS

At the entrance, Alberto Viani's *Nudo*,
a sculpture in gilded bronze mounted on a Belgian
black marble base, welcomes visitors.

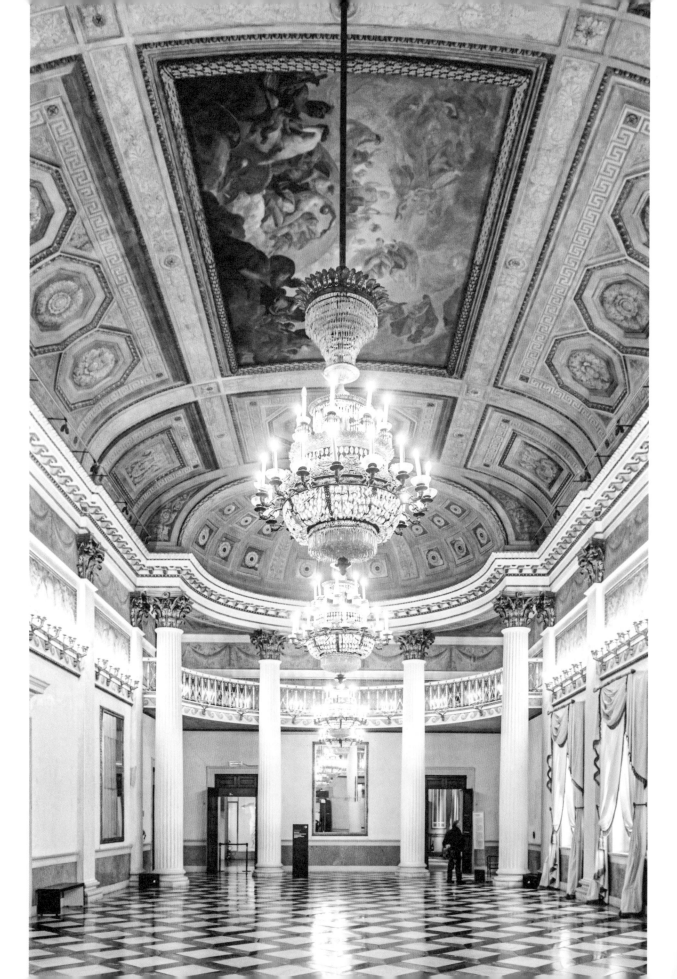

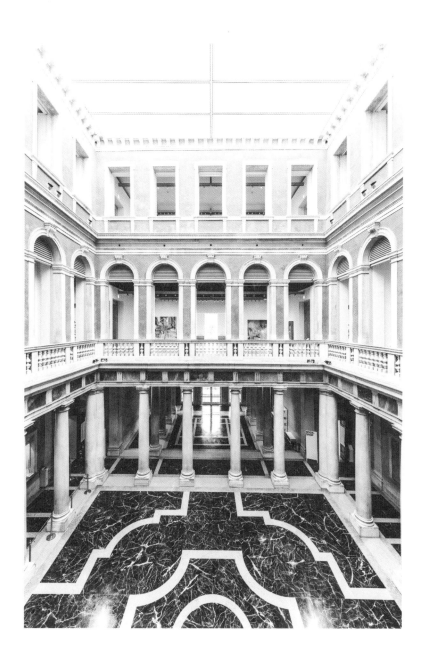

ABOVE

*Located away from Saint Mark's Square and the congested streets,
Palazzo Grassi is one of Venice's leading landmarks of contemporary art.*

LEFT

*Today, the Procuraties are in part an extension of the Museo Correr.
During the French occupation of Venice, Napoleon had a church demolished
to add a new, dazzling wing to these administrative buildings.*

FOOD & DRINK

HARRY'S BAR

THE BIRTHPLACE OF THE BELLINI

Just a short distance from Piazza San Marco
and down one of Venice's most luxurious thoroughfares,
a now-world-famous cocktail was born.

The six stools at the counter are covered in brown leather. In the dining room are just a dozen wooden tables. It's as if the clock stopped here, a space that has barely changed since opening in 1931. Behind the bar, the skillful art of cocktail making is passed down from bartender to bartender as they prepare with care the cocktails that make Harry's Bar what it is. It is here where white peaches were first married with the bubbles of Prosecco and served in the eternal highball glass, accompanied by a small plate of olives for nibbling.

The famous Bellini cocktail was born from a chance encounter of an American tourist, a Veronese bartender, and a Renaissance painter. Harry Pickering, the American, was staying in Venice in 1929 with his aunt, who left him there. His funds quickly dwindled. The bartender, Giuseppe Cipriani, who worked at the Hotel Europa, where Harry was staying, lent him the sum of ten thousand lira to help him get home.

Two years later, Harry was back in Venice and reimbursed Cipriani four times the amount he gave him. Cipriani now had the money to realize his dream of opening his own bar. Inside an old rope-making factory, at the back of Calle Vallaresso, he opened what would eventually become the haunt of Ernest Hemingway, Orson Welles, and Peggy Guggenheim. In 1948, he invented a new cocktail, the Bellini, made from Prosecco from the neighboring hills and the pulp of white peaches from Sant'Erasmo. Its pink-orange hue conjured up the palette of artist Giovanni Bellini, a Venetian painter whose frescoes adorn the Frari and San Zaccaria churches—thus the name for the cocktail was found.

Cipriani opened hotels and bars in the lagoon and then in the United States, popularizing the cocktail that would eventually conquer the dining tables of New York. The International Bartenders Association even placed the Bellini on its official list, making this Venetian cocktail a classic now consumed worldwide.

THE FAMOUS BELLINI COCKTAIL WAS BORN FROM A CHANCE ENCOUNTER OF AN AMERICAN TOURIST, A VERONESE BARTENDER, AND A RENAISSANCE PAINTER.

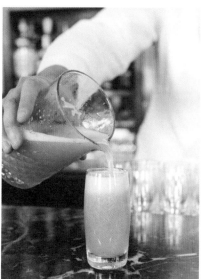

THE BELLINI
AS SERVED
AT HARRY'S BAR

—

*2 fl. oz. (50 ml) pulp from
fresh, white peaches
1 lemon
ice cubes
3 ½ fl. oz. (100 ml) Prosecco*

—

Wash the peaches, cut them into quarters, and remove the pits. Crush the flesh with a mortar, then strain the pulp to remove the skin. Add a few drops of lemon juice. Cool a highball glass by placing ice cubes in it. Once the glass is chilled, discard the ice. Add the peach pulp and Prosecco. Stir to combine using a cocktail spoon. Serve with Lucca olives.

*From the top of the spiral staircase of the Contarini del Bovolo palace located
at the back of a narrow lane, the entire district comes into view.*

ABOVE

*The marble floor at the entrance hall of the Venier Casino conceals a
peephole used to spy on those coming and going from the street.*

RIGHT

*Starting from the fifteenth century, Venice was teeming with casinos, both public and private,
where people could meet to talk, relax, and banter. The Venier Casino, which belonged
to the procurator Venier, is one of the few to have survived.*

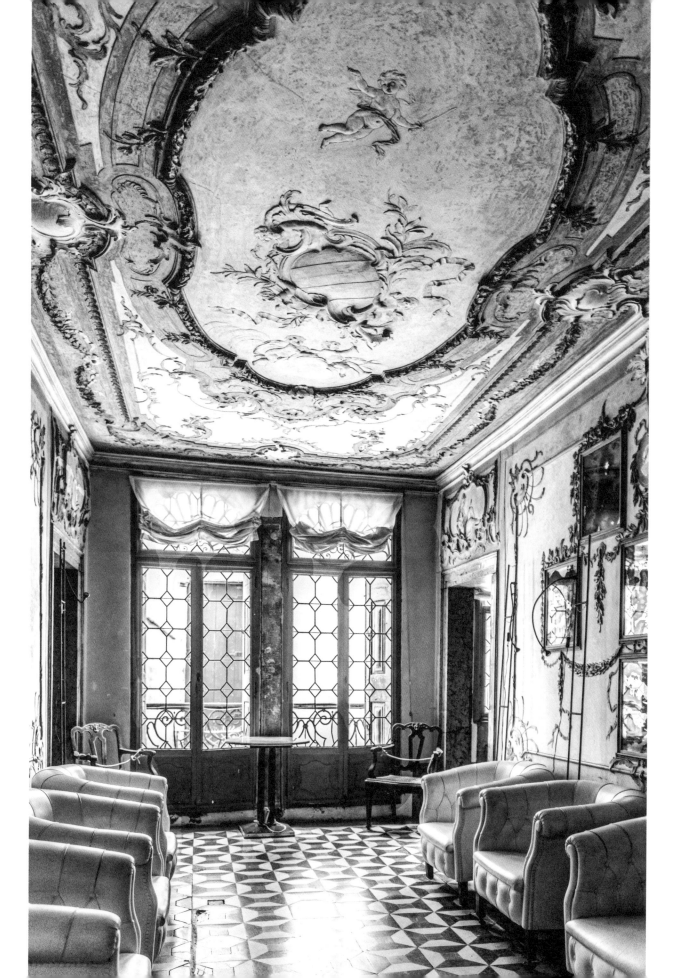

ARCHITECTURE

VENETIAN RENAISSANCE

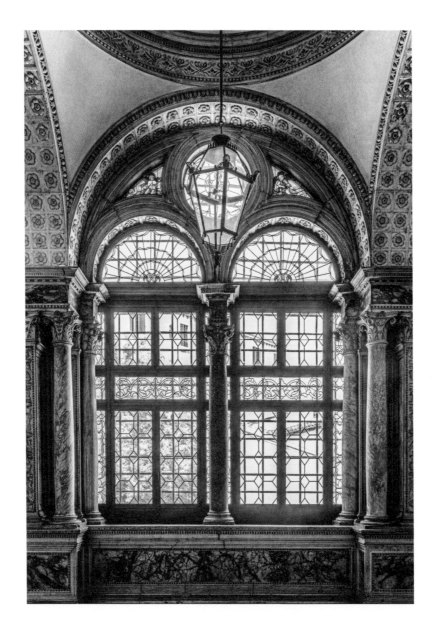

SCUOLA GRANDE DI SAN GIOVANNI EVANGELISTA

Thanks most notably to the Lombards, the Renaissance style arrived in Venice and flourished
in the fifteenth and sixteenth centuries, leaving many architectural jewels throughout the city.

CA' VENDRAMIN CALERGI

The Venice Casino is located here, one of the most splendid Renaissance palaces.

SCUOLA GRANDE DI SAN MARCO

Its facade creates a marble trompe l'oeil perspective.

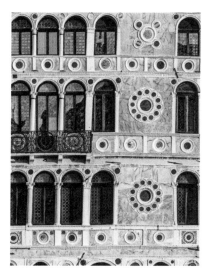

CA' DARIO

This palace is believed to be cursed because of the many incidents that have occurred to its owners.

SANTA MARIA DEI MIRACOLI

Pietro Lombardo was one of the great architects of the time and worked on this small church of delicate refinement.

SANTA MARIA DEI CARMINI

At the beginning of the sixteenth century, Sebastiano Mariani created the facade, a play on rounded shapes.

SAN ZACCARIA

Antonio Gambello and Mauro Codussi built this church between 1458 and 1490.

SANTA MARIA FORMOSA

Above the door, a grimacing face is frozen in stone.

PALAZZO DELLE ZATTERE

The V-A-C, the Russian contemporary art foundation, houses exhibits in this superb building overlooking the Giudecca Canal.

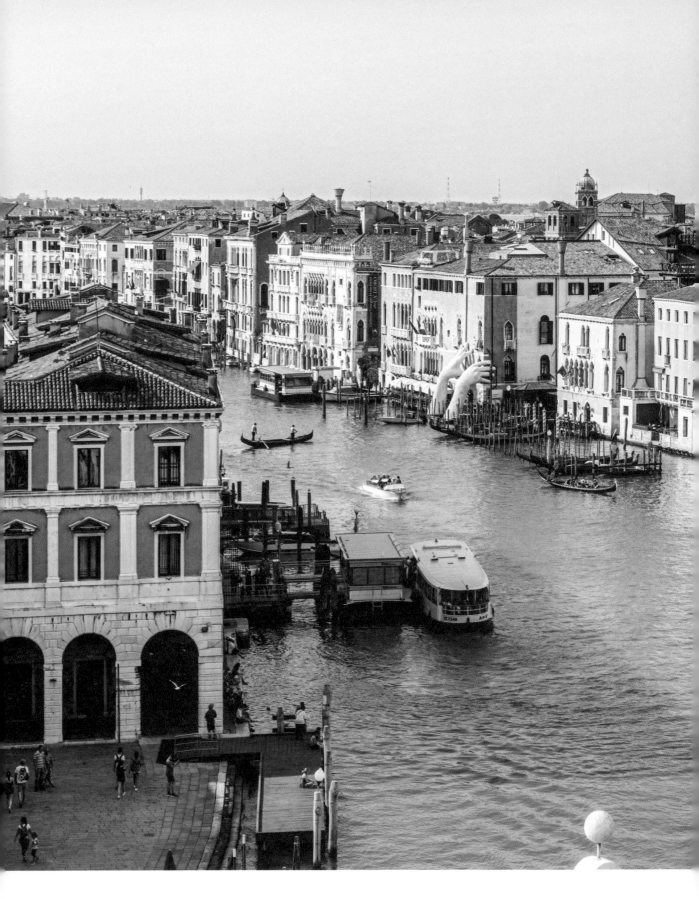

The rooftop terrace of the Fondaco dei Tedeschi overlooks the Rialto Bridge. This fifteenth-century merchant warehouse is now the location of an elegant luxury shopping center.

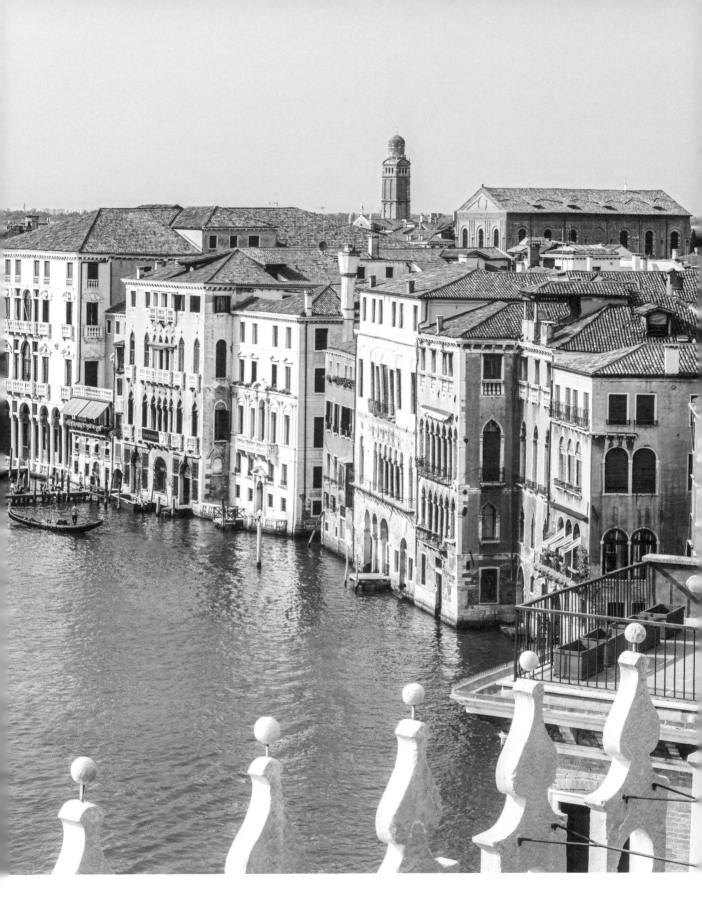

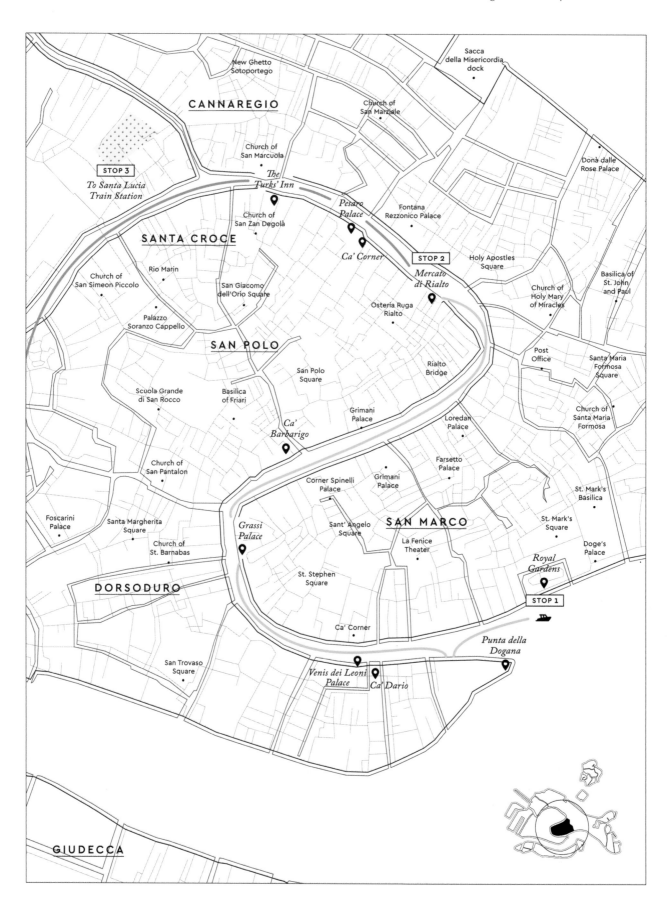

THE GRAND CANAL, FROM ONE PALACE TO ANOTHER

In the shape of a backward S snaking through the city, the Grand Canal serves as Venice's main waterway. Along the water's edge, important families built sumptuous palaces that now serve as locations for foundations, museums, and luxury hotels. Linking the worlds of fine art, high society, and commerce, here is an itinerary for discovering the diversity along the Grand Canal.

STOP 1: FROM THE PUNTA DELLA DOGANA TO THE PALAZZO GRASSI

Vaporetto no. 2 starts in front of the Royal Gardens, the Giardini Reali, created at the behest of Napoleon as a green extension for Piazza San Marco. Not far away, the Punta della Dogana, crowned with a bronze sphere lifted by two Atlases, welcomes you at the entrance to the canal, which serves as a sort of open-air museum where the frescoes that adorned the facades have now disappeared. The polychromatic marbles of Ca' Dario, from the fifteenth century, draw the eye toward this small palace, which many claim is cursed. A little farther on are the shimmering colors of Ca' Barbarigo, covered with mosaics. The works of art located behind its walls reinforce the enchantment of the canal. For contemporary art, visit the Punta della Dogana and the Palazzo Grassi of the Pinault Foundation. At Ca' Venier dei Leoni, located in the former home of Peggy Guggenheim, you can admire the incredible modern art collection. Just a few steps away is the Cini Foundation, exhibiting the canvases of great Italian painters of the thirteenth to the sixteenth century. You'll also see the Biennale pavilions grouped on the canal from May to November.

STOP 2: THE RIALTO MARKET

Continuing along its course and after a wide turn, the *vaporetto* reaches the Rialto district. On both sides, the banks are bustling with carts and pedestrians; since its establishment in the eleventh century, the market has continued to thrive. It is best to visit at dawn when the boats unload their goods in the morning silence onto the piers that still bear the name of the products once sold there: *Riva del Vin*, *del Carbon*, or *del Ogio* (wine, coal, and oil). Under the neo-gothic arcades of the Loggia della Pescheria, built in 1907 by the architect Domenico Rupolo, fishmongers work under a swirl of seagulls. In the stalls, the vegetables of Sant'Erasmo and the fish from the Adriatic brighten the area with their many colors.

STOP 3: THE GRAND FINALE

Around its last turns, the Grand Canal presents surprising contrasts. From palace to palace, the city's history is revealed. First, the casino and its splendid Renaissance facade reminds us of the madness of gambling that prevailed throughout a city known for its Carnival and celebrations. Then appear the imposing baroque structures of two patrician mansions that became museums: Ca' Corner della Regina and Ca' Pesaro. Finally, the Fondaco dei Turchi, a thirteenth-century warehouse where Turkish traders were allowed to live and store their goods. The journey ends at the Santa Lucia station, a long, gray rectangular structure built in 1952 in the Rationalist style promoted by the architects of fascism. In all, this journey leads you from Saint Mark's Square, the long-time gateway of Venice, to the contemporary access of Santa Lucia, now connected to the mainland by a bridge.

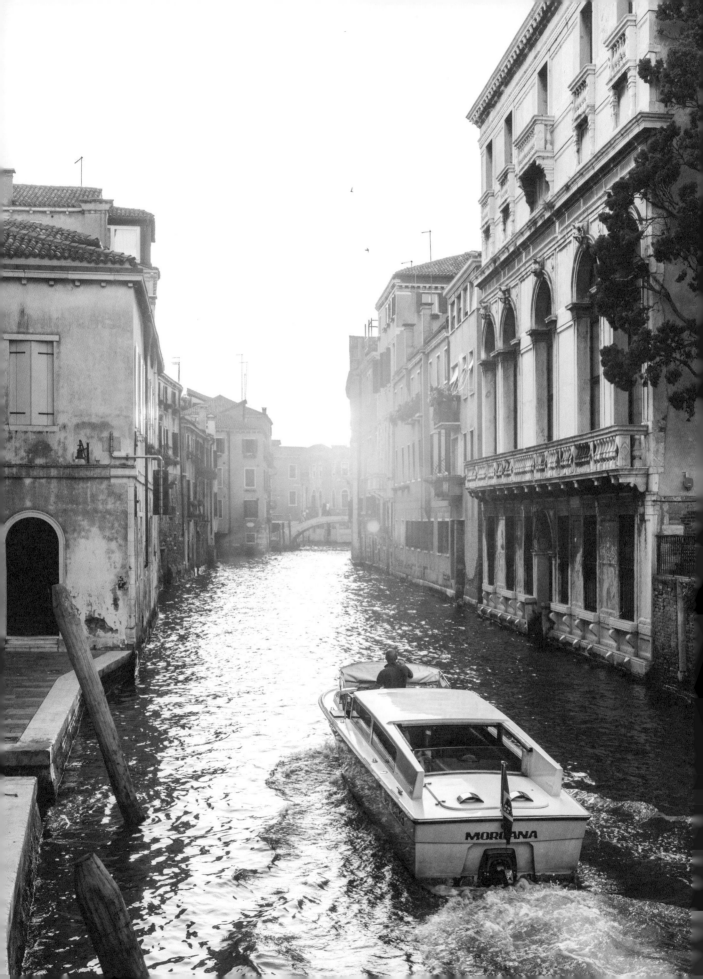

DORSODURO

This *sestiere* promises an artistic crescendo
starting at the church of San Pantalon and ending at the
Punta della Dogana at the confluence of the Giudecca and
Grand Canals. Here, aesthetic views into dizzying heights in
churches and museums combine with restful breaks on
café terraces to enjoy all this neighborhood has to offer.

P.74

*The Rio de Ca' Foscari connects the Grand Canal
and the heart of the university district of Dorsoduro.*

RIGHT

*On Campo Santa Margherita, Caffè Rosso is a late-night institution
frequented by students and residents.*

With your head tilted far back while standing in the church of San Pantalon, you can admire the largest painted canvas in the world, gazing up while getting lost in the immensity of an artificial sky. This is but a small taste of the artistic splendors in this district strewn with masterpieces. Leaving San Pantalon, you venture beyond the Rio de Ca' Foscari to enter the vast Campo Santa Margherita. As the hours pass during the day, this square, a symbol of student life, transforms: the morning hours arrive with the sounds from the fish market and the cries of seagulls; the day bustles with the echo of conversations from the terrace of Caffè Rosso; and evening arrives accompanied by the shade of orange from glasses filled with spritz, a local drink made with Aperol, Campari, or Select bitters.

At the foot of Ponte dei Pugni is a colorful boat loaded with baby artichokes, curly lettuce, and sun-yellow lemons. The gondolas and the church of San Barnaba offer their reflections on the canal's waters as the day drifts by. Continuing on, the stroller can take a break by entering Ca' Rezzonico to see eighteenth-century Venice, or continue straight toward the Accademia, via the *sottoportego*, the covered passageway.

Gradually, the district becomes denser, in a concentration of buildings that extends as far as the Punta della Dogana. To better explore it, you have to stay along the edges from one bank to the other, from the Grand Canal to the Zattere promenade, with long breaks to visit, observe, and contemplate. First, you'll notice the parade of boats on the Grand Canal side, which can be seen in front of the church of Santa Maria della Salute or from the small Campo San Vio. From the Zattere side, a long and wide promenade, you can look out onto the island of Giudecca. Many museums can be found housing numerous works of art to stop and admire. Beneath the gilded ceilings of the Gallerie dell'Accademia, the history of Venetian art from the fourteenth to the eighteenth century is told through the great masters. The Peggy Guggenheim Foundation offers another style, that of modern art, exhibited in the former home and gardens of the eccentric collector.

At the end of the district, the Dogana da Mar (Sea Customs House)—now a vast exhibition space redesigned by the Japanese architect Tadao Ando for the Pinault Foundation—is a triumph. The goods that arrived in Venice passed through these sublime warehouses, surrounded today by artists from all walks of life. From this perfect and ideal vantage point with its narrowing end, the city appears as an exotic land viewed from the bow of a ship.

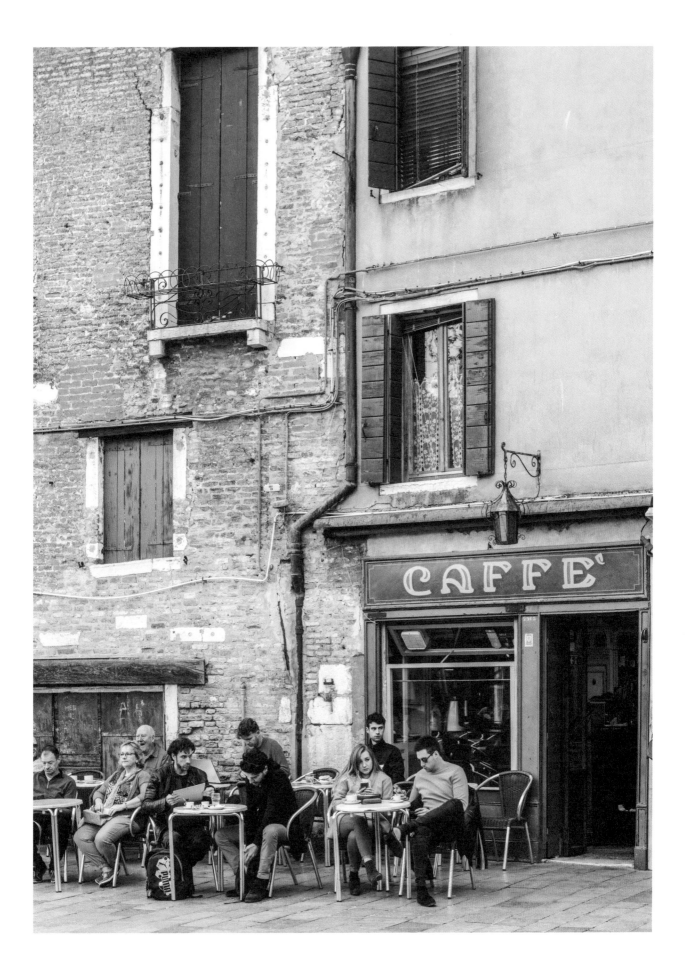

THE ESSENTIALS

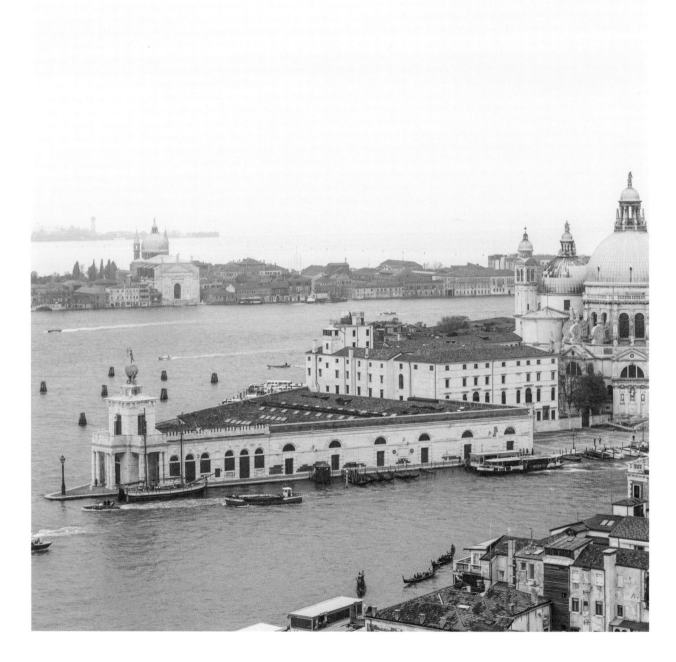

PUNTA DELLA DOGANA

From the Punta della Dogana, it's as if the bow of a ship has pulled into the city. The moment is best savored at sunset when the light bathes the surrounding monuments in golden colors.

20

GALLERIE DELL'ACCADEMIA

The Gallerie dell'Accademia is an enormous museum dedicated to Venetian paintings.

21

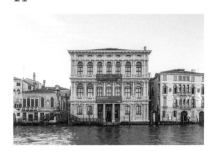

CA' REZZONICO

At Ca' Rezzonico, among a setting of stuccos and frescoes, you can relive eighteenth-century Venice.

22

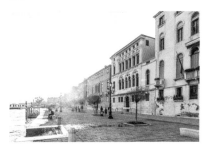

ZATTERE

Stroll along the Zattere with an ice cream in hand. This is a favorite promenade of many Venetians.

23

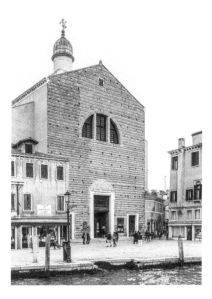

SAN PANTALON

The simple facade of San Pantalon may not be impressive, but those who pass through its doors will be pleased.

24

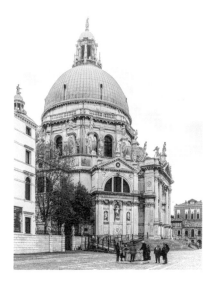

SANTA MARIA DELLA SALUTE

The church of Santa Maria della Salute magnificently expresses baroque genius in its domed structure.

25

PONTE DELL'ACCADEMIA

The Ponte dell'Accademia is more than a wooden bridge; it's also a superb vantage point over the Grand Canal.

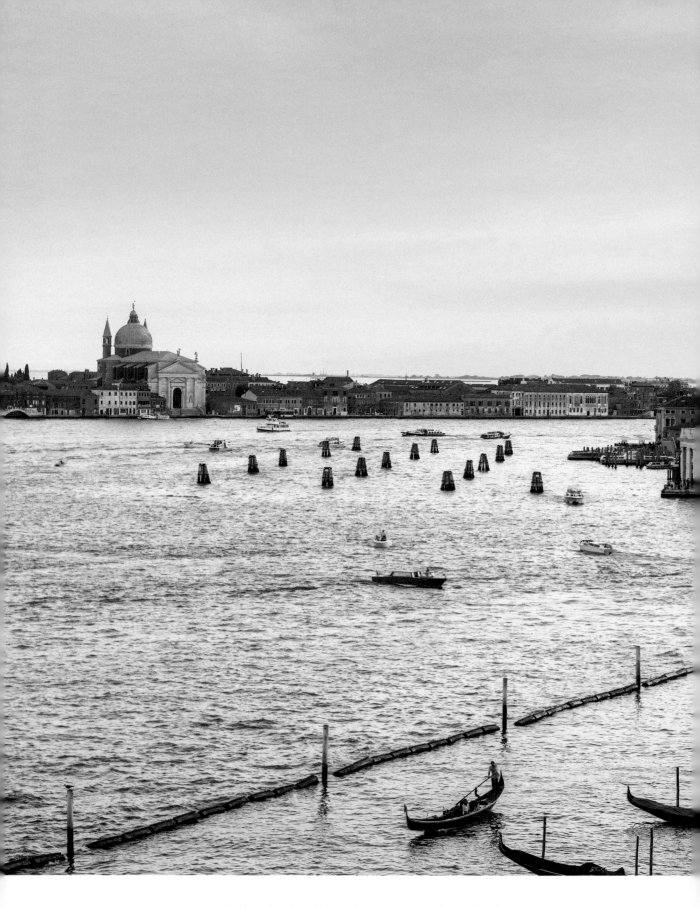

In the shape of a point, the Dorsoduro district marks the mouth of the Grand Canal on one side and the Giudecca on the other.

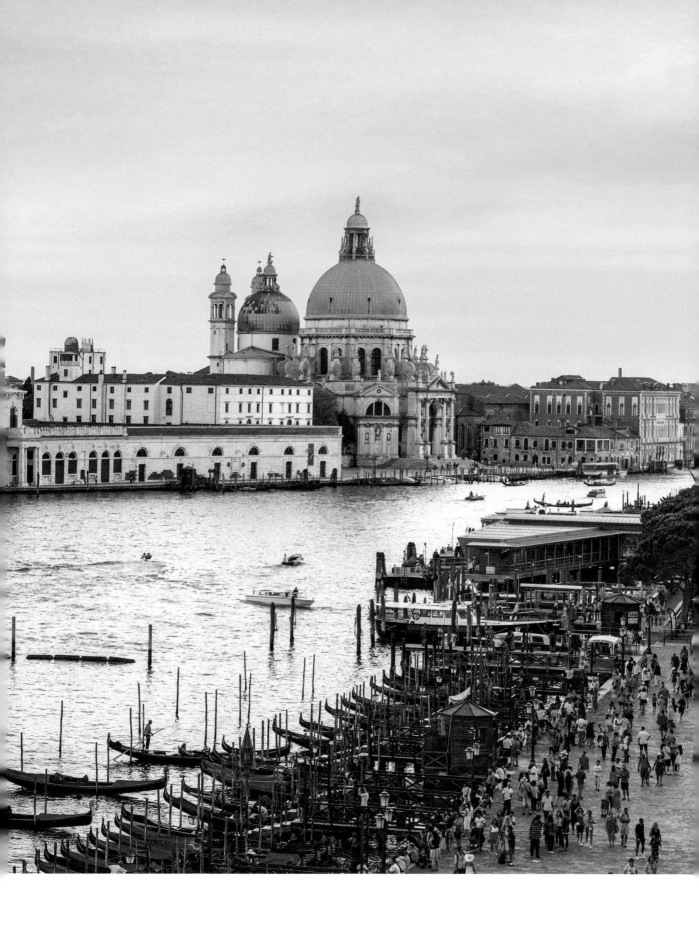

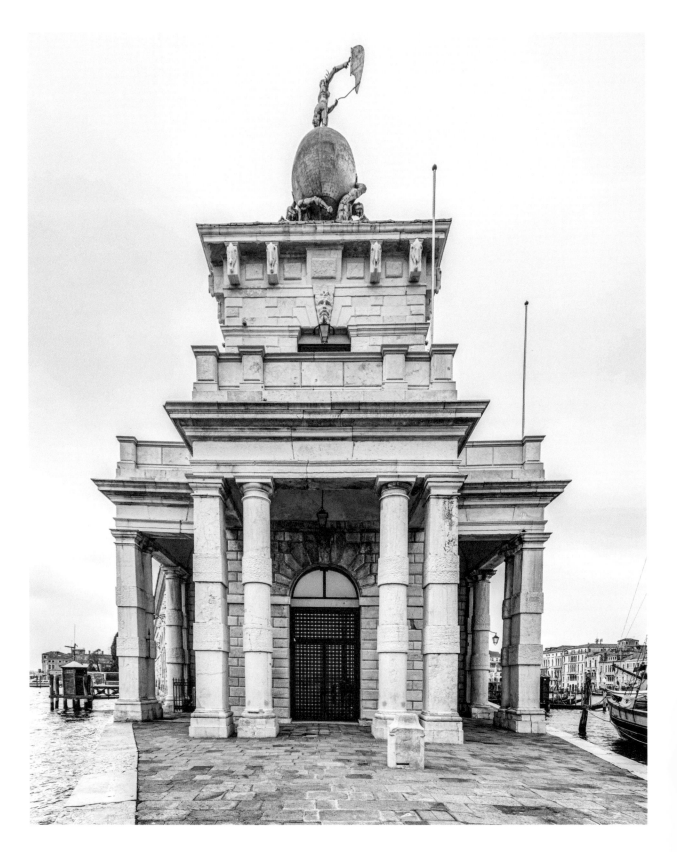

Located at the entrance to the Grand Canal, the Sea Customs House
regulated goods arriving in Venice.

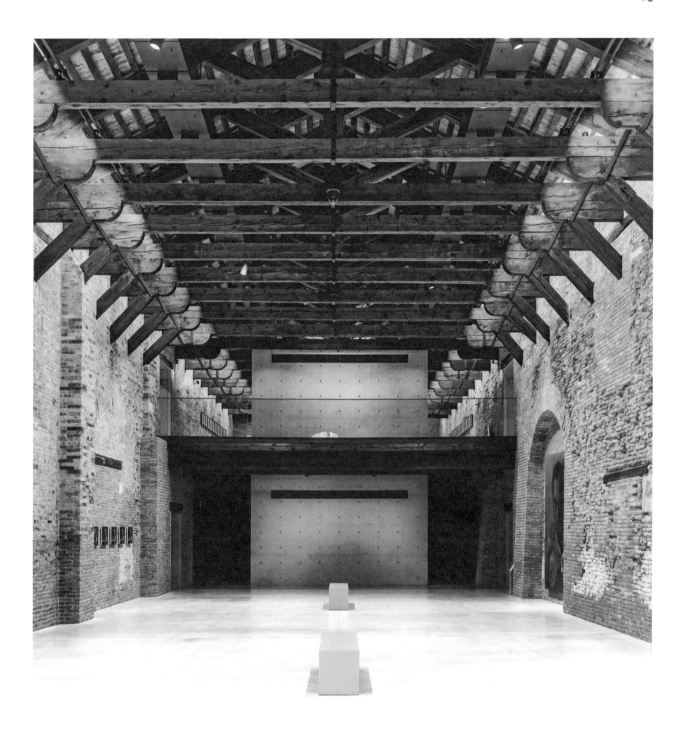

*Former warehouses where salt and spices were once stored are today concrete spaces
designed by architect Tadao Ando for exhibiting contemporary art.*

VISITING

CA' REZZONICO

RELIVING THE EIGHTEENTH CENTURY

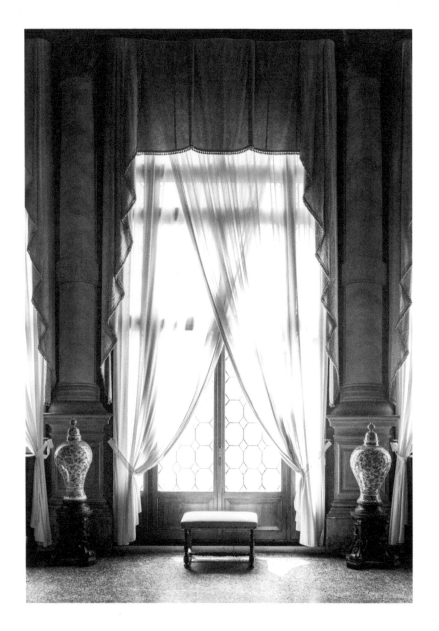

A MUSEUM OF THE PAST

Transformed into a museum dedicated to the eighteenth century, this former residence on the Grand Canal provides a glimpse into what the most luxurious Venetian interiors would have been.

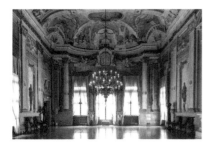

SALONE DA BALLO

Venice's largest ballroom hosted memorable celebrations.

CAPPELLA

This small chapel room houses paintings from Villa Zianigo.

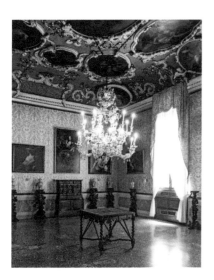

SALA DEL BRUSTOLON

The furniture in this room comes from Palazzo San Vio.

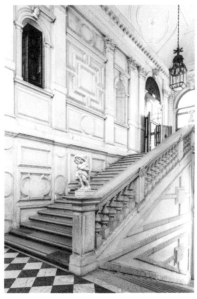

SCALONE

Proportionately scaled to the enormity of the palace, this monumental staircase leads directly to the ballroom.

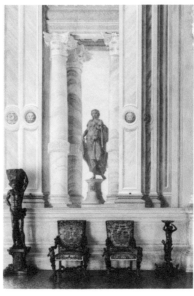

TROMPE L'OEIL

From the brush of Girolamo Mengozzi Colonna emerges artificial architecture to enlarge the space of the ballroom.

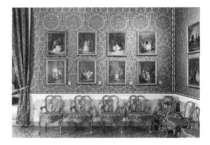

SALA PIETRO LONGHI

This room offers a moving panorama of everyday eighteenth-century life.

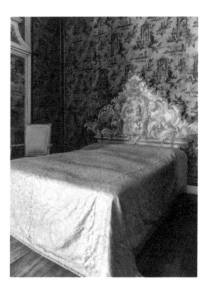

BEDROOM

Tucked into an alcove is the re-creation of an eighteenth-century intimate space.

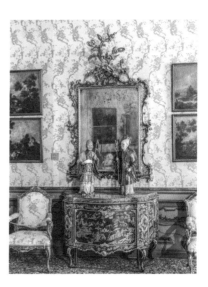

SALA LACCHE VERDI

Lacquered emerald-green furniture testifies to the popularity of chinoiserie at the time.

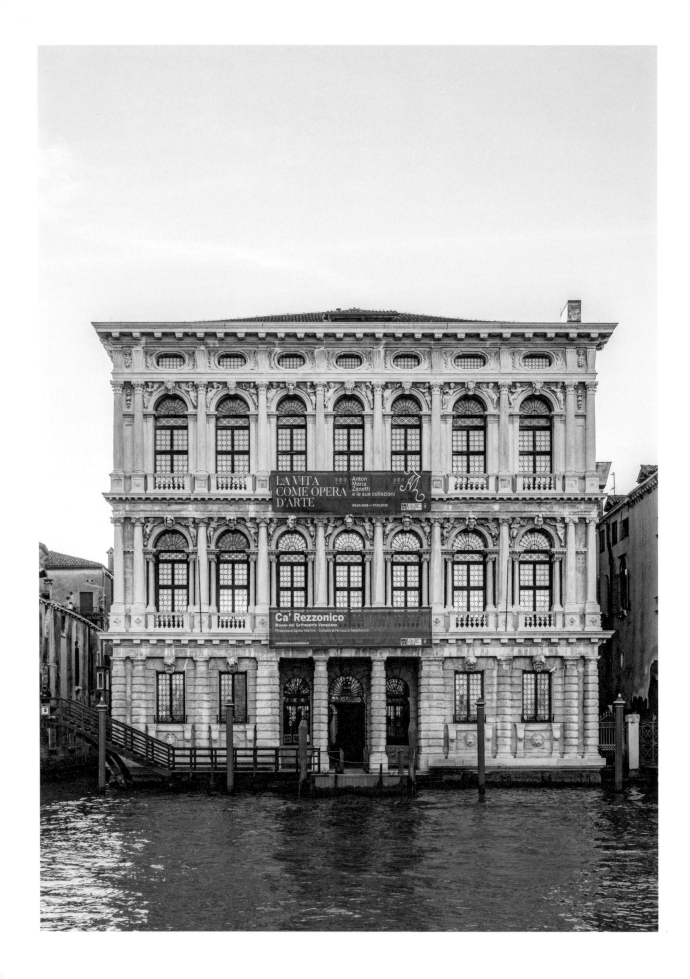

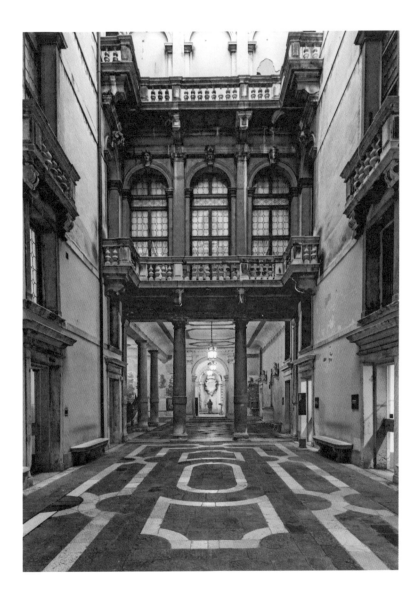

*In the tradition of a Venetian palace, the courtyard of Ca' Rezzonico
opens onto the Grand Canal to facilitate access by gondola or boat.*

*The white marble facade of Ca' Rezzonico has been overlooking the
right bank of the Grand Canal since the seventeenth century.*

AN INVITATION TO CARNIVAL

On the second floor of Ca' Rezzonico,
in a room hanging with red and gold brocade,
some twenty small canvases that take us
into eighteenth-century Venice are exhibited.

Surprisingly, these modest paintings capture all the attention, eclipsing the delicate fresco on the ceiling by Giambattista Tiepolo representing Zephyr and Flora. In the former bedroom of Antonio Pesaro and Caterina Sagredo hang works that made Pietro Longhi a leading painter of the time. An eighteenth-century Venetian artist and contemporary and friend of playwright Carlo Goldoni, Longhi began his career as a historical painter, but his works were met with mixed reception. Turning to genre painting, he enjoyed success painting everyday Venetian society, which he depicted with great realism. He thus revealed the modern days of his time, ranging from street scenes to inside the apartments of aristocrats.

Longhi painted the aristocracy in uncommon settings tinged with realism and subtle irony. Rather than glorify his subjects, he represented them going about their everyday lives: drinking a cup of chocolate, preparing themselves for the day, or in the painter's studio. He followed them into public spaces, inviting us to join them at Carnival. During the time of Longhi, this important festival on the Venetian calendar was spread over three months, during which masked attendees would gather on Piazza San Marco. To amuse guests, stalls were set up in front of the arcades of the Procuraties or the Marciana library. Magicians, astrologers, puppeteers, and charmers would set up there, as Longhi's paintings depict. One of these paintings is of Carla, a female rhinoceros who arrived in Venice in 1751, portrayed in her stable and admired by several onlookers, some wearing masks.

In the next room, the invitation to relive Carnival continues in a painting by Francesco Guardi, another eighteenth-century artist. The figures of *Il Ridotto*, all in masks except for the dealer, crowd into the casino's gambling room, which then took place in Palazzo Dandolo in San Moisè. This place of celebrations, which was frequented by nobility, foreigners, and prostitutes, was closed in 1774 for violating public order.

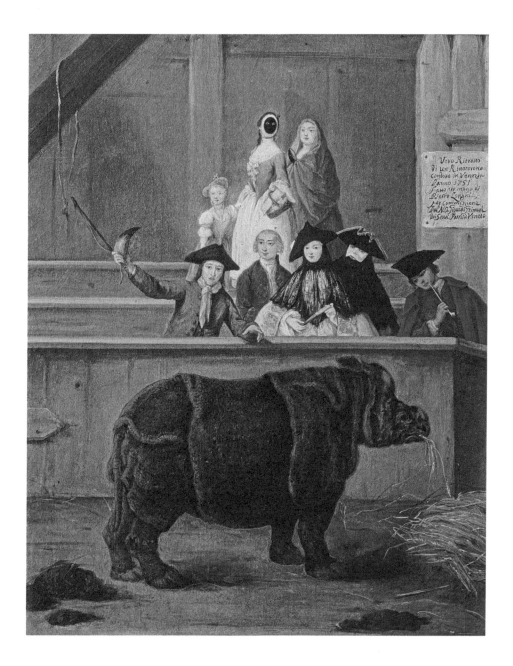

A GAME OF MASKS

In this painting, Pietro Longhi depicts Venetians,
some wearing masks, admiring Carla, a female rhinoceros
who arrived in Venice in 1751.

Venice's restaurant industry employs many Venetians.
In the kitchens, chefs combine seafoods with spices.

At the foot of Ponte dei Pugni, the boat from San Barnaba
offers fresh and seasonal vegetables every day.

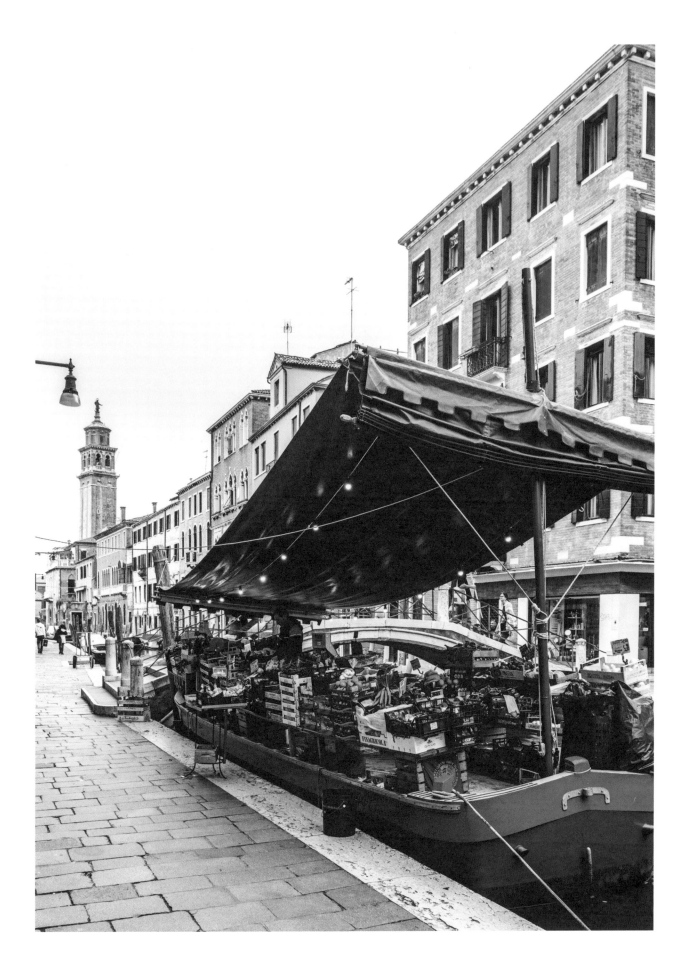

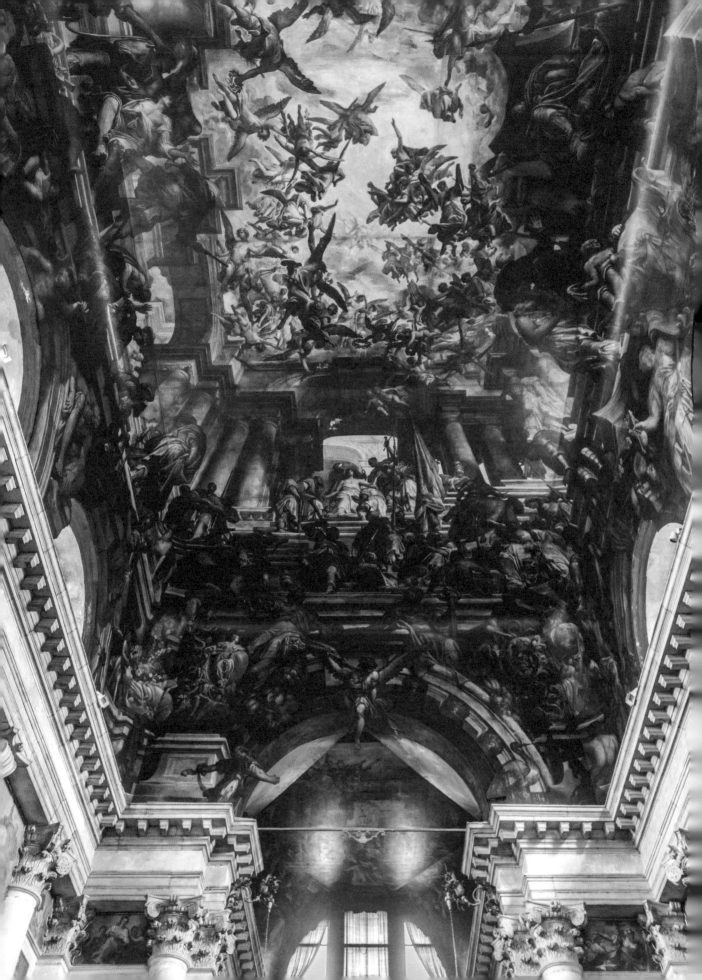

ABOVE

Shrines to the Virgin Mary can be found all around the city.

LEFT

*On the ceiling of the San Pantalon church, forty panels painted
by Gian Antonio Fumiani in the eighteenth century
on 13,500 square feet (1,250 square meters) of canvas evoke
the martyrdom of San Pantalon in the fourth century.*

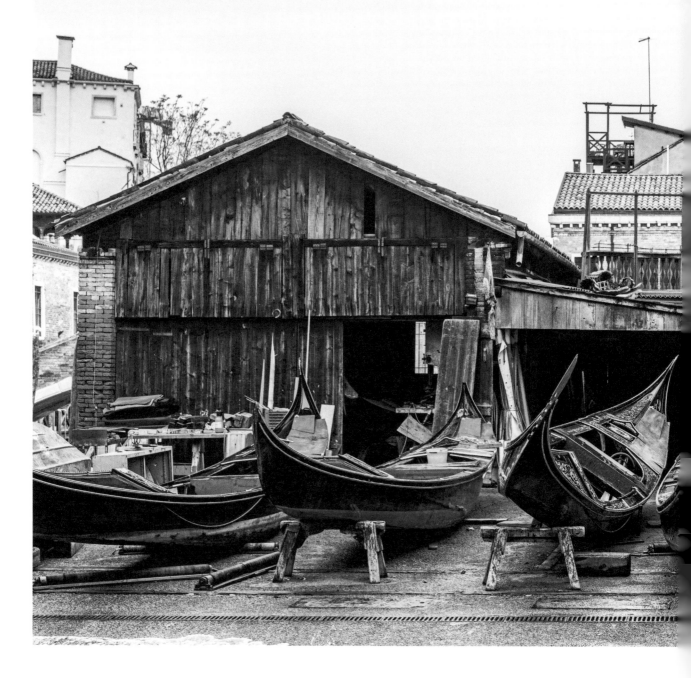

*This shipyard specializes in the manufacture and repair of gondolas. Many workers
come from the Dolomites, which is why the sheds resemble mountain chalets.*

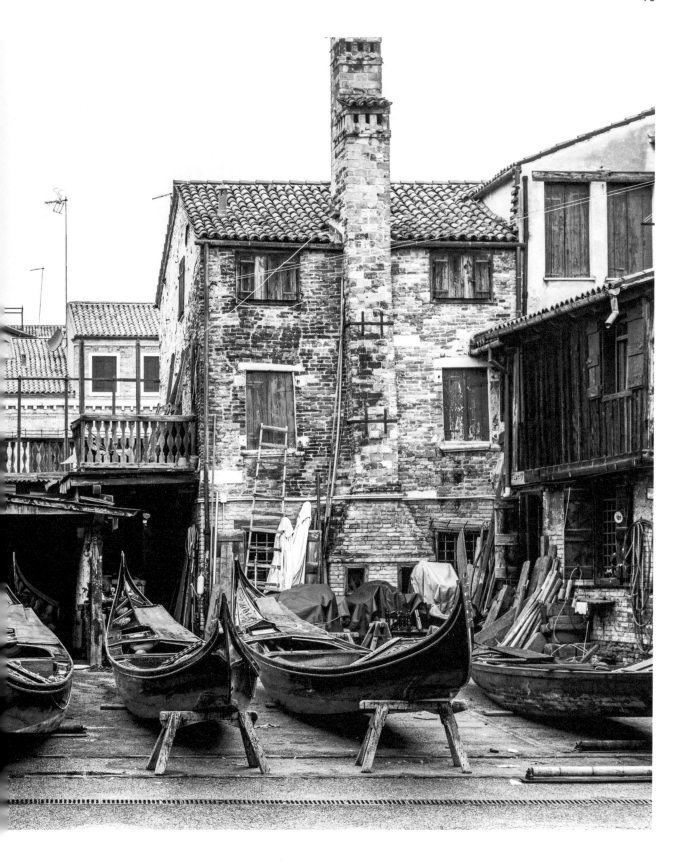

A CITY THAT DRIFTS

Quietly and gently, gondoliers drift along in their gondolas more often than they row. Sliding along the water, they propel their boats with a movement that starts from the legs, moves up through the chest, and extends through the arms.

In Venice there are just over four hundred gondoliers, a profession born out of the need to navigate the city's network of canals. But in Venice, *voga* is more than a tradition; it is a lifestyle, intrinsically linked to the history of the city. The smallest stones used for the construction of the city, and which can still be seen reflecting off the waters today, arrived through the canals from the mainland aboard flat-bottomed boats adapted to the lagoon traffic. These types of boats are still used today.

There was a time in Venice when everyone tied his boat to his house. Even after the sounds of the *vaporetti* became part of the lagoon, which caused a gondolier strike when they arrived in 1881, many held on to the old rowing traditions, still dipping their oars into the water as their daily means of transport. Some attend the *remiere*, the rowing schools where regatta champions train for the Vogalonga, while others row along the waters just for the pleasure of it. On the small, isolated canals,

Venetians enjoy exploring their city of water while meandering through the *rii*, as these minor waterways are called, to the light sound of water lapping from a single oar.

A *squero*, a site for the construction and restoration of boats, is an essential part of the waterways. The one in San Trovaso resembles a mountain chalet, recalling that the best gondola makers came from the Dolomites. Pulled up onto the shore, gondolas rest side by side, waiting to be restored or for a new coat of varnish, ready again to welcome couples who will discover a Venice that can only be seen from the water.

But romantic couples are not the only ones being served by the gondolas. On board the *traghetto gondola* men or women in suits or people returning from the market can be spotted hastily crossing the Grand Canal. In the age of motorboats, Venice remains a city that drifts.

THE *BRICOLE*

The *bricole* are huge wooden poles embedded
in the lagoon, used to navigate the channels.
The small white plate indicates the navigable side
(13 to 16 feet/4 to 5 meters deep) and the maximum
allowed speed (in knots). Assembled in threes,
the poles indicate the boundaries of the channel.
When assembled in fours and fives,
they indicate crossing with another lane.

THE *PALINA*

The *palina* is a single pole that was used
to anchor a gondola but is now used for boats.
Often painted in an attractive way, its colors
represented a particular important family.

REGATTA GONDOLA

Led by two rowers, it is fast
and specially designed to win regattas.

REGATTA "CAORLINA"

This boat requires six rowers. It can be
spotted on the water during the historic regattas.

Walking along the Fondamenta del Gaffaro, you can spot amazing architecture, such as this residence with a private garden.

VISITING

PEGGY GUGGENHEIM

THE COLLECTOR

On the banks of the Grand Canal, Ca' Venier dei Leoni stands with its long, low profile. The palace was intended to be of monumental size, but the work stopped after the construction of the ground floor. For Peggy Guggenheim, however, the unfinished palace was love at first sight. She lived here for thirty years before it became an exhibit space for her modern art collection.

During her years in Europe, traveling between Paris, London, and Switzerland, the New Yorker accumulated an impressive collection of modern art. Starting in 1920, she met many avant-garde artists, bought their works, and developed the flair of a connoisseur. Jean Arp, Brâncuși, Cocteau, and Kandinsky were among her first acquisitions. During the Second World War, thanks to her help, many artists managed to flee Europe for the United States. After returning to New York, she expanded her collection of American art. Once again, her role was fundamental to the careers of artists such as Jackson Pollock. Thanks to Peggy Guggenheim, who paid him a remuneration, he quit his job and devoted himself to painting, developing the dripping technique that would make him a leading artist.

Guggenheim arrived in Venice in 1948 for the reopening of the Biennale, which was interrupted during the war. Her collection was shown in the Greek pavilion, which remained vacant at the time, but at the end of the exhibition, she sought to keep the works in Venice. Her quest for a place eventually led her to settle into this unfinished palace located along the Grand Canal. Picasso, Dalí, Calder, Mondrian, Max Ernst, Giacometti, Pollock, and others arrived to live with Peggy and her dogs in this unconventional home. Venice was her home base for the next thirty years until her death in 1979. She became the most eccentric of the Venetians, recognizable to all by her butterfly sunglasses and her private gondola. In front of the Grand Canal, she installed the irreverent cavalier, sculpted by Marino Marini, which depicts a man on horseback showing off his erect penis to passersby in boats.

Early on, the idea of a museum for Ca' Venier was inscribed by Peggy into the identity of her home, whose doors she opened to Venetians on Sundays, inviting them to enter her residence to admire paintings and sculptures. In 1976, she donated her collection to her uncle's foundation, the Solomon R. Guggenheim Foundation, on the condition that it remain on display in Venice. Peggy's ashes would also remain in Venice, buried in the museum garden alongside her dogs.

IN 1976, PEGGY GUGGENHEIM DONATED
HER COLLECTION TO HER UNCLE'S FOUNDATION,
THE SOLOMON R. GUGGENHEIM FOUNDATION,
ON THE CONDITION THAT IT REMAIN ON DISPLAY IN
VENICE. PEGGY'S ASHES WOULD ALSO REMAIN
IN VENICE, BURIED IN THE MUSEUM'S GARDEN
ALONGSIDE HER DOGS.

1. CA' VENIER DEI LEONI

On the roof of the palace, there
is a terrace where Peggy would
sit and sunbathe.

2. IN THE MUSEUM

The permanent collection is rich
in paintings by Peggy's favorite
artists, such as Magritte.

3. THE SCULPTURE GARDEN

The garden also serves as the
burial site of Peggy Guggenheim
and her dogs.

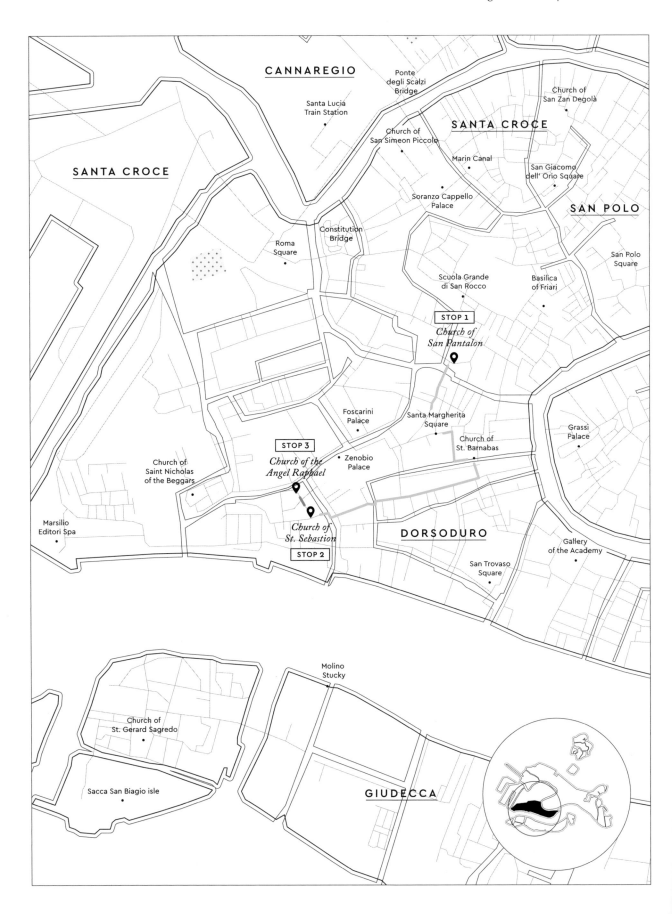

BEHIND CHURCH DOORS

There are several doors in the Dorsoduro district worth opening
to explore inside. Behind them are found surprising churches with
canvases of chiaroscuro, shimmering colors, marble columns,
and enchanting objects in stone. These are places of both quiet and space.

STOP 1: SAN PANTALON

This walk starts in a small square on the banks of the Rio Novo, a short walk from Campo Santa Margherita, popular for its cafés and nightlife. In front of the church of San Pantalon, the small square is often nearly deserted. Venice is the city of hide-and-seek par excellence where every door seems closed off to a new secret inviting discovery. For those seeing these places for the first time, their lesser-known treasures reveal themselves as magical secrets. The high wooden door of San Pantalon, over which is a beautiful sun window, often goes unnoticed in the middle of the church's bare brick facade as you walk by. The marble that should have given the facade the same luster as the interior was never installed as intended in 1668. It is difficult to imagine from the outside that this place of worship houses one of the largest painted canvases in the world: 13,500 square feet (1,250 square meters) in forty juxtaposed panels depicting the martyrdom of San Pantalon, a monumental work executed over twenty years by the artist Gian Antonio Fumiani.

STOP 2: SAN SEBASTIANO

At the end of Calle Lunga San Barnaba, a street lined with beautiful shops of artisans and wine merchants, a bridge leads to the forecourt of the church of San Sebastiano. The church has a sober facade, attached to that of the language department of Ca' Foscari University, and an entrance designed by Carlo Scarpa. Passing under the eyes of a marble statue of San Sebastiano standing atop the pediment, you cross the threshold of this small church. Located far from the most popular paths, almost along a peripheral route, the church houses a precious cycle of frescoes and paintings by Paolo Veronese. At the age of twenty-seven, Veronese depicted several biblical scenes in which his taste for the play on color and trompe l'oeil are apparent. His work extends to the ceiling of the nave and the sacristy, up the altar walls, within the side chapels, and even on the organ, all harmonized in a symphony expressing the artist's talent. He was interred inside the church and still rests there today.

STOP 3: SAN RAFFAELE ARCANGELO

The atmosphere of the district is unmistakably one of devotion. In the reverent silence that inhabits the surrounding streets, it takes only a few minutes on foot to reach the next church, crossing the Campazzo San Sebastiano. In this square, a small, isolated orange house stands out from the others: that of the executioner, next to which no one wanted to build his house. Early in the morning, the song of the sisters from the nearby convent can sometimes be heard. On the site of one of Venice's original churches, whose foundation was lost between the fifth and sixth centuries, stands the church of Angelo Raffaele, officially called San Raffaele Arcangelo. Inside the building, which was rebuilt in 1618, the nave and apse are laid out in a plan of Greek crosses. The church is a beautiful baroque ensemble where light penetrates the space to illuminate the vaults richly decorated by Francesco Fontebasso, as well as paintings by Francesco Guardi, illustrating the story of Tobias.

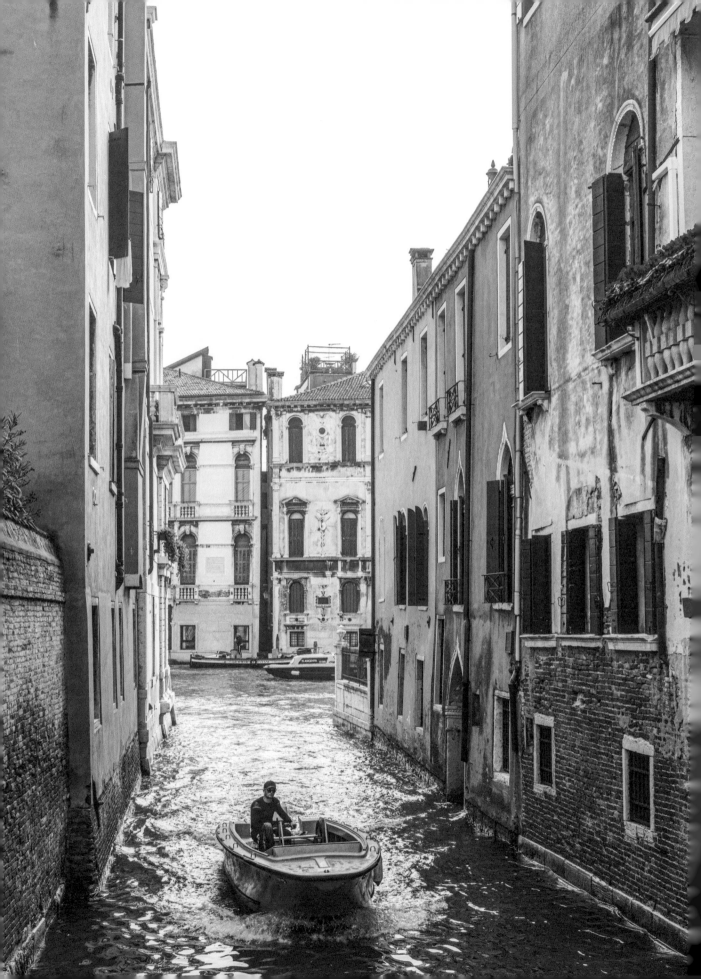

VIBRANT MARKET

SAN POLO

With the arrival of the new day, the first boats
unload their crates of goods, awakening the neighborhood's
typical flurry of activity. Above the Rialto market,
seagulls congregate. The day now begins in one
of Venice's oldest *sestiere*.

P.104

The Grand Canal bathes the banks of the San Polo sestiere.

RIGHT

Walking down the wide steps of the Ponte di Rialto,
you gradually enter the San Polo district.

Down the center of the bridge steps lined with shops, you gradually enter the commercial atmosphere of the San Polo district. At the bottom of the bridge lies a series of squares and passages where, since the origins of Venice, goods were bargained for, sold, and traded. Their names recall the products that can still sometimes be purchased there: the fish of the Pescheria, the fruits and vegetables at the Erbaria. The Naranzaria, on the other hand, is no longer the citrus warehouse of the market. A series of *bacari* have been installed in its place, where spritz is now served accompanied, of course, by an olive and an orange slice. At lunchtime, it is time to nibble *cicchetti*, Venetian appetizers prepared with fresh market produce, while standing at the counter with a glass of wine in hand.

The path then proceeds through the winding maze carved by the alleys through the neighborhood, one of the oldest of Venice. It was here, on the Rialtine Islands, which later became Rialto, that the city first developed, taking advantage of its high banks. Randomly walking the narrow pathways, you will appreciate the mysteries of the covered passageways, the clarity of the reflections on the canal's green waters, and the invitation from a small twisting bridge to continue exploring.

At the heart of this maze lies Venice's largest *campo*, the Campo San Polo, named, just as the district, after Saint Paul. In summer, children play in the shade of its plane trees; in winter, enthusiasts glide and play on its ice rink set up for the season. While randomly strolling through the narrow lanes, you can meet several of the great artists who have made their mark on Venice. The house of eighteenth-century playwright Carlo Goldoni, with its beautiful gothic fifteenth-century staircase, is now a museum. The Scuola Grande di San Rocco is considered a shrine to the work of artist Tintoretto, whose paintings cover over ten thousand square feet (one thousand square meters) of the walls and ceilings.

In this postage stamp–size *sestiere*, it is just a short distance to conclude the walk by passing through the gothic door, the largest in Venice, of the Basilica di Santa Maria Gloriosa dei Frari with its unique concentration of masterpieces.

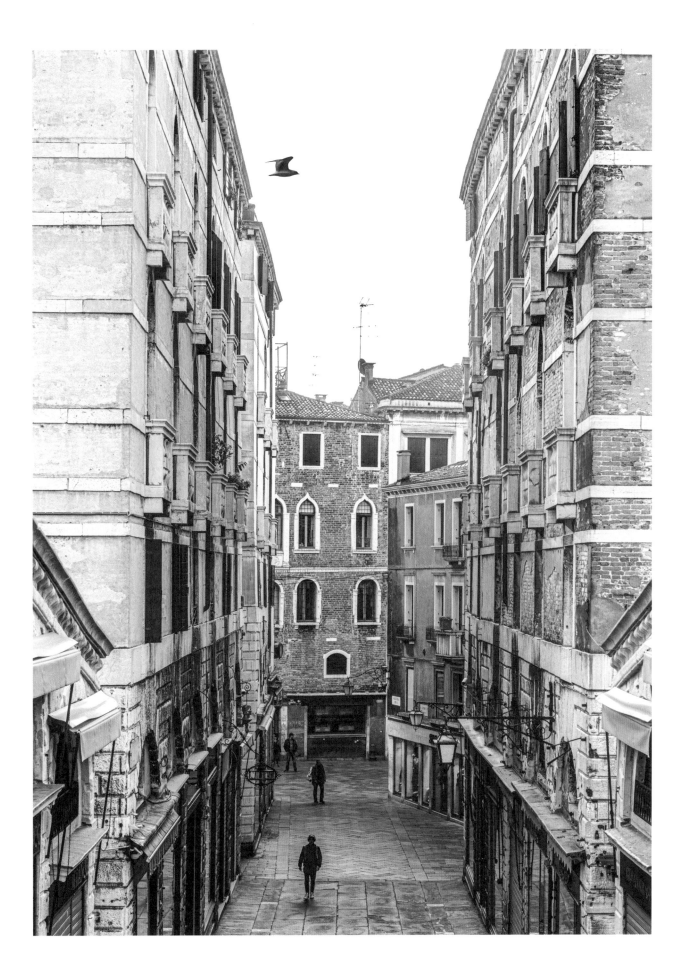

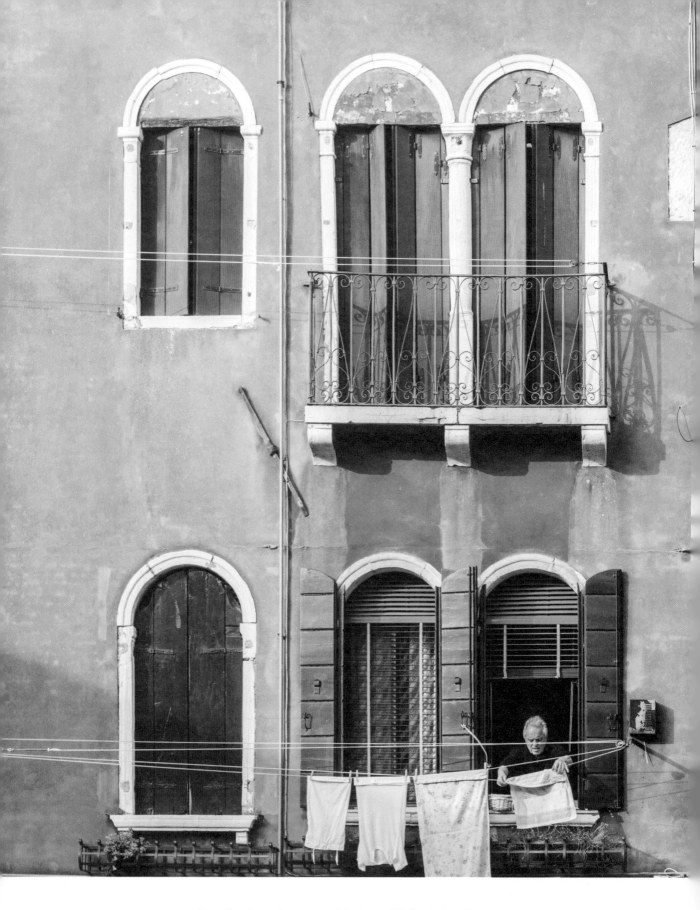

*Linens hanging to dry are part of the image of Venice: during all seasons,
even in fog, sheets can be seen hanging from balconies.*

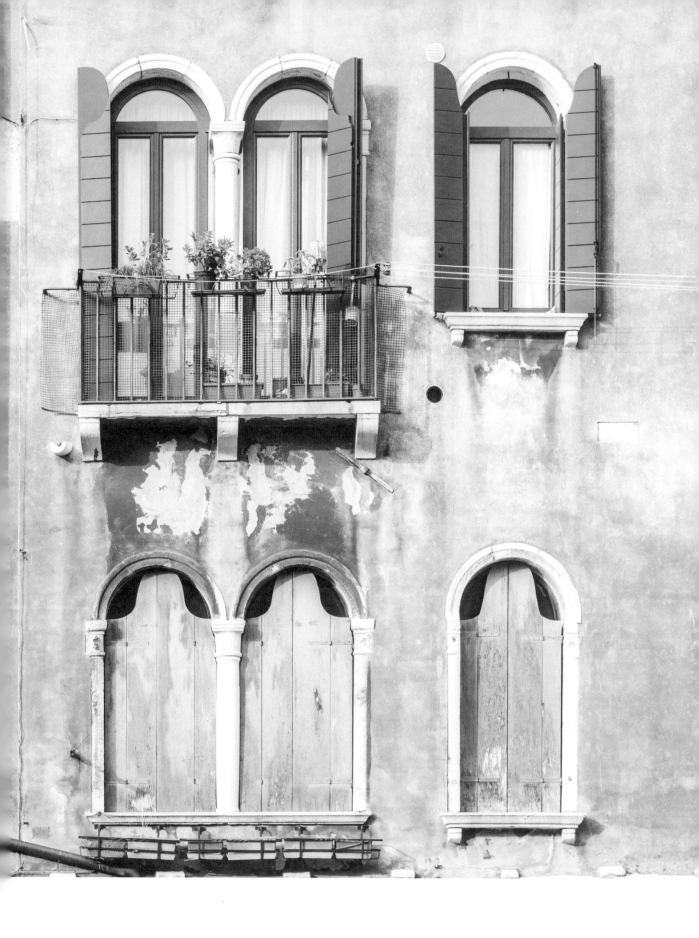

THE ESSENTIALS

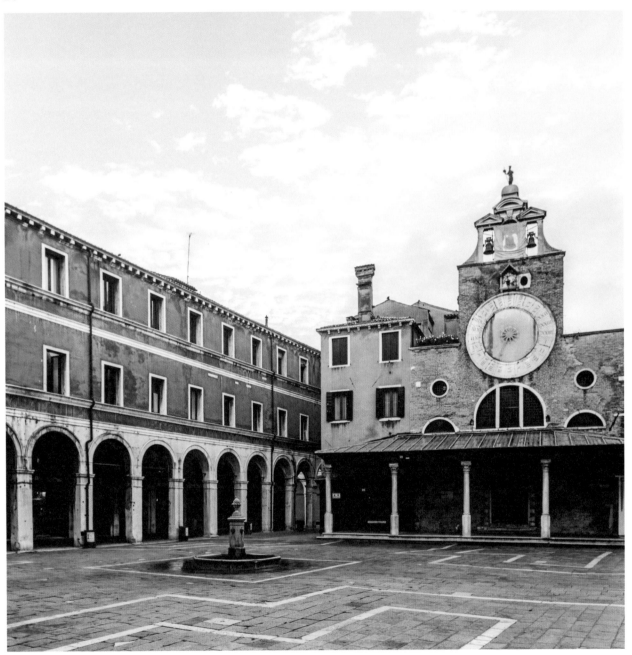

CHIESA SAN GIACOMO DI RIALTO

The Church of Saint James of Rialto and its sunray clock have
watched over this market district since the twelfth century.

27

SCUOLA GRANDE DI SAN GIOVANNI EVANGELISTA

An architectural marvel, the Scuola Grande di San Giovanni Evangelista is the oldest still-active *scuola*.

28

CASA DI CARLO GOLDONI

Goldoni's house, with its beautiful medieval staircase, is a museum dedicated to the Venetian playwright and to theatrical art.

29

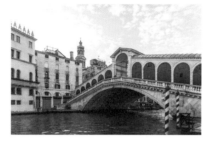

PONTE DI RIALTO

An architectural feat, the Rialto Bridge spans the canal, 121 feet (37 meters) long, with a single massive arch.

30

CAMPO SAN POLO

Campo San Polo, the largest Venetian *campo*, is part of the heart and soul of the neighborhood.

31

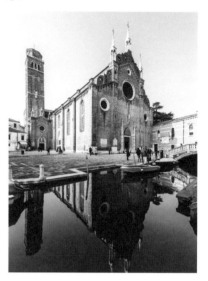

BASILICA DEI FRARI

Enormous works of art flourish under the vaults of the Basilica dei Frari, itself an immense gothic monument.

32

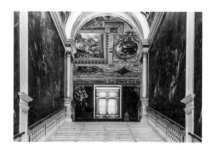

SCUOLA GRANDE DI SAN ROCCO

The scale and power of the works by Tintoretto that decorate the Scuola Grande di San Rocco will leave you speechless.

ESSENTIAL BRIDGES

**More than four hundred bridges span the winding network
of Venice's canals, making the archipelago on which the city is
built a hospitable place for pedestrians.**

Sometimes, such as on the Ponte dei Bareteri located along the Mercerie, the oldest thoroughfare in the city, up to five streets may lead to a single bridge. This is the result of a maze of bridges that sprang up quickly, as during the time of the Republic permission was not needed to build a bridge.

Venice's bridging techniques gradually diversified and adapted to the conditions of life in the lagoon. At first, a simple wooden plank, the *toletta*, allowing the passage of horses, was sufficient. For wider canals, a system of bridges floating on small boats was invented, as is the case with the Rialto. Once horses, which became forbidden between Saint Mark's and the Mercerie as early as 1292, were no longer a source of transportation, traffic increased on the water. The arches of bridges were consequently enlarged, made of brick or stone, to allow the passage of gondolas and other boats. On the Grand Canal, the Rialto Bridge remained the only crossing point until the nineteenth century,

when the Ponte dell'Accademia and the Ponte degli Scalzi were constructed.

In 2008, a modern steel and glass structure, the Ponte della Costituzione, nicknamed Ponte di Calatrava in honor of its architect, was opened to connect Piazzale Roma and the railway station.

Even small bridges have their history. In the Cannaregio district, Ponte Chiodo has remained without rails, as did all the bridges before the nineteenth century. Rival factions would organize fights and battles there. On the Ponte dei Pugni, you can still see footprints as evidence of opponents who would fall into the canal during bare-handed battles. Prostitutes also had their designated bridge, the Ponte delle Tette, literally "bridge of breasts," from where one could see courtesans showing off their busts to attract customers. The Bridge of Sighs, under which couples can be seen kissing today, has a more sorrowful history, as it led to the prisons, the sighs being those of the prisoners aware of their fate.

The first Rialto bridge floated on a series of boats. In 1264, a wooden bridge was built on stilts. A central drawbridge allowed the passage of galleys. Later, shops, also built on stilts, were added.

In 1444, the entire bridge collapsed under the weight of a crowd attending the wedding of the Marquis of Ferrara. After an architectural competition, won by Antonio da Ponte, its stone reconstruction occurred between 1588 and 1591. This is the bridge that still stands today.

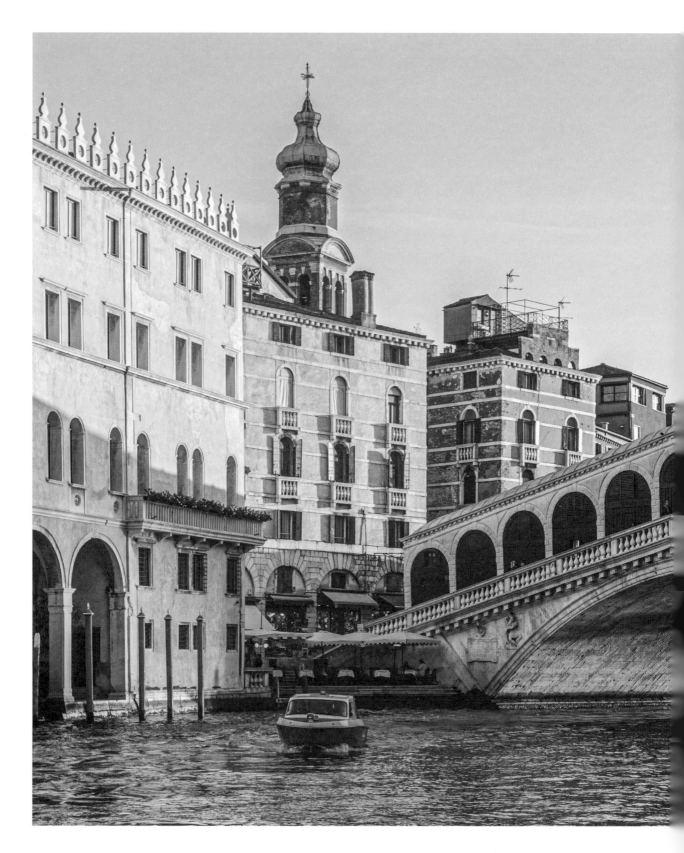

The Rialto Bridge is the link between the district of San Marco,
the center of political power, and the economic center surrounding the market.

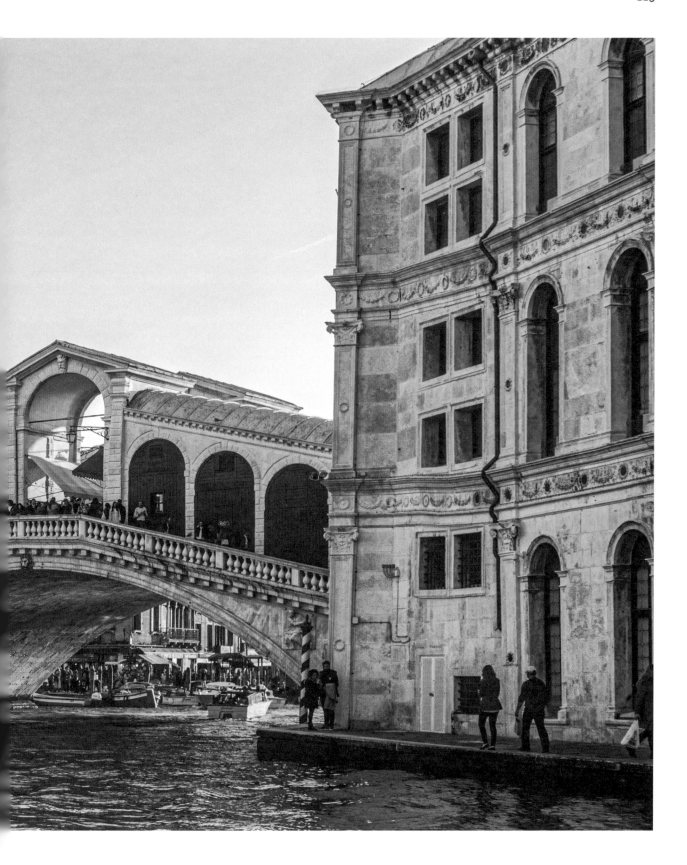

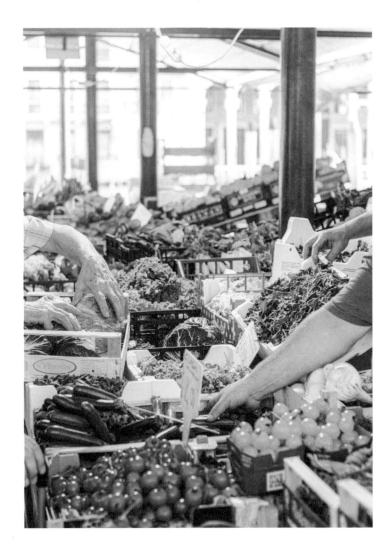

ABOVE

*At the Erbaria, an ancient herb market, you can still find fresh fruits
and vegetables, some of which are grown in Sant'Erasmo.*

RIGHT

*Fish arrive daily from the Adriatic (and more distant waters)
at the Pescheria.*

FOLLOWING SPREAD

*The fish market is housed in a neo-gothic building. In the nineteenth century,
there were hundreds of fishmongers there, but today only a handful are found in Venice.*

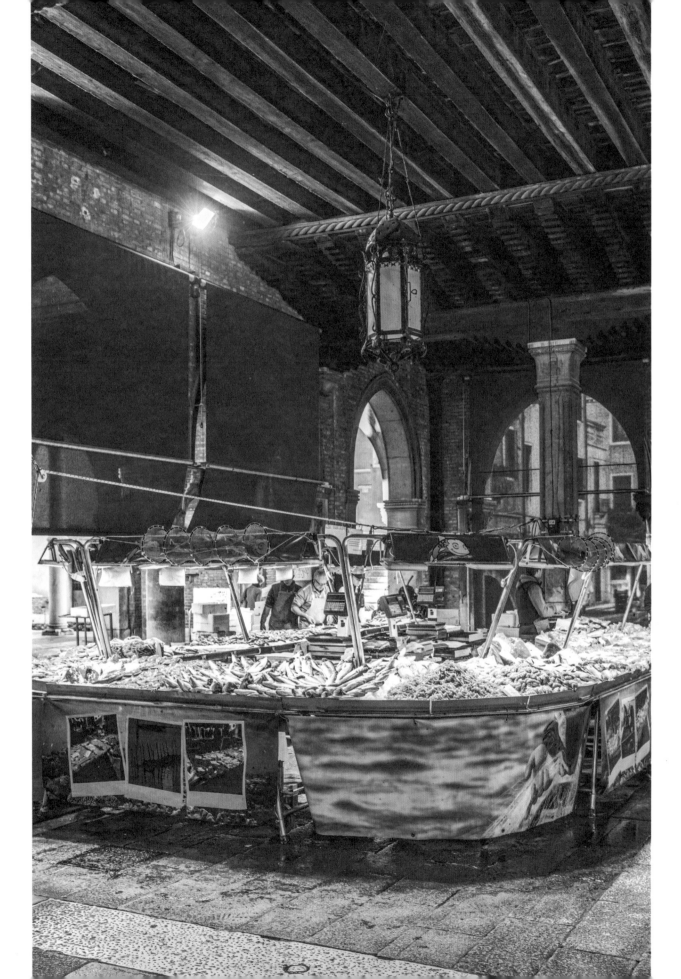

FOOD & DRINK

A SLIGHT TASTE OF THE SEA

It is said that the first fork, called a *piron*, was invented in
Venice in the fourteenth century. The city's briny aromas from
the sea come together with the city's colorful vegetables
to create pleasurable harmonies at the table.

As everywhere in Italy, you can also enjoy deliciously prepared dishes in Venice, such as risotto or polenta enlivened with flavors from all over—Venetian gastronomy reflects its openness to the world. The East brought a strong appetite for spices to the lagoon. During the sixteenth century, five thousand tons of peppers and ginger passed through the warehouses of the Republic. In the kitchens, the use of slaves from the Balkans resulted in the mixing of flavors from afar. In time, the Jewish, Turkish, Albanian, German, and Greek communities brought their flavors to the local cuisine. The Jewish community, for example, introduced the artichoke and the custom of mixing vegetables with rice, as in the traditional dish *risi e bisi*, a risotto with peas.

Venice combines the excellence of its products and an *art de vivre* that makes it an outstanding gastronomic destination. Around the Erbaria and Pescheria, the products sold at the stalls of the Rialto market can be found served at the counters of the *bacari* in the form of delicious *cicchetti* or antipasti. Sardines or shrimp can be eaten in *saor*, a sweet-and-sour sauce with pine nuts and currants invented by sailors to preserve food during their long journeys. At the table, you can enjoy langoustines served with *spaghetti alla busara*, a subtly spiced specialty, as well as delicate fried fish and vegetables.

During Carnival, which is a time devoted to excess, the city fills with the sweet scent of *fritoe*, small fried beignets, a welcome comfort during the wet cold of winter. All year round, pastry shops, as temples of gastronomy, adorn the streets of Venice. *Busolai*, typical butter cookies from Burano, are displayed temptingly in shop windows. They add the perfect touch of sweetness to accompany a strong Italian espresso.

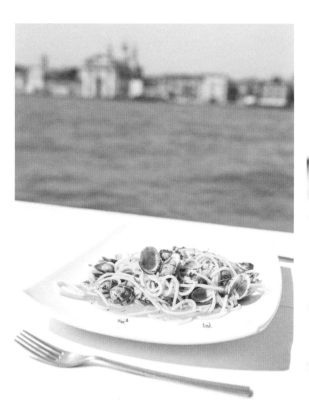

Typical Venetian dishes can be found on
every table, from *pasta alle vongole* to tiramisu,
a dessert invented in the region.

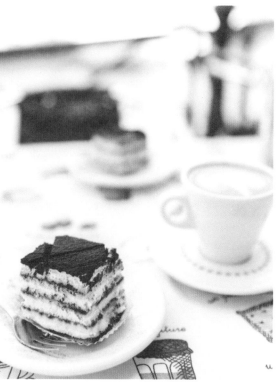

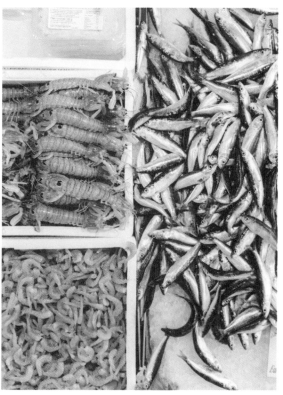

AT THE MARKET

Products from the Adriatic or the lagoon
fill the market stalls where restaurateurs
come to purchase supplies.

Gondolas are moored on the Riva del Vin, where goods
destined for the Rialto market were unloaded.

ARCHITECTURE

THE *SCUOLE*

SMALL AND LARGE BROTHERHOODS

Among the decor of Venice, much of which has gone unchanged for centuries, the majestic facades of the *scuole* are visible throughout. The immense legacy these brotherhoods have left behind is a testament to their enduring power.

Even though their names might suggest it, the *scuole* have nothing to do with schools. Rather, they are brotherhoods that perform social services. Created during the eleventh century, they lasted until 1806 when Napoleon ordered their dissolution. As ancient associations, they included members from civil society, ethnic minorities, or members of a particular trade, such as the Scuola degli Albanesi for Albanians, or the Scoletta dei Calegheri for shoemakers. The most important *scuole*, known as *grandi*, are named after a saint, although these associations are secular. They handle donations to charities, collecting cash or clothing to help the poor. The greatest architects are sought for their construction while painters vie for their requests. This speaks to the power and importance of these institutions.

Among the *scuole* that can still be visited, the Scuola Grande di San Giovanni Evangelista stands out for its extravagance. Founded in 1261 in the Cannaregio district, it moved to San Polo in 1301. Thanks to the work of painters, sculptors, and architects who continue their work there, this *scuola* allows a fascinating journey into the history of Venetian arts.

From the exterior, Pietro Lombardo's ornate marble screen, built in 1481, opens into a once-private atrium. A stone eagle, the symbol of Saint John, watches over the walls of the *scuola* from atop the gate. The large double windows, surmounted by pediments, are the signature of Mauro Codussi, a Renaissance architect summoned in 1498 to design the facade and staircase. To give the impression of grandeur, the double staircase creates an optical illusion by gradually shortening the steps to enlarge the convergence lines. Upstairs, as in all the other *scuoles grandi*, is the room where the members gathered, whose floor in 1752 was laid with a marble mosaic of extraordinary beauty. On the ceiling, the figures of the *Last Judgment*, painted by Giuseppe Angeli, enjoy classical music concerts that the *scuola* has organized since its reopening in 1856.

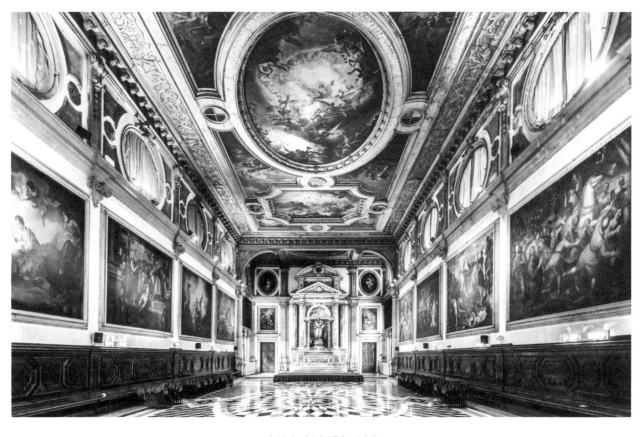

SALA CAPITOLARE

The meeting room of the Scuola Grande di San Giovanni Evangelista is now the setting for classical concerts.

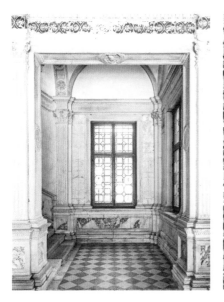

SCALONE

The monumental staircase plays with the perception of space.

TERRAZZO ALLA VENEZIANA

Lighter than marble, *terrazzo* is made from shards of colored stones.

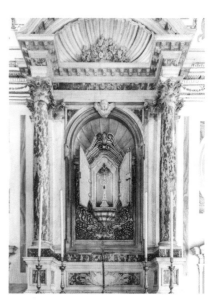

RELIGIOUS RELIC

A gift from Philippe de Mézières, it has contributed to the *scuola*'s development and prestige.

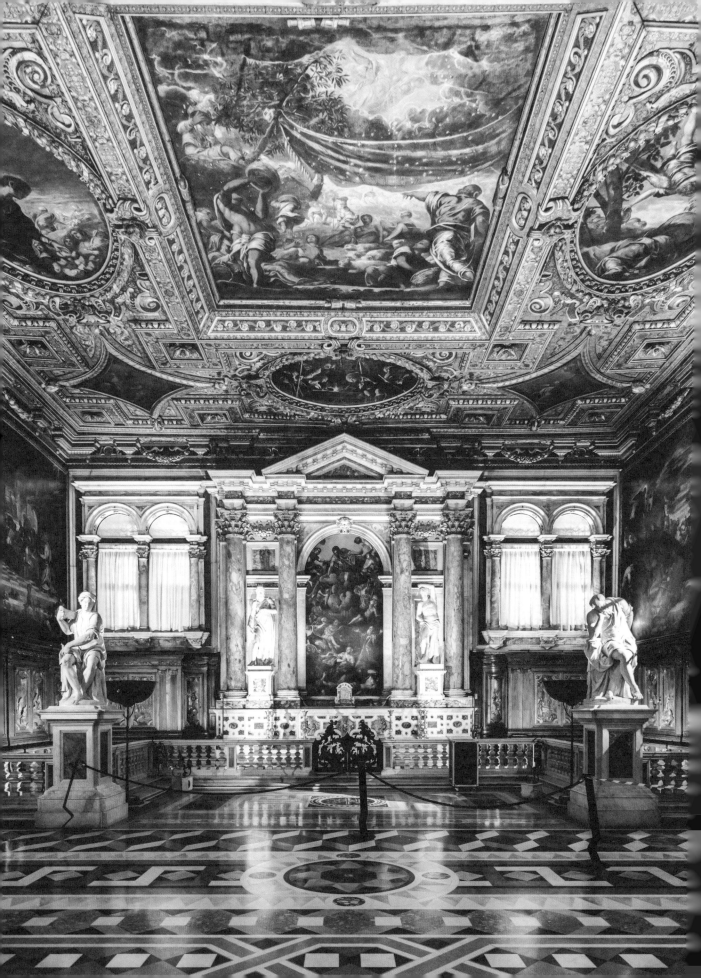

ABOVE

Antonio Scarpignano, one of the architects of the Venetian Rinascimento,
*gave the Scuola Grande di San Rocco an immaculate facade,
gloriously supported by eight detached columns.*

LEFT

*Tintoretto worked for more than twenty years to decorate the
Scuola Grande di San Rocco, which bears his signature style from walls
to ceiling. The Sala Capitolare, located upstairs, is his triumph.*

ARCHITECTURE

THE VENICE LABYRINTH

CUL-DE-SAC

The winding streets of Venice, which follow the curves of the neighborhoods,
invite you to get lost in their maze.

BEHIND THE SCENES

Before building streets, Venetians traveled mostly on water.

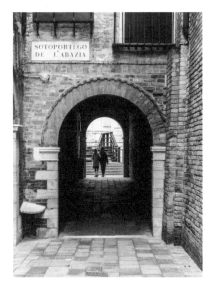

SOTOPORTEGO DE L'ABAZIA

Panels, known as *nizioleti*, are still inscribed in Venetian dialect.

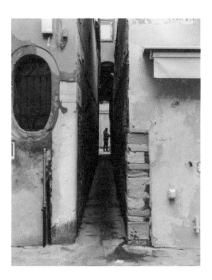

ALTERNATIVE PATHS

Some alleys are so narrow that one person can barely pass through them.

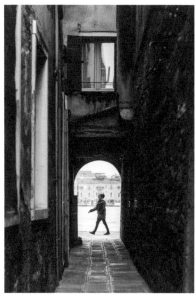

OPENINGS

When tucked under houses, passageways are called *sottoporteghi*.

UNDER SHELTER

These alleys bear the name of *calle*.

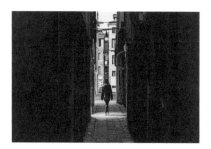

AT NIGHT

When night falls, the maze takes on a surreal atmosphere.

ON COBBLESTONES

The *massegni* that pave the streets are carved from volcanic rock.

CANAL VIEW

Alleyways often lead pedestrians to access a canal.

The Rialto continues to embody the central passageway of the city,
crossed by thousands of people every day.

*Everywhere in Venice, Madonnas and saints
watch over bridges and streets.*

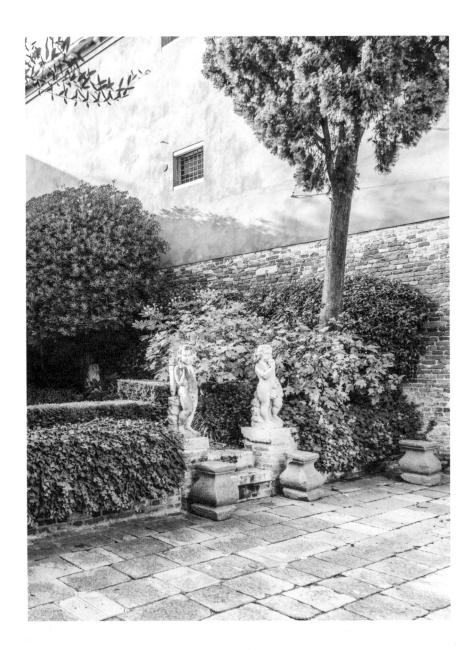

ABOVE

*In the seventeenth century, members of the Zane family would entertain themselves
in this small casino they had built just a few steps from their palace.*

RIGHT

*The Palazzetto Bru Zane, which became the Centre de musique romantique française
in 2009, offers a diverse program of concerts.*

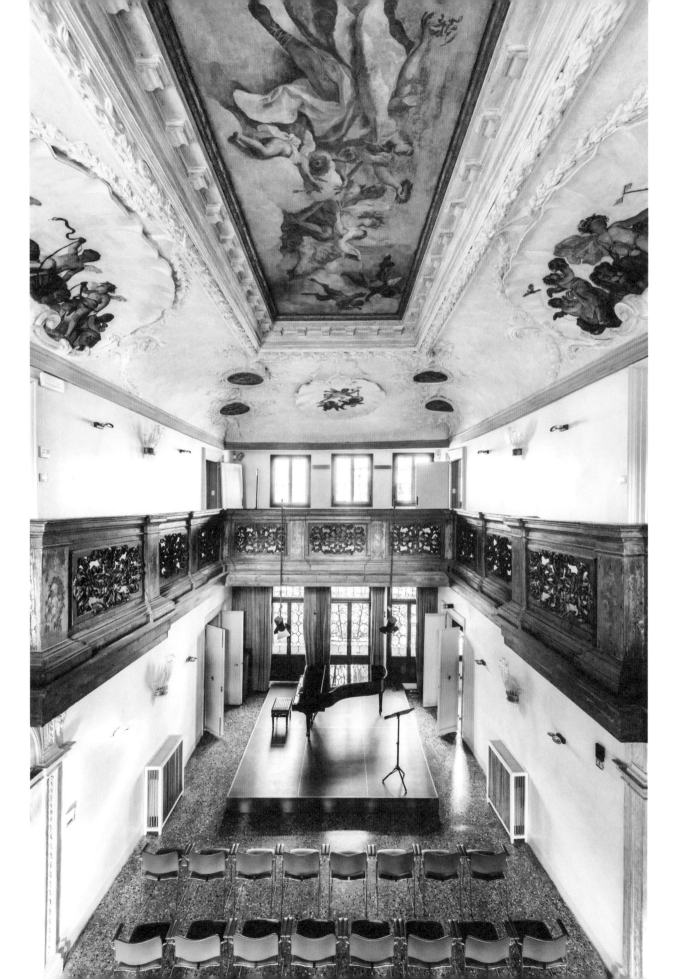

A GOURMAND'S STROLL THROUGH THE *BACARI*

Almost every day for a thousand years, the stalls of the Rialto market have been filled with fresh products from the islands, the sea, and distant lands. Throughout the city, in the *bacari*, you can taste these fresh foods, which convey the traditions of Venice.

STOP 1: AROUND CAMPO SAN GIACOMO DI RIALTO

Here you will find the statue of a hunchback man, crouching and supporting a small flight of marble stairs. On this *pietra di bando* is where news, laws, and decrees were announced to the population gathered en masse in the Campo San Giacomo di Rialto, the main entrance to the market. The warehouses that surround the square on the canal side still bear the name of Naranzaria, a reminder that citrus fruits were once stored there before being put out for sale. Beneath the arches, the sounds emanating from the kitchens of the *bacari* can be heard. Born from retail wine sellers who as early as the twelfth century (at least!) would add small portions of fried fish to their offerings, these bar-restaurant hybrids continue to operate around the market. Through the square, one enters the bar side of the Naranzaria or Bancogiro, two of the busiest of these *bacari*. On the other side, the terrace along the Grand Canal is a recent modification, adding a romantic note to this popular tradition.

STOP 2: THE *RUGA*

A few steps away, the market begins, stocked with fresh products. Walk between the stalls of Sant'Erasmo to the Loggia della Pescheria, whose neo-gothic columns are carved with odd fish. Next, enter the Ruga Vecchia San Giovanni, a narrow thoroughfare saturated with shops. Unlike the *calle*, where houses face a pier or canal, in the *ruga*, they face each other. They are found everywhere in Venice, but especially in Rialto, a shopping district where pedestrians had to be able to access the shops that filled these *rughe* (in the plural). The etymology of the word is uncertain but may trace back to the Latin *ruga*, a furrow, or to the French *rue* (street). This name and history inspired the patron saint of the Ruga Rialto, a *bacaro* that opened more than seventy years ago in a fifteenth-century building, frequented by students and professionals. The black cat that used to camp out on the counter is no longer there, but his memory remains.

STOP 3: VENICE'S OLDEST *OSTERIA*

Many restaurant owners in Venice will claim, smiling proudly with their hands on their hips, to own the city's oldest *osteria*. But hidden under a dark passageway, with its entrance subtly marked with a barrel by the door, Cantina Do Spade perhaps can claim the title. As early as 1448, it was mentioned by a certain Carlo de Zuane, host at Do Spade, and already bore a signboard marked with two swords, the Do Spade. As in any good *osteria*, here you can eat traditional cuisine made with food from the market, showcasing Venetian dishes. Maintaining the popular and lively spirit that animates the entire district, you can enjoy *cicchetti*, small appetizers, while standing at the counter. Thus, through the alley, you can spot customers busy enjoying meatballs and fried fish.

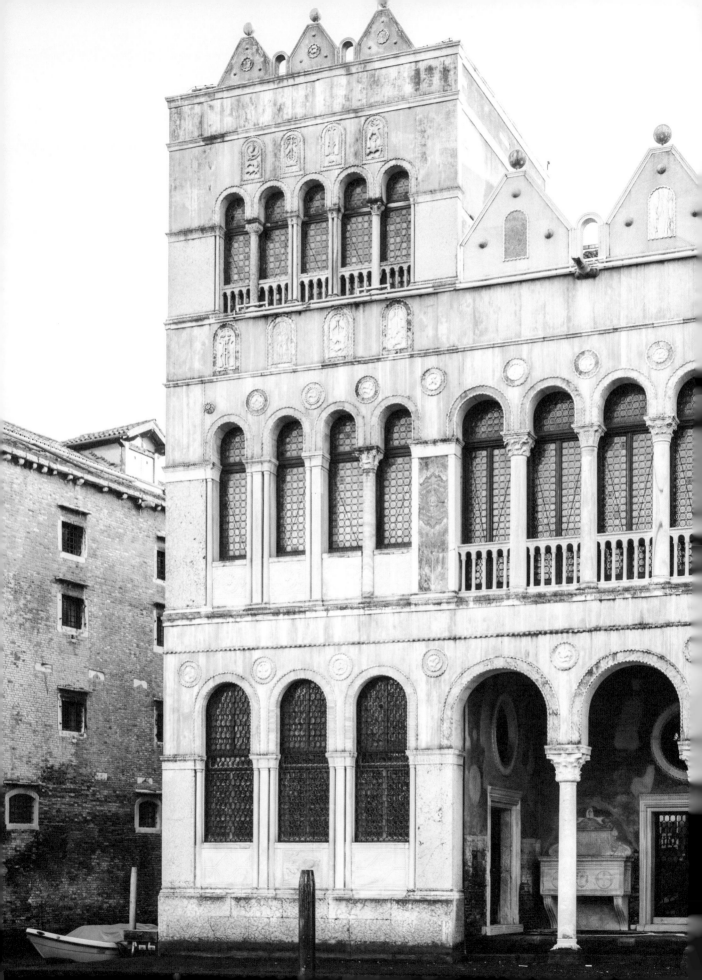

SANTA CROCE

The *sestiere* Santa Croce is the most humble of
Venice's districts. At first sight, it may be the canals,
the tangle of bridges of all sizes, or the palaces battered
by the waves, that impress. But as you look closer,
another side of Venice is revealed.

P.136

Dating back to the thirteenth century, the Fondaco dei Turchi was home to Turkish merchants.

RIGHT

*Santa Croce has many palaces whose foundations plunge directly down
the banks of the Grand Canal.*

Beyond the stones, behind the stucco, on the other side of the walls, through the heart of the hidden gardens, lies a neighborhood visitors often pass through yet rarely visit. Sometimes tourists come here for the museums but rarely to walk around and explore. This is unfortunate because on closer inspection, this district offers a unique motif made up of various eras and styles that often feel like a game of hide-and-seek. You enter the district by crossing over the thin arched white stone of Ponte degli Scalzi, whose shape reminds you of a parenthesis, or through the glass steps of Ponte della Costituzione, the newest of the Venetian bridges, designed by the Spaniard Santiago Calatrava. Along the Rio Novo, a canal dug during the fascist era, Rationalist architecture offers surprises. Next, as you turn around, you come across the entrance of the Tolentini convent, whose renovation was constructed as a dialogue of concrete and glass by the brilliant Carlo Scarpa.

Curiosity guides your steps as you weave through the district whose different eras and styles merge, overlap, and reappear where you least expect them. In Bevilacqua's ateliers, set in a modest house in front of the church of San Zuan Degolà, the colorful spools of thread come alive on a loom to create fabrics that are as sumptuous today as they were in the fifteenth century. Inside the church of San Giacomo dell'Orio, the gothic ceiling was built using the same techniques used by the workers of the Arsenale for the hulls of boats.

Taking chronological leaps, you arrive at the edge of the neighborhood with its selection of palaces with their facades facing the Grand Canal. Some, now museums, are a dialogue of the ages. The Fondaco dei Turchi, a thirteenth-century warehouse flanked by towers, hides within its walls the Natural History Museum and its collection of dinosaur bones. Two steps farther, the Prada Foundation adopted an old palace, Ca' Corner della Regina, as a place for contemporary art exhibits. Finally, Ca' Pesaro is an ode to modern art behind its baroque architecture. Thus, from its alleys to its palaces, the neighborhood seduces with its unusual gems that it reveals little by little.

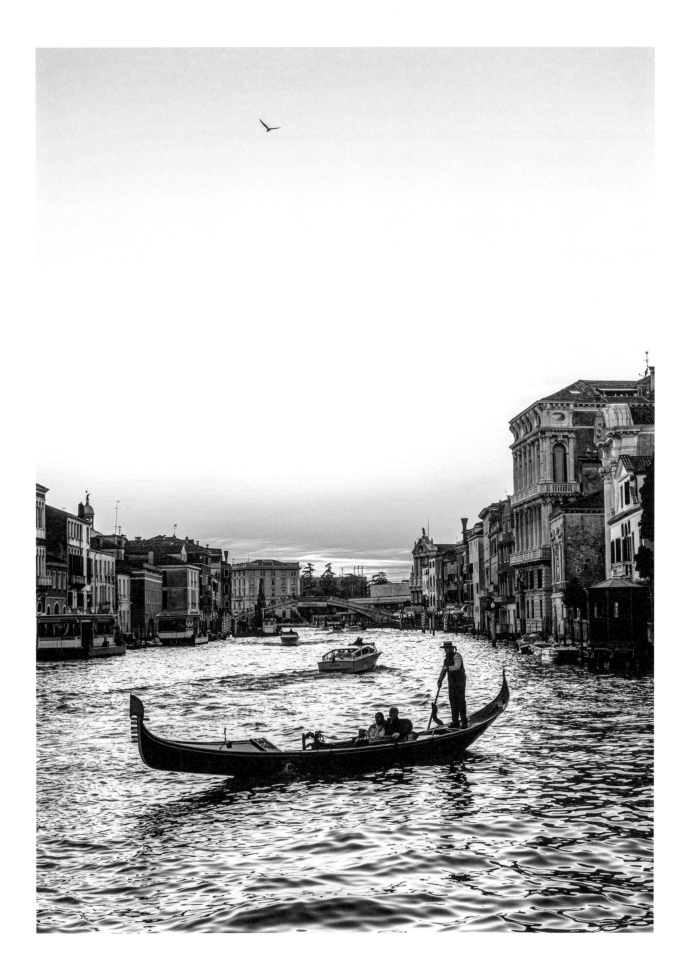

THE ESSENTIALS

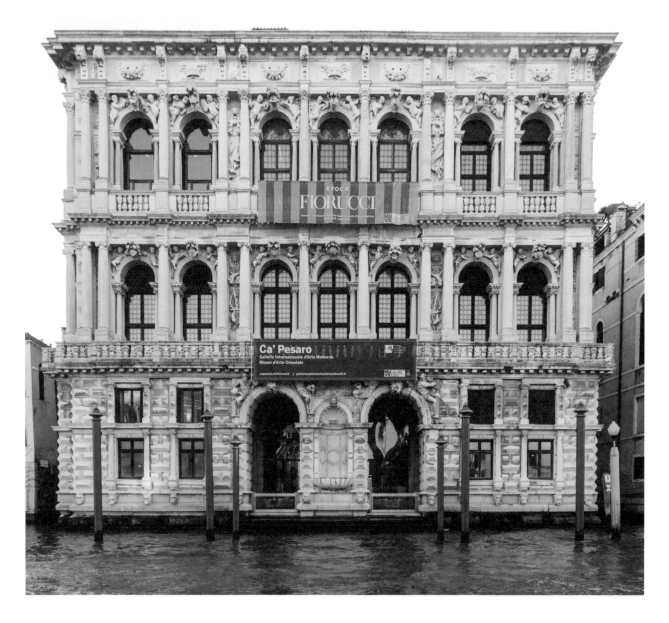

CA' PESARO

At Ca' Pesaro, modern art is displayed within a baroque backdrop.

34

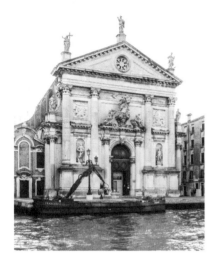

CHIESA DI SAN STAE

This eighteenth-century church is dedicated to Saint Eustace, called San Stae in Italy. Giambattista Pittoni's *The Torture of St. Thomas* is found here.

35

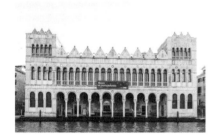

FONDACO DEI TURCHI

Housed here is the Natural History Museum, where skeletons of dinosaurs coexist with mounted animals.

36

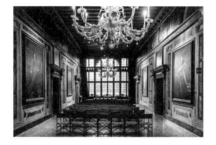

PALAZZO MOCENIGO

This eighteenth-century palace became the Study Center for the History of Textiles, Costume, and Perfume.

37

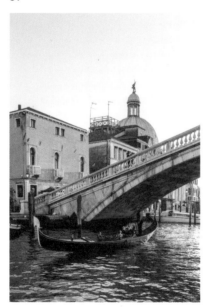

PONTE DEGLI SCALZI

To pass from Cannaregio to Santa Croce, you cross the majestic Scalzi bridge.

38

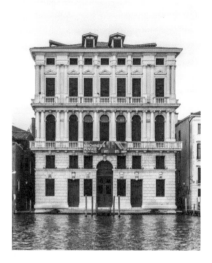

CA' CORNER DELLA REGINA

Contemporary art and architecture are on display at the Prada Foundation headquarters in Venice.

39

CONVENTO DEI TOLENTINI

The Tolentini convent, transformed into a school of architecture, adds a university-life ambiance to the neighborhood.

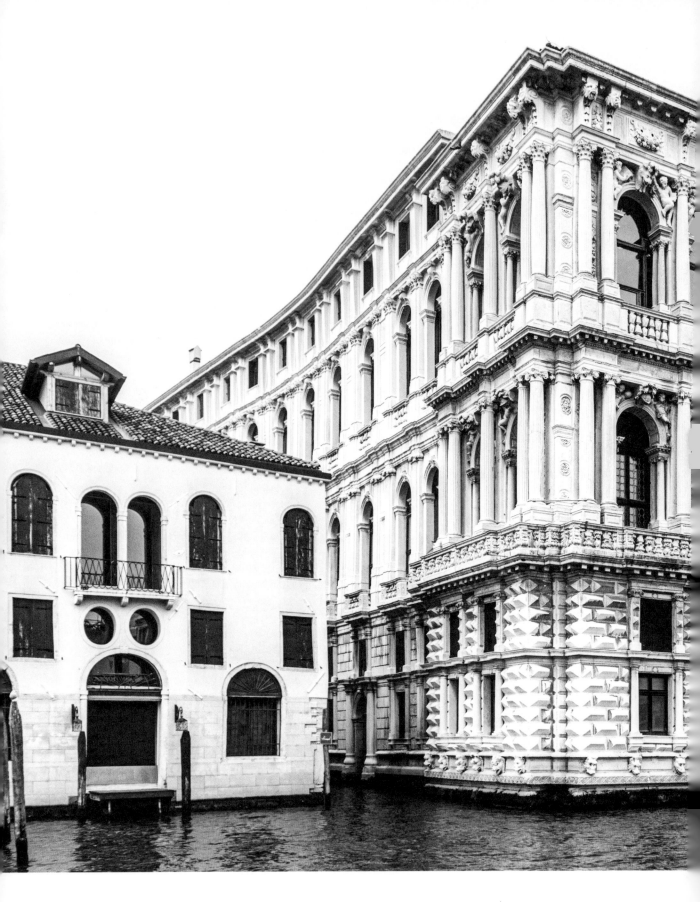

*The baroque white marble facade of Ca' Pesaro can be admired from
both the Grand Canal and the small canal that runs next to it.*

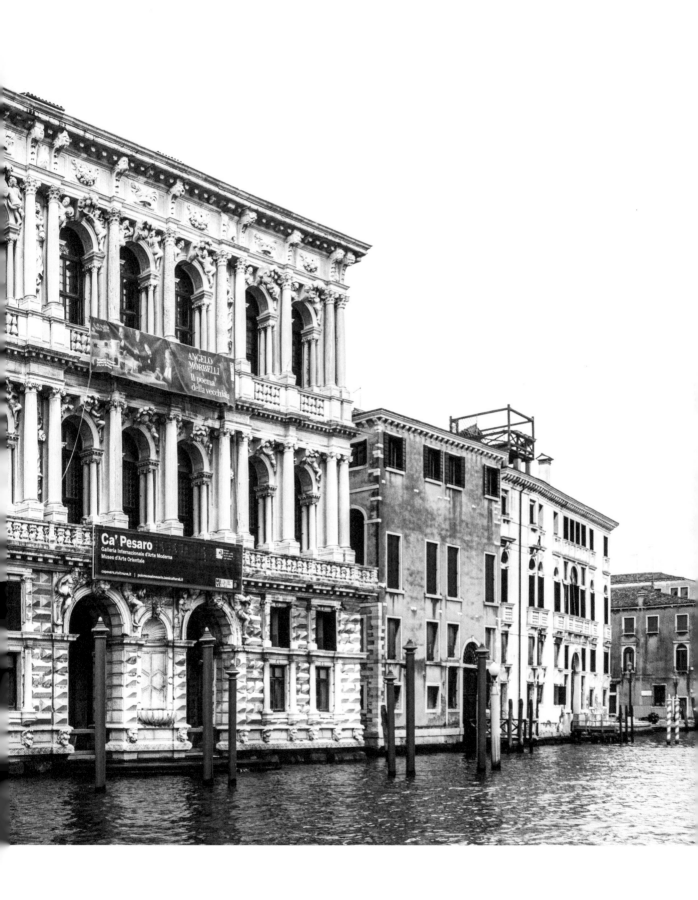

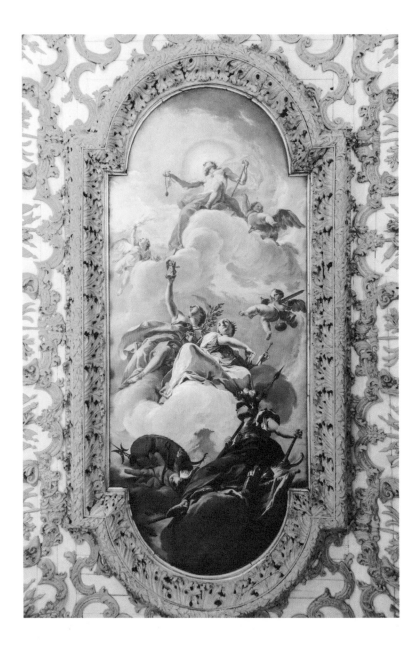

ABOVE

*Dating back to the early eighteenth century, Ca' Pesaro is decorated with frescoes
by Giambattista Pittoni and Giambattista Tiepolo.*

RIGHT

*Donated to the city in 1899 by the duchess Felicita Bevilacqua La Masa,
Ca' Pesaro was transformed into a museum of modern art.*

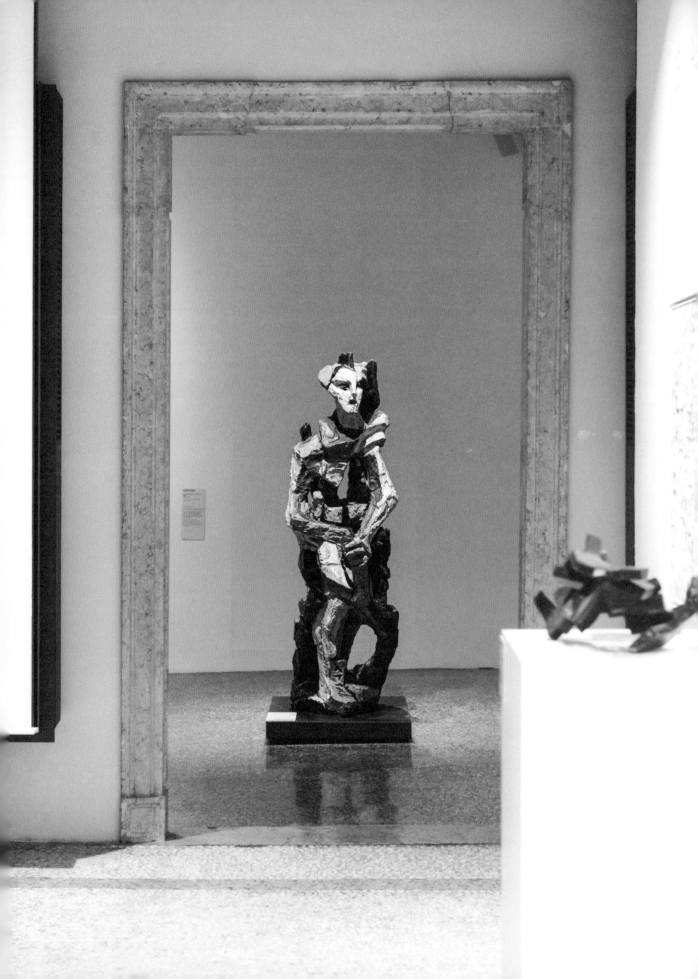

BUILDING IN VENICE

When viewed from above, Venice resembles a fish, its head facing the mainland, the tail formed by the Castello *sestiere*. But the shape of the city wasn't always like this.

On muddy ground bathed by the tides, Venice was an invention born at the crossroads of ingenuity, necessity, and imagination. Around the primitive islands, the city's foundations were laid, gradually gaining ground on the waters and shaping the city. In the watery lands of the lagoon, it was necessary to create space. The raw materials, transported from the mainland, sometimes arrived from afar. In Saint Mark's Square, marbles arrived from Constantinople. Those of the columns bearing the lion of Saint Mark and the crocodile of Saint Theodore are the spoils of a war in the East.

The Venice we see today may seem fragile, in peril even. Yet its foundations are centuries old. Like a tree supported on its roots, Venice rests on wooden poles driven deep into the *caranto*, a compact layer of sedimentary clay. Isolated from water and air, these poles support a primary floor on which stand the load-bearing walls and internal partitions. The surface is then placed on an embankment, the assembly allowing for construction in loose soil. This forest of poles, which has supported the city for centuries, must be protected, however, because the waves caused by passing motorboats eat away at the foundations. Speed limits have been established to regulate traffic and to avoid too much swell, but the constant passing of many boats and cruise ships continues to raise questions.

From the sumptuous palaces on the Grand Canal to the smallest houses, all of Venice's buildings face the same problem. On soft ground, they must be able to follow the progressive movements of the earth. It is difficult to find a right angle in Venice: floors and partitions are designed to move. This is why you sometimes feel the vibrations of the floor as you walk through the vast halls of the palaces. Venetian buildings also need openness and light materials. Brick is preferred over marble, which is reserved for facades in which large windows are carved. The floors, in *terrazzo alla Veneziana*, are a mix of marble or stone pieces and mortar to retain their lightness.

Thus, each architectural style has adapted to the conditions of the lagoon to allow Venice to establish itself on the water.

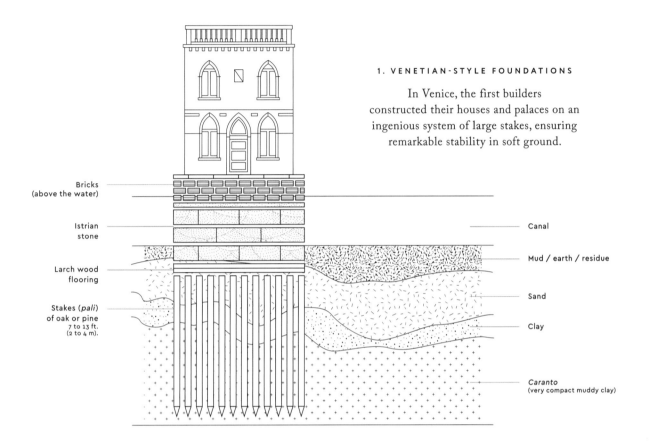

1. VENETIAN-STYLE FOUNDATIONS

In Venice, the first builders constructed their houses and palaces on an ingenious system of large stakes, ensuring remarkable stability in soft ground.

Bricks (above the water)

Istrian stone

Larch wood flooring

Stakes (*pali*) of oak or pine 7 to 13 ft. (2 to 4 m).

Canal

Mud / earth / residue

Sand

Clay

Caranto (very compact muddy clay)

2. *ALTANA* AND VENETIAN BLOND

On these wooden terraces added to palace rooftops, grand ladies of the past would sunbathe after coating their hair with a urine mixture to bleach it, then add a coloring powder made from saffron, lemon, and rhubarb root, lending their hair the famous Venetian blond hue.

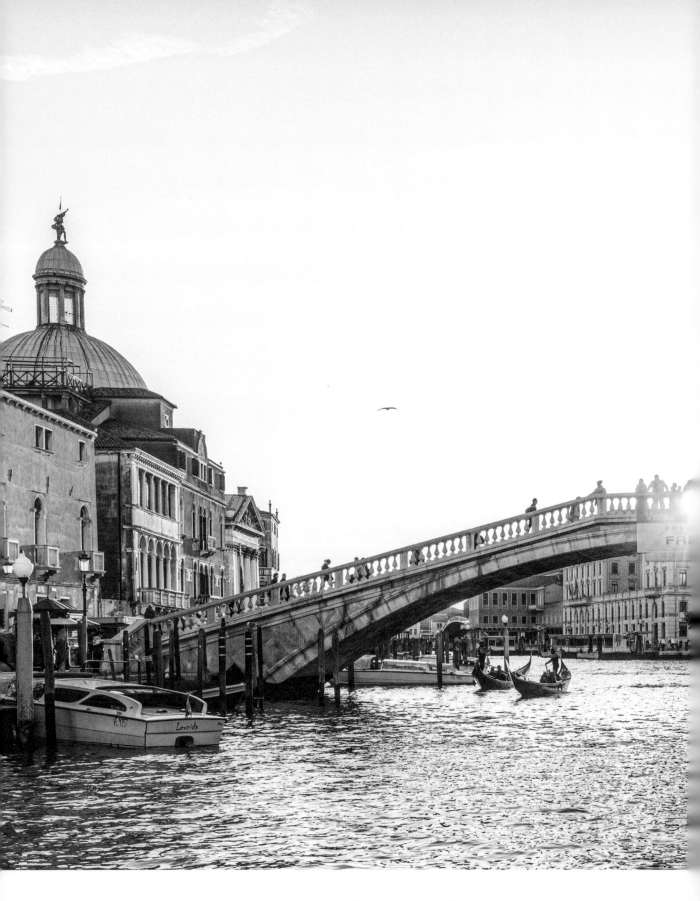

Built in 1934 over the Grand Canal, the Ponte degli Scalzi is made of an Istrian stone arch, the work of Eugenio Miozzi, architect of the Ponte della Libertà (Liberty Bridge) that connects Venice to the mainland.

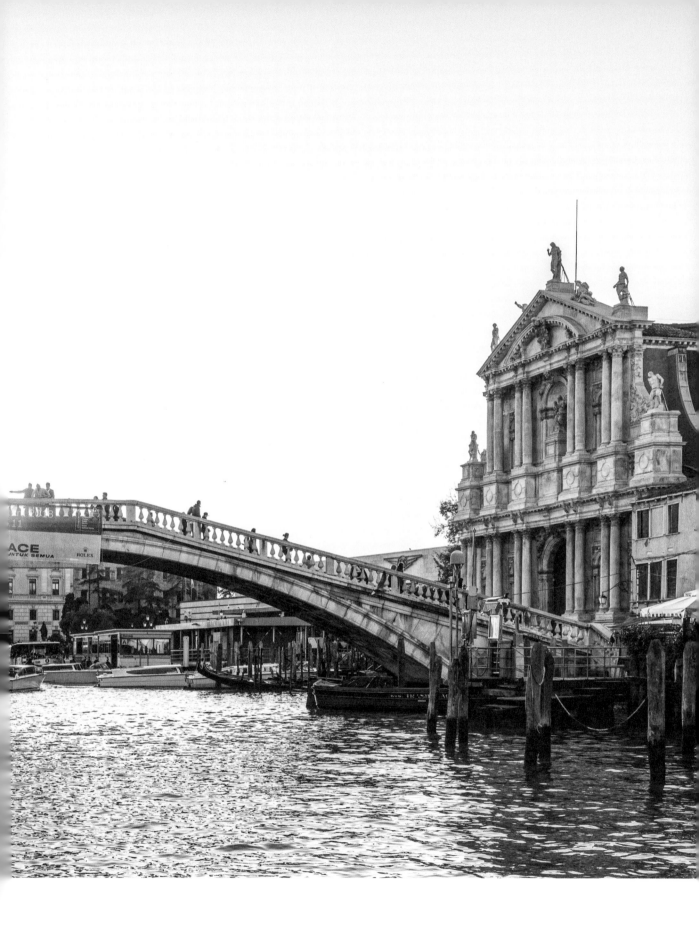

ARCHITECTURE

CROSSING CANALS

On a map, the blue lines of Venice's canals make up
what would be roads in other cities. On its waterways, transport boats,
fire and ambulance boats, gondolas, and taxis move about daily.

The architect Le Corbusier, whose concept for a hospital in Venice was never realized, saw in the canals an ideal modern city radically separating pedestrians from their means of transport. Because it is built on water, Venice was spared the invasion of cars, which now come only as far as Piazzale Roma after the construction of the Liberty Bridge in 1933.

Everywhere else throughout the city, only the sounds of the waters can be heard through the canals. In addition to the Grand Canal, the Cannaregio Canal, and the Giudecca Canal, which are major thoroughfares, there are a multitude of smaller waterways that branch into a total of 177 canals. The Venetians call these minor routes *rio*, or *rii* in the plural. Narrow and winding, their courses naturally take the outline of the neighborhoods. To excavate them, the Venetians followed the path of the waters, allowing the canals to take their natural shapes.

Pedestrians have gradually gained ground in Venice. In the eighteenth century, major work to bury the *rii* was undertaken to smooth the flow of traffic or to make room for new buildings. Thirty-nine canals disappeared, giving way to new streets. Instead of being called *calle*, like other streets in the city, they are usually called *rio terà*, "buried canal," in the local dialect. Others are called *piscina* when a small pond would appear in their place. The Via Garibaldi, a modern wide street created during the Napoleonic era at the eastern end of the city, is in fact an ancient canal. At the end of the street, the *rio* reappears as an extension, giving way to the small canal Sant'Anna, on which the boats of vegetable merchants can be seen. Looking at the *massegni*, the ancient tuff cobblestones that cover the city's roads, you can sometimes notice a difference in color or orientation, which can be a sign of a missing *rio*.

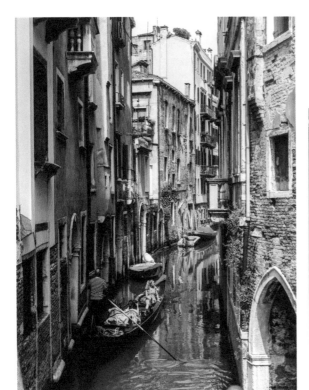

By observing the current, a person can
determine whether the tide is rising or receding,
depending on the direction of the water.

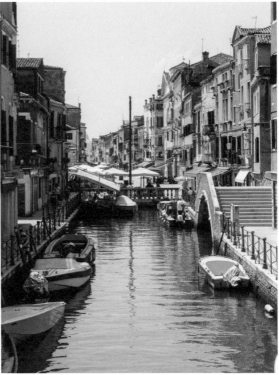

NOTHING BUT WATER

There are many canals only boats can navigate,
which provide an intimate view of the city.

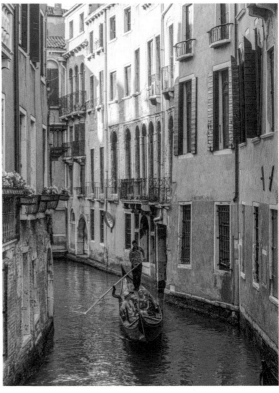

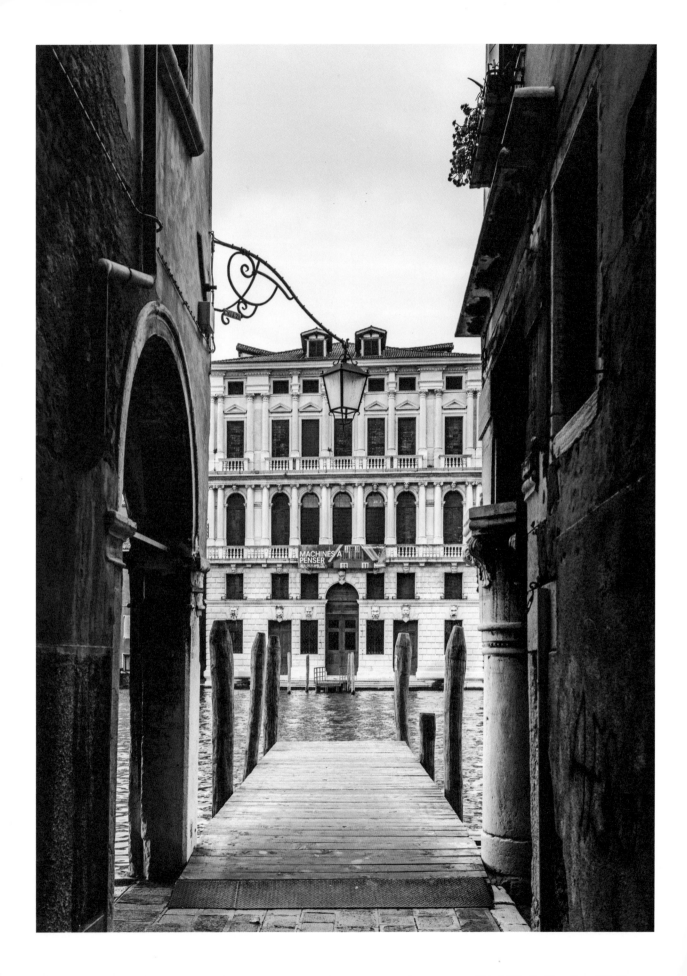

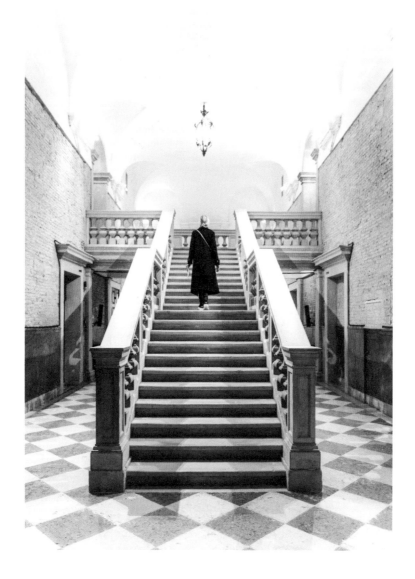

ABOVE

*Ca' Corner della Regina is a beautiful seventeenth-century setting
for contemporary art collections.*

LEFT

*On the banks of the Grand Canal, the Prada Foundation opened an exhibition
space for contemporary art in the massive Ca' Corner della Regina in 2011.*

ARCHITECTURE

A COLORFUL PALETTE

RICORDO
ANNO MARIANO
19

POPULAR DEVOTION

The streets of Venice are full of these improvised altars where
a light shines at the foot of a statuette of the Virgin.

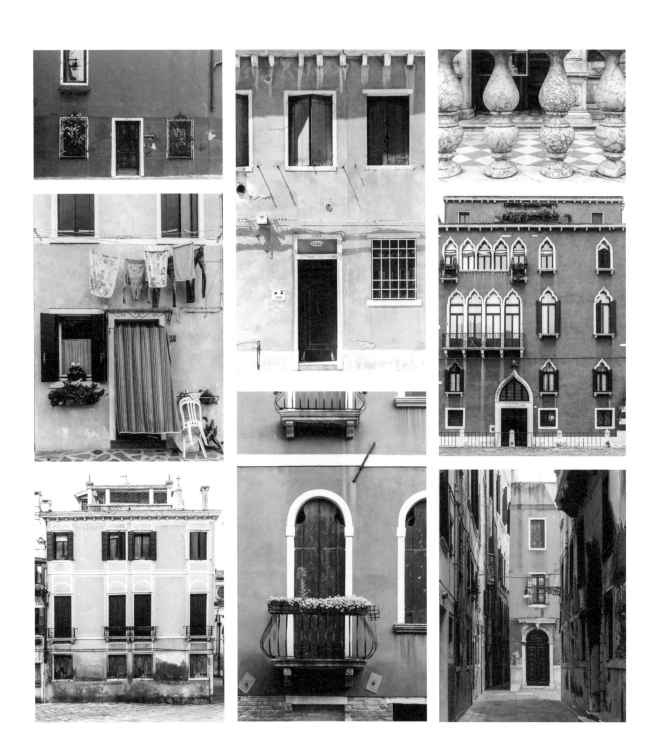

BRIGHT FACADES

Although there is no particular reason for the explosion of colors found
on some Venetian walls, these colorful spots serve to lift the spirit.

Stirring with activity, the Fondaco dei Turchi served both as warehouses (on the ground floor) and as a residence (upstairs)
for Turkish merchants. It is now the location of the Natural History Museum.

ABOVE

This concrete and glass door, which replaced the ancient entrance to the Tolentini
convent, was designed by Carlo Scarpa in 1966 and completed in 1978.
The former sanctuary is now home to IUAV, the university of architecture.

RIGHT

In Venice, Saint Eustace is nicknamed San Stae, which is the name of
this church from 1708 dedicated to him on the Grand Canal.

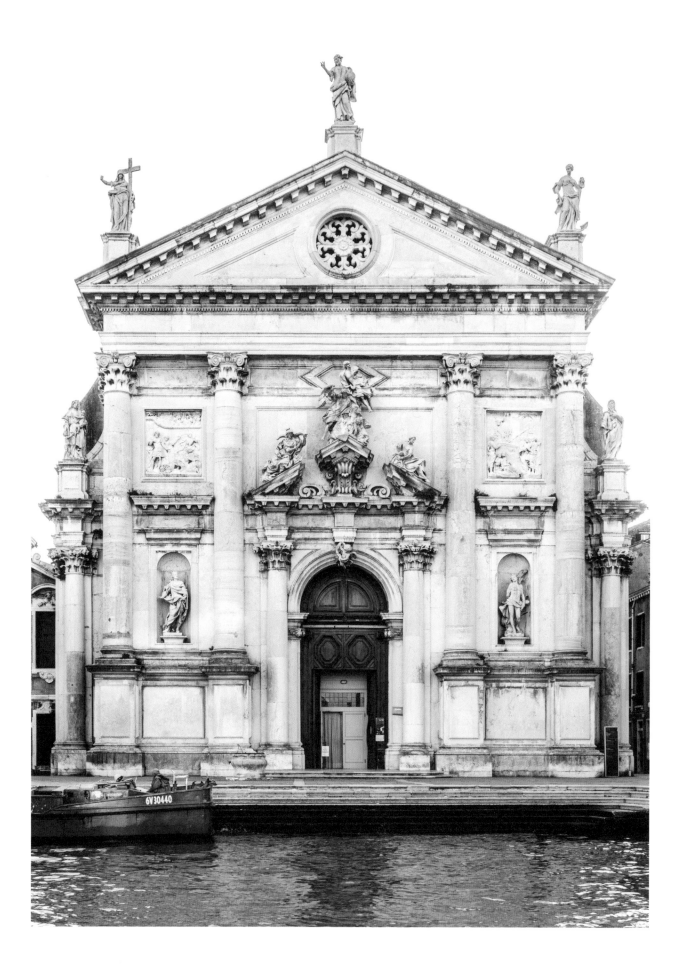

BEVILACQUA

HANDMADE VELVETS

In the tight space of an ancient atelier, the Tessitura Bevilacqua
has been weaving threads since 1875. It is one of the last factories to use looms,
a centuries-old tradition in Venice, which once included many factories
along the edge of the Grand Canal.

It is hard to imagine that the unassuming Luigi Bevilacqua palace, bathed by the waters of the Grand Canal, is the setting for an amazing theater of moving threads and pedals. There is something magical about seeing its looms come alive. The interlacing of the spools and the shelves stocked with cardboard templates used as weaving guides present a mysterious chaos. The work of the artisans here, however, is one of rare meticulousness, as they skillfully manage up to 6,400 different threads intertwined on their looms. At the rate of about one foot (thirty centimeters) of fabric produced per day, they manually operate the pedals and cogs of these complex machines dating from the sixteenth century.

Their work is invaluable, as they are among the last to keep alive this traditional Venetian know-how. In 1875, when Luigi Bevilacqua created the eponymous company, the techniques were based on an already centuries-old tradition. During the Renaissance, Venice had at least one thousand looms whose production was regulated for quality by ducal law. The workers of Bevilacqua still make the various fabrics today, producing the motifs from the collection of historical archives that includes 3,500 documents. On their looms, they can make a simple velvet or a *soprarizzo*, a chiseled velvet, which is a technique that cannot be reproduced on mechanical looms.

The unique quality of these historical fabrics makes them sought after by prestigious clients around the world, from the White House to the Kremlin, from the opera house of La Fenice to the Teatro di Roma, and from the Royal Palace in Stockholm to the Al-Yamamah residence of the Saudi-ruling dynasty. Fashion houses such as Roberta di Camerino and Begonghi (whose handbang was once carried by Grace Kelly) also seek to enrich their creations by including Bevilacqua fabrics.

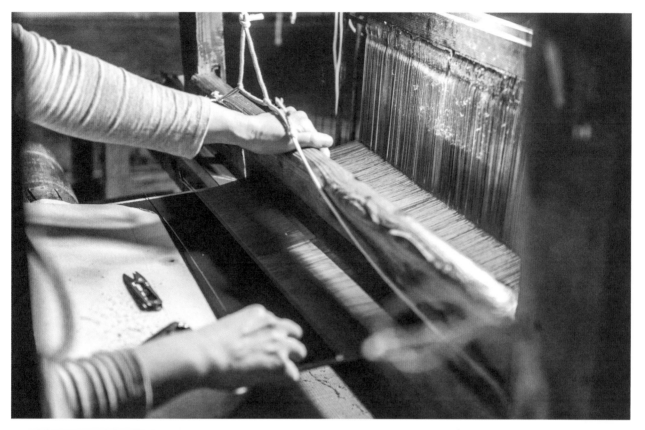

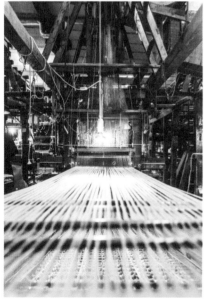

LOOMS

The preparation of the loom requires
extreme precision to create a perfect weave.

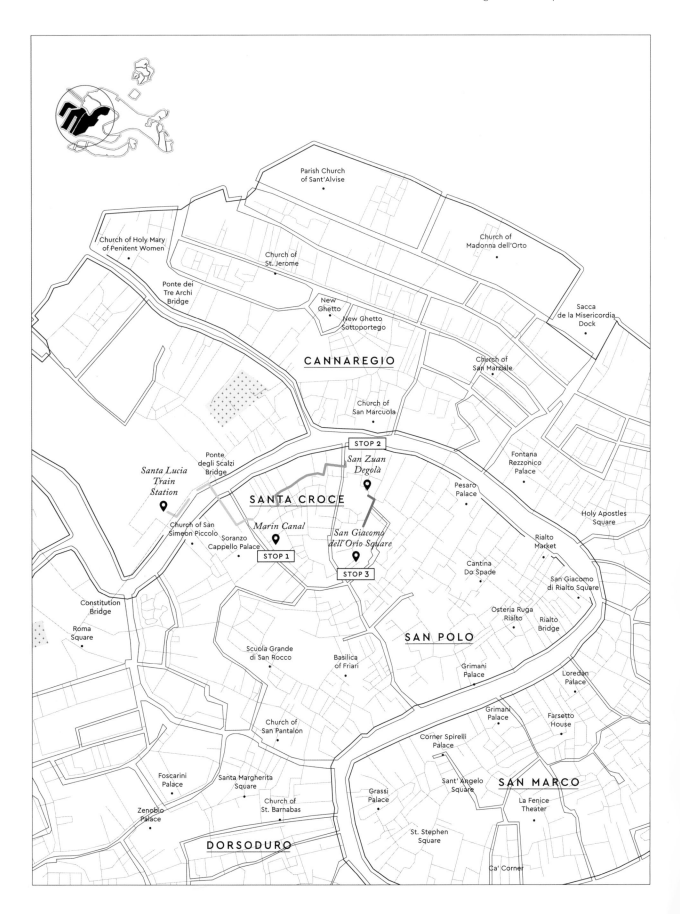

THROUGH THE ALLEYWAYS OF MINOR VENICE

Venice is not only the grandeur and splendor of a past that has provided it glory, jewels, and riches. It is also a city of quaint alleyways, small churches, quiet canals, and simple squares where everyday life takes place.

STOP 1: RIO MARIN

Venezia Minore is the title of Francesco Pasinetti's 1942 film and the 1948 book by architect Egle Renata Trincanato. Both evoke in their own way the city's minor canals, life in the squares, and the everyday Venice. These works have given rise to the expression "minor Venice," which has since been used to refer to working-class neighborhoods, simple dwellings, and the mundane beauty of more modest houses. From this perspective, Venice inspires us to take a deeper and more focused look into the city. In the Santa Croce *sestiere*, you can discover places hidden in the hollows of the particularly dense maze that makes up the neighborhood. Starting near the Rio Marin, a canal just a few minutes from the railway station, you cross into the neighborhood by way of the Ponte degli Scalzi. You can also reach it by private boat or gondola directly from the Grand Canal, onto which it opens. Seemingly unremarkable, Rio Marin offers everything needed for a charming walk, ending at the terrace of the small pastry shop with the same name where informed gourmands know to order the tiramisu, the specialty of the house. If it is open, walk through the door of the Palazzo Soranzo Cappello to look at its splendid garden.

STOP 2: SAN ZUAN DEGOLÀ

From the Rio Marin, walk up toward the Grand Canal through a maze of narrow lanes where you will see fewer and fewer pedestrians. As is often the case in Venice, you have but to travel a short distance to find yourself in another world. Through the Lista dei Bari and then the Calle Bembo, you will reach a square enclosing a church with a surprising name: San Zuan Degolà, the Venetian version of the beheaded Saint John the Baptist. The first mention of the church dates to 1007, and even today, despite numerous restorations, it remains a virtually intact example of Venetian-Byzantine architecture, evidenced inside by the eight Greek columns with Byzantine capitals. Today, the Russian Orthodox community of Venice congregates there.

STOP 3: CAMPO SAN GIACOMO DELL'ORIO

Through a hidden alleyway at the back of Campo San Zuan Degolà, you will access Calle del Capitello and then Calle dello Spezier. Walking just a short distance along the Rio del Megio, you will arrive at Campo San Giacomo dell'Orio, a vast square with plane trees where residents have planted vegetable gardens and where children play freely. In summer, the *sagra* is held, a large, popular weeklong festival attended by the residents of the surrounding neighborhoods who gather to eat and dance. The rest of the year, tango lovers regularly arrive to dance here under the stars. The square, with its irregular shape, stretches all around the church, from the ancient anatomical theater to the entrance into the nave on the canal side. It is not clear where its name originates: *dell'Orio* might mean *del rio*, "from the canal," but this is uncertain. Standing since the tenth century, the church contains an even older green marble column, dating from the sixth century and brought back by the Crusaders from Constantinople.

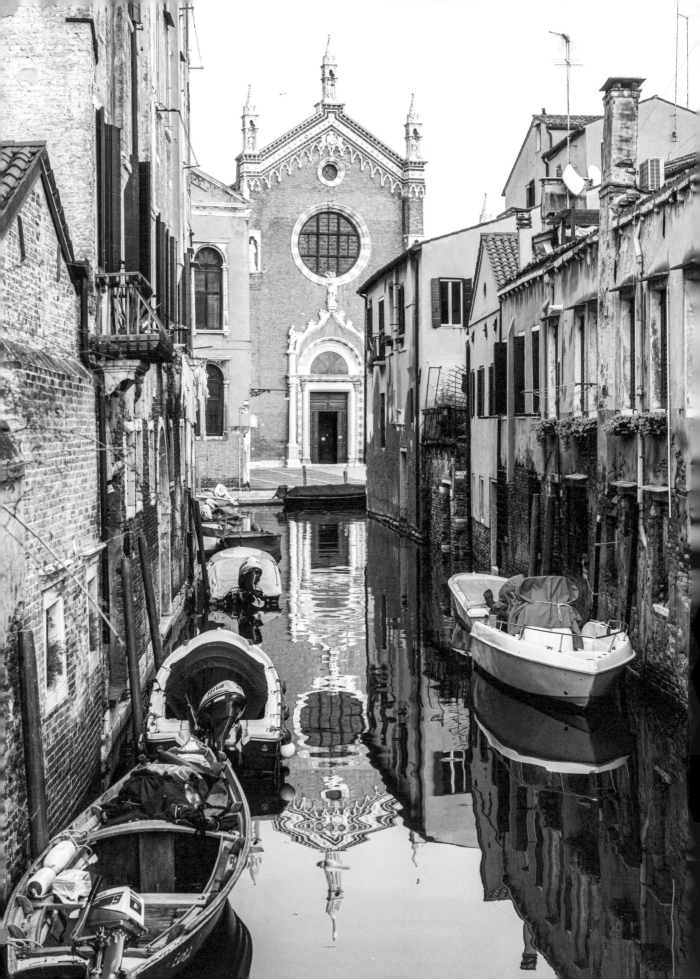

CANNAREGIO

The northernmost of Venice's *sestieri*, Cannaregio
is crossed by the Strada Nova, which leads directly
to the heart of Venice. You must wander to discover this
peaceful neighborhood, lined from west to east with
long stretches of piers. These straight-line *fondamente*,
in a city where lines are most often curved, create a
walking path inviting pleasurable detours.

P.164

*Located in a scarcely frequented area, the Chiesa della Madonna dell'Orto
contains the tomb of Tintoretto and several of his works.*

RIGHT

Cannaregio is the most populous of the six sestieri *of Venice.
There are many cafés where you can relax on the terrace.*

From the Liberty Bridge, the passing train's reflection on the waters gives it a sense of floating. In the distance, where the azure sky meets the pearl gray of the waters, appear colorful spots: the first houses of Venice. Today, it is no longer through the monumental entrance of Saint Mark's basin where visitors access the city but instead through the back entrance, in the *sestiere* Cannaregio.

Past the Ponte delle Guglie, a covered, narrow passage leads to the ghetto, the first in the world, established in 1516. At its exit is the Fondamenta della Misericordia, lined with numerous *bacari*, small bars where you can nibble on *cicchetti*, Venetian small appetizers, accompanied by an *ombra*, a glass of red or white wine. In the morning, you can see the cats of the restaurant Paradiso Perduto watching every gesture of the chef cleaning the fish he will serve for lunch.

From alleyway to bridge, your footsteps take you to Fondamenta della Sensa, which runs along the canal where prostitutes, at the time of the Republic, were allowed to parade by in gondolas. Behind the walls grow wild gardens that fill the spring air with the scent of wisteria. Through a laurel appears the brick silhouette of the Madonna dell'Orto, beautifully embellished with flowers, and white marble statues. In the nave of the church can be seen the tomb and the paintings of Tintoretto, a painter "from the neighborhood" whose red house with gothic windows is only a short distance away.

Cannaregio continues to reveal its treasures along the squares called, in Venetian, *campi* or *campielli*, as vegetables were once grown in these spots. Salty sea air rushes from the back of Campo dei Gesuiti, which is open to the lagoon. Perched on the front facade of its baroque church, angels observe the comings and goings of passersby who embark for the islands of Murano, Burano, or Torcello. Farther still, the church of Santa Maria dei Miracoli seems to emerge from the waters of the canal next to it. On a small square with red benches, the district of Cannaregio ends, a great spot for one last pause to observe the gondoliers or peek inside the window of a bookshop.

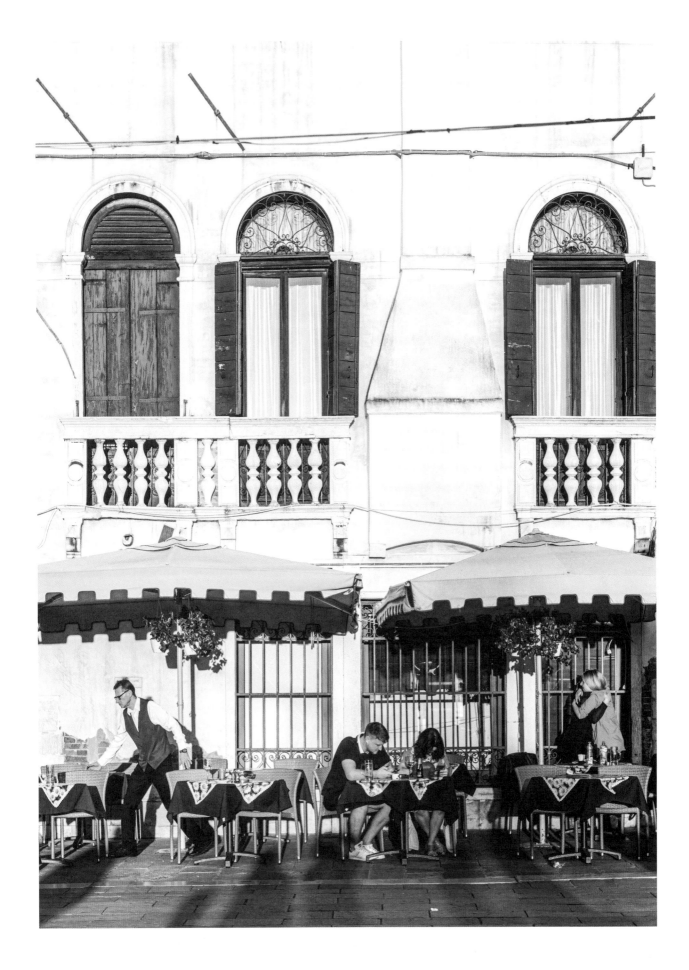

THE ESSENTIALS

40

THE GHETTO

The ghetto of Venice is chock-ful of small art galleries and great choices for Jewish-Venetian cuisine.

41

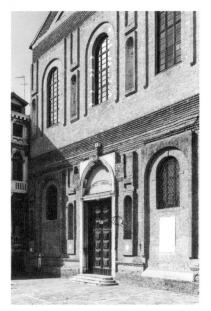

SCUOLA GRANDE DELLA MISERICORDIA

The Scuola Grande della Misericordia is an imposing massive structure. It is currently a venue for exhibitions.

42

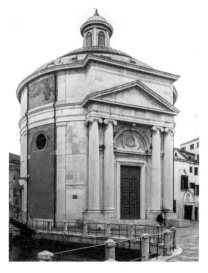

STRADA NOVA

The Strada Nova is the district's popular main artery. It is strewn with small churches, such as the Chiesa della Maddalena.

43

FONDAMENTA DELLA MISERICORDIA

Well known to night owls, the Fondamenta della Misericordia offers many small bars where visitors can recharge.

44

CAMPO DEL GHETTO

The Campo del Ghetto is the meeting place for children playing a game of soccer as well as a starting point to visit the synagogues.

45

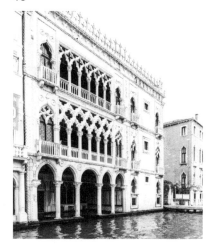

CA' D'ORO

A marvelous example of elaborate gothic architecture, Ca' d'Oro is one of the most beautiful palaces in Venice.

169

46

CHIESA DELLA MADONNA DELL'ORTO

The Madonna dell'Orto could be mistaken for a simple rural church if it weren't for the masterpieces by Tintoretto contained inside.

47

PONTE DELLE GUGLIE

The faces carved in stone on the Guglie Bridge tirelessly observe the canal's passing boats.

48

FONDAMENTE NOVE

From the Fondamente Nove, the view extends to the San Michele and Murano islands.

49

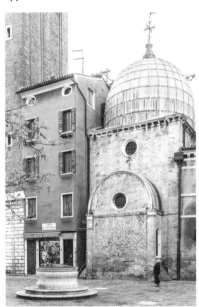

CAMPO DEI SANTI APOSTOLI

The small square of Santi Apostoli and its church are dominated by an imposing campanile.

50

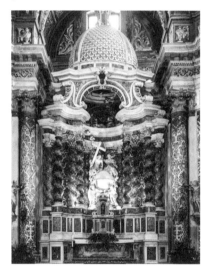

CHIESA DEI GESUITI

Marble extravagances reside inside this Jesuit church.

51

CHIESA DI SAN GEREMIA

The church of San Geremia houses the relics of Saint Lucia.

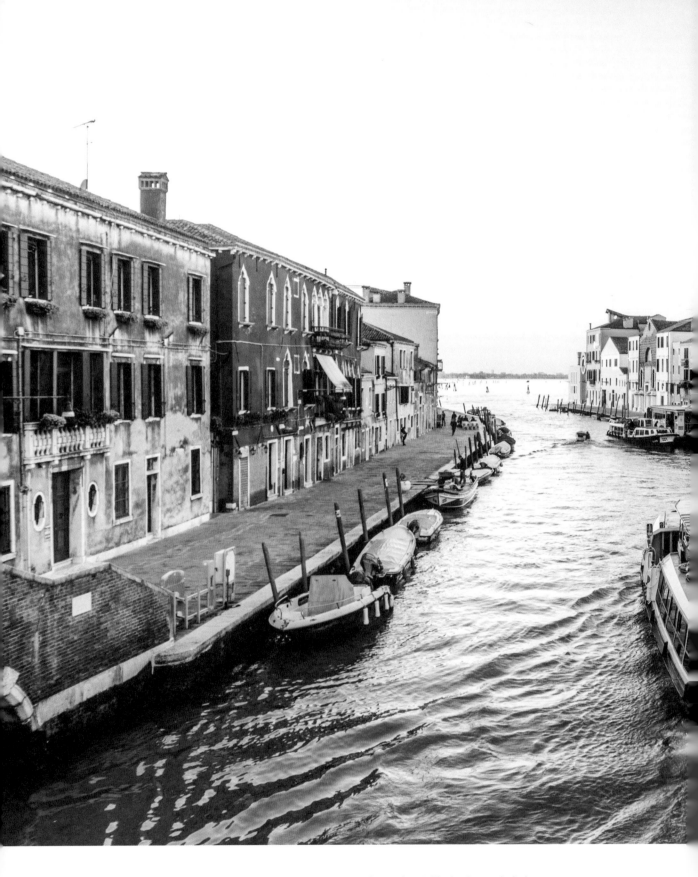

At the end of the Rio di Cannaregio, the vaporetto *leaves the neighborhood to reach the lagoon.*
Although a minor canal, it is lined with beautiful mansions and small churches.

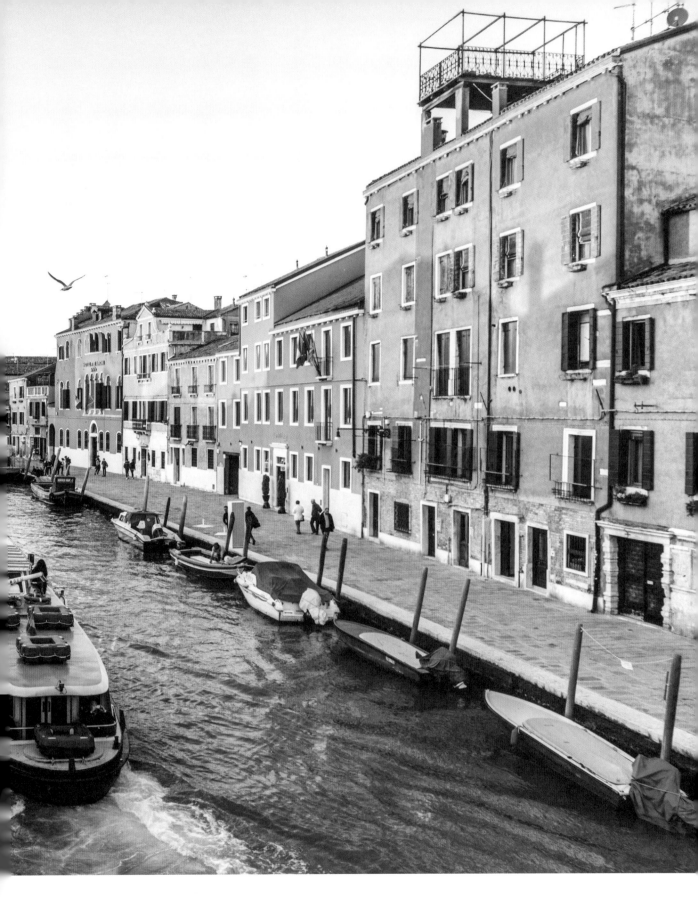

UNDERSTANDING

THE BUILDING OF GONDOLAS

The gondolas of Venice embody the city's postcard image: a kissing couple drifting by in a gondola passing beneath the Bridge of Sighs. Despite its iconic look, the design and function of the gondola have evolved quite a bit over the centuries.

Today asymmetrical, black, and open to the skies so passengers can admire the surroundings, gondolas were at one time colorful, outfitted with a cabin, and used as a means of private daily transport.

The gondola's unique shape is intrinsically linked to the Venice lagoon where it was born. To get around, the first inhabitants of the lagoon needed flat-bottom boats adapted to shallow water. As early as the sixth century, a text by the Roman Cassiodorus attests to the presence of the boats in the Venice lagoon. They managed to maneuver through the narrowest channels, operated by one or two standing rowers. Little by little, the gondola took shape, responding perfectly to the needs of the Venetians.

The gondola's appearance has changed quite a bit: at first colorful, they were painted black when the Senate in 1633 imposed temperance on families who were competing by flaunting their wealth. The boats are constructed from 280 pieces of wood. In the shipyards, called *squero* in the local dialect, a great deal of expertise is required. First, the *maestro d'ascia*, or axe master, fashions the wood pieces that will make the gondola into the correct shapes. He thus defines the hull of the boat on which he will place the circles, the wooden planks connecting the stern and bow. To give the desired shape of every piece of this giant puzzle, he uses the properties of fire and water. A torch made of lagoon grasses creates the steam needed to curl the boards one at a time. The frame is complemented by side pieces, called *volti*, *nerve*, and *corboli*. Next, the exterior is constructed, which will be covered with seven layers of protective varnish. The final touch is added by another tradesman, the *forcolai*, who will make the *forcola*, the piece of custom-made wood on which the gondolier presses his oar to propel the gondola.

In total, the making of a gondola requires one year's work. These places still construct the boats, but the shipyards are used mainly for maintenance and restoration.

1. A SYMBOLIC IRON BOW

The iron bow (*ferro da prua*) of the gondola is an allegory of Venice and its lagoon.
On it is an indication of the main symbols of the city of doges.

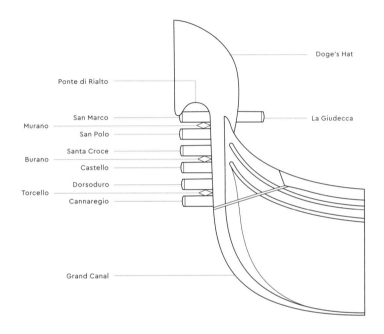

Doge's Hat

Ponte di Rialto

San Marco
Murano
San Polo
Santa Croce
Burano
Castello
Dorsoduro
Torcello
Cannaregio

La Giudecca

Grand Canal

2. GONDOLA OCCUPATIONS

It takes about five hundred hours of work to make a gondola and to outfit
its gondolier. There are many craftsmen involved in its creation.

- The *squerarili* ("carpenter-joiners") work the wood and create the hull and body of the boat.

- The *forcolai* make the oars and the *forcola*, the oar's wooden support.

- The *intagiadóri* sculpt and carve the wood.

- The *fondidóri* melt and mold brass for the adornments.

- The *battiloro e indoradóri* take care of the gilding.

- The *tappezzieri* ("upholsterers") decorate the inside of the gondola and provide the padding.

- The *fravi* ("blacksmiths") forge the iron of the bow.

- The *sartori* ("tailors") create the clothes worn by gondoliers.

- The *calegheri* ("cobblers") fashion the shoes of the gondoliers, making them black, comfortable, and nonslip.

- The *baretèri* create the caps worn in the summer and winter by the gondoliers.

ABOVE

*Scattered throughout the city, newsstands sell
not only newspapers and magazines but
also postcards and souvenirs for the many tourists.*

RIGHT

Wind and fog drift through the lagoon's canals.

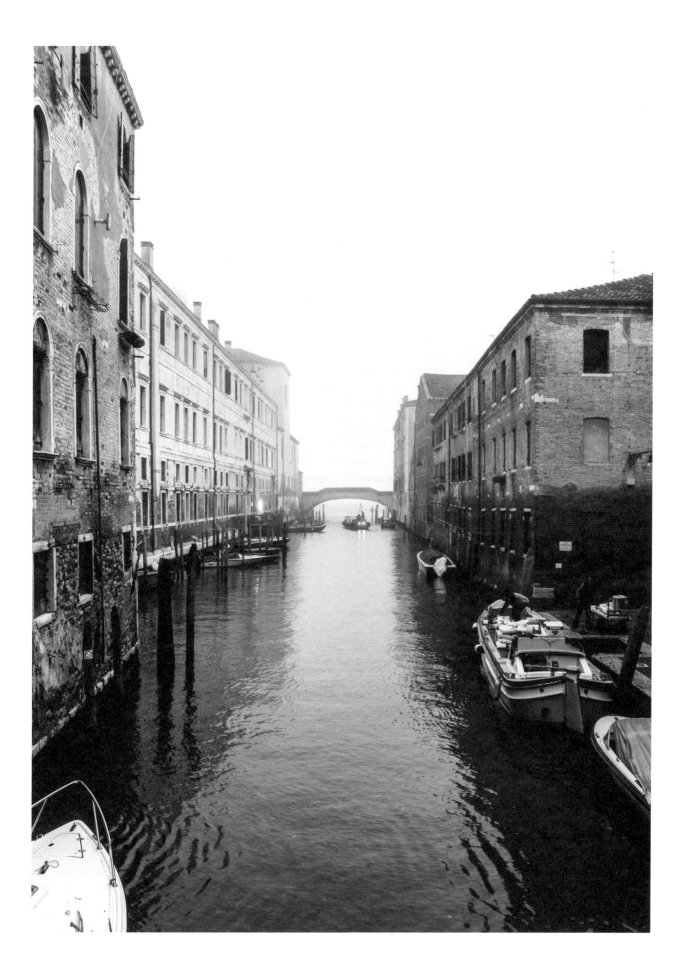

VISITING

CA' D'ORO

GOTHIC SPLENDOR

Taking the *vaporetto* from Santa Lucia station down the Grand Canal takes you past a procession of elaborate facades that parade by at the slow pace of the boat. Among them, Ca' d'Oro catches the eye.

Its facade is capped with a parapet of thin stone spiers; it is sculpted with the attention of a goldsmith down to the smallest detail; it is lined with a multitude of gothic windows; and it is gilded with gold leaf and covered with colorful frescoes. Today you can admire its exterior just as it was when first built in 1440, earning it the nickname the Golden House (Ca' d'Oro). The name of Marino Contarini, the wealthy sponsor of its construction, and that of the Lombard and Venetian master architects are no longer part of the palace's name, contrary to Venetian custom.

Ca' d'Oro continues to be an emblem of the lagoon's architecture, a common thread through the ages that evokes the different uses of space. Built on a Byzantine warehouse, whose water well and bricks were recovered, Ca' d'Oro first had a commercial use, as did many of the palaces along the Grand Canal. The gate, which could be lowered onto the canal, allowed the ground floor to be used as a warehouse. The building is topped by a mezzanine where offices were located while the upper floor was dedicated to the family's living space. The palace would later have many owners who used it for residential purposes. It would eventually be restored in the nineteenth century, led by Giovanni Battista Meduna.

When Baron Giorgio Franchetti bought the palace in 1894, he had to rebuild the staircase of the inner courtyard and recover the wellhead of the Byzantine water well—which had been sold by the previous owners—from a Parisian bookseller. Franchetti had the sublime mosaic installed on the ground floor, inspired by the motifs of Saint Mark's Basilica. From the outset, the baron's intention was to turn Ca' d'Oro into a museum to house his collection of Tuscan and Flemish paintings, thus predicting the fate of many palaces of the Grand Canal now transformed into museums. Warehouse, residence, exhibition space: Ca' d'Oro represents the changing functions of the Grand Canal palaces through the ages.

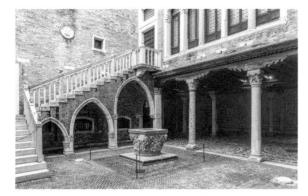

The facade impresses as much as the mosaic, painstakingly composed in the nineteenth century by Baron Franchetti.

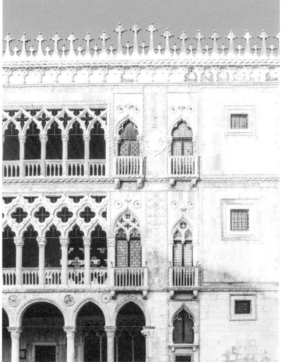

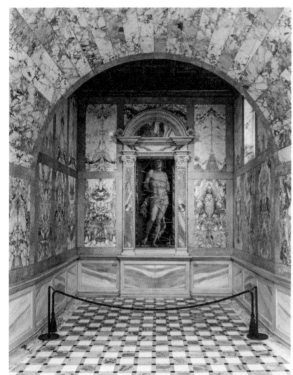

A ONE-OF-A-KIND MUSEUM

Few museums can boast such a beautiful setting in which to highlight their collections, including marble alcoves and gothic windows opening onto the Grand Canal . . .

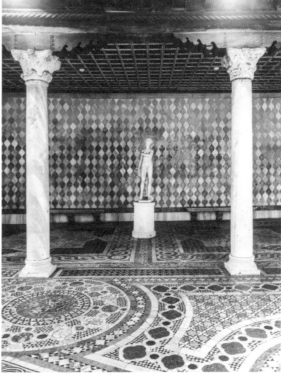

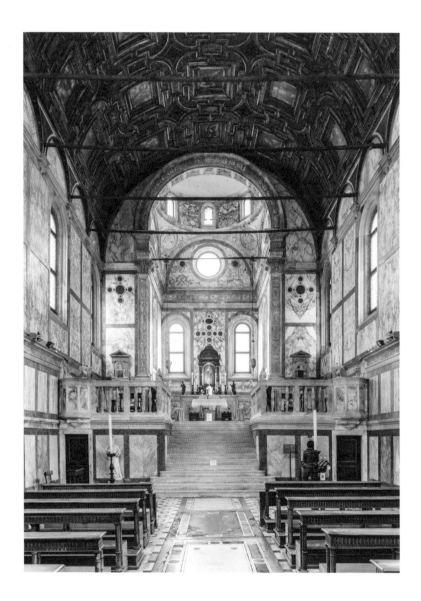

ABOVE

*The small rectangular church of Santa Maria dei Miracoli was restored in the
nineteenth century by Queen Margherita of Savoy to admire her artistic treasures.*

RIGHT

In front, the Santa Maria dei Miracoli opens onto the eponymous campo
and is bordered at the back by the Rio dei Miracoli.

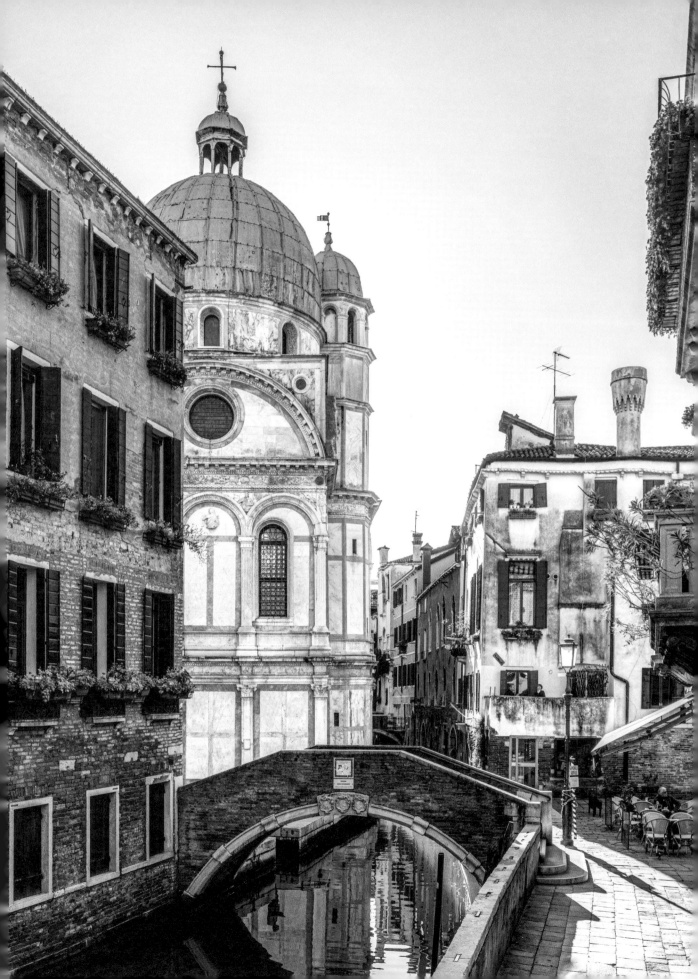

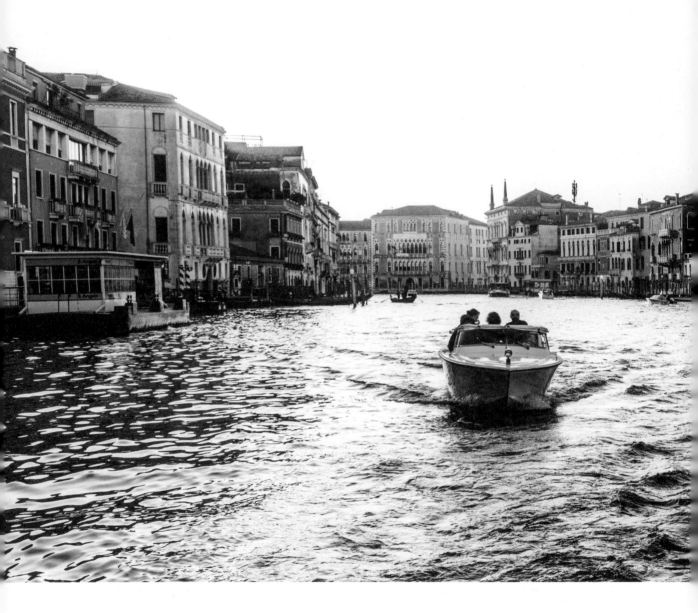

*At sunset, Venice offers up its golden colors reflected on the waters of the
Grand Canal to all those who travel its nearly two miles (three kilometers).*

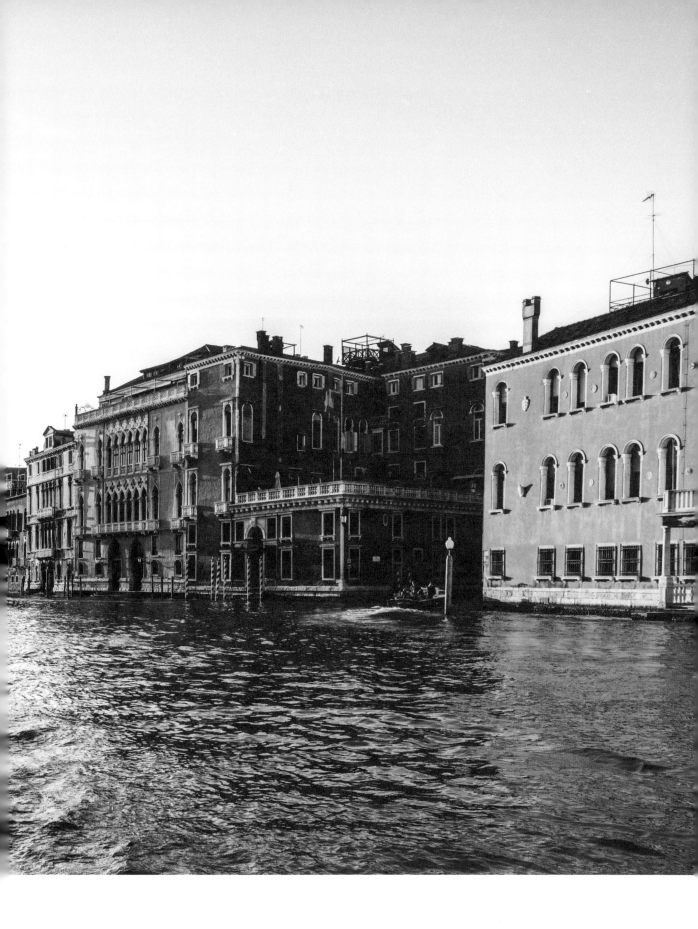

LIFESTYLE

ORSONI

THE LAST *FORNACE*

Every day, just a stone's throw away from the ghetto in Cannaregio,
a thousand colorful shards emerge from the ovens of the *fornace* of Orsoni,
the last master glassmaker in Venice.

In Venice, most glassmakers' ovens are located on the island of Murano, where they were required by a thirteenth-century ducal law to set up operations to avoid spreading fires. When Orsoni was founded in 1865, the Republic no longer existed, so the law of the doges no longer applied. The Orsoni *fornace* was established in Cannaregio in the historic center of Venice where it now produces mosaics exported all over the world.

In the workshop, the oven heaves with heat. It must reach a temperature of around 1,800 degrees Fahrenheit (1,000 degrees Celsius) to make glass. Every two to three months, the oven is destroyed then replaced. It is inside this oven where sand, from Fontainebleau, transforms into colored glass. For each shade of color, Orsoni has a specific recipe; there are nearly three thousand. From the belly of the *fornace* emerges the glass, which is then pressed by a machine to form disks that are set aside

to cool. Then, with the utmost precision, a worker places a delicate gold leaf on the disk then covers it with another layer of glass.

The disks are then cut in half and stored in the color library. They are placed upright on shelves where their edges are visible like spines of books. This is where the true color of the glass can be seen: the color that the pieces of mosaic will have, once cut.

A workshop is set up in the factory's small garden. Here the cutters sound like a rhythmic chorus as they slowly transform the disks into small squares of color. Designers, artists, and art restorers from all over the world order glass from Orsoni. Clients include the Sagrada Familia in Barcelona, a pagoda in Korea, and a luxury hotel in Dubai, all relying on the meticulous and resplendent quality of Orsoni's colors.

THE ORSONI COLOR LIBRARY

The precious slices of glass are presented in a colorful library.

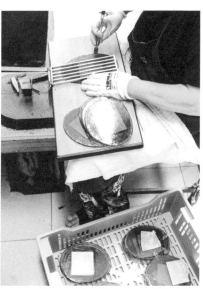

BY THE WINDOW

Natural light is important for observing different colors.

SLICING

The disks melted in the *fornace* pass into the expert hands of a worker.

SIZING

All the work is done by hand, using a small machine.

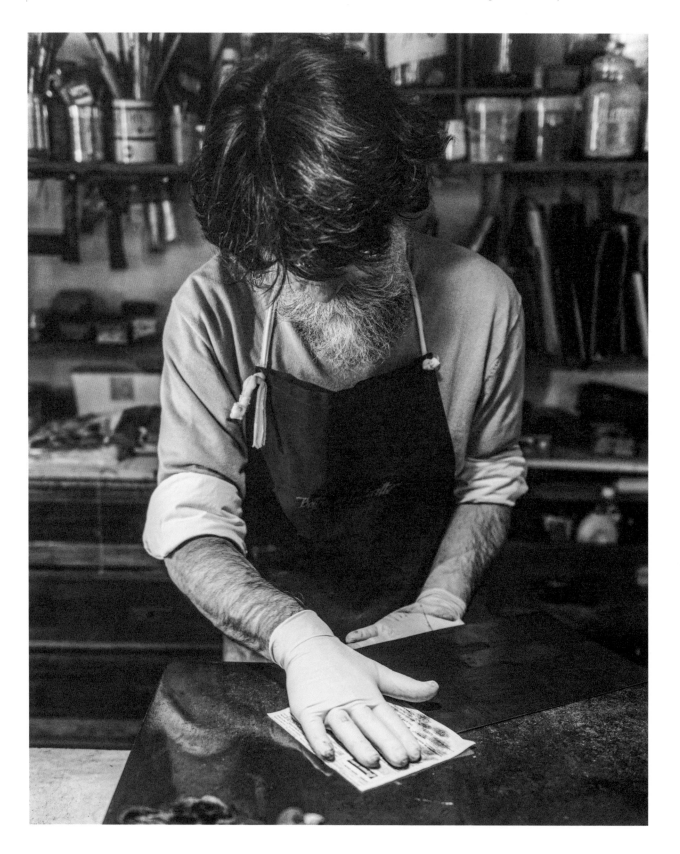

*The Bottega del Tintoretto is an art printing house opened by a collective of artists,
located in the painter's former studio.*

*This art printing press is a graceful tool from which
handmade prints are produced.*

FOOD & DRINK

THE *APERITIVO* HOUR

AT THE COUNTER

Ordering takes place at the counter, where you point
to the small bites that entice you most.

A BREAK FOR AN *APERITIVO*

They are available all day long, but *cicchetti* are typically associated with the *aperitivo* hour.

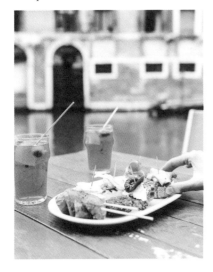

ALWAYS A SPRITZ

The spritz, invented in Venice, is one of the symbols of the Venetian *aperitivo*.

WINDOW-SHOPPING

Al Bottegon is one of Venice's most traditional *bacari*.

ON THE STREET

Some *bacari* are so small that customers order from the street, such as at Da Lele.

PREPARATIONS

At Paradiso Perduto in Cannaregio, the cook is often busy preparing *cicchetti*.

THE SEVEN O'CLOCK BELL

As soon as the workday ends, everything is ready in the neighborhood bars for *aperitivo*.

SMALL TERRACES

In the small alleyways, terraces are replaced by barrels and stools.

TOASTS AND SPREADS

A piece of bread and some traditional spreads: this is *aperitivo* as they love it in Venice.

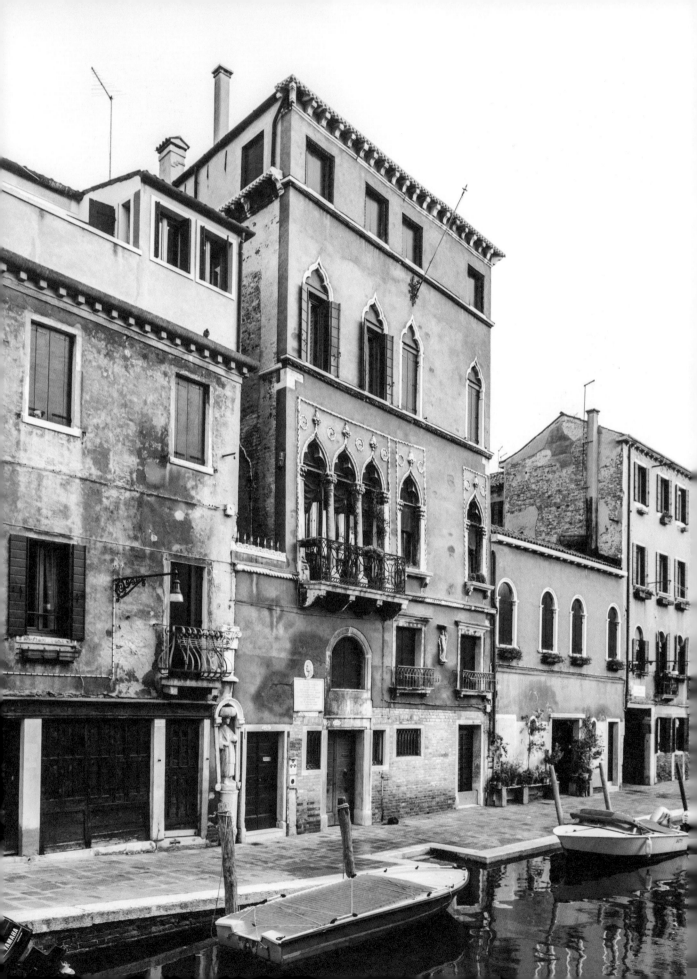

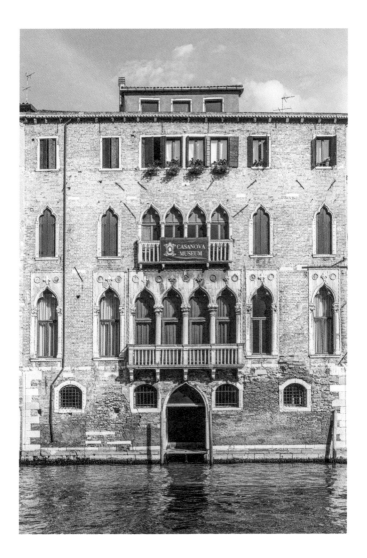

ABOVE

*The beautiful Pesaro Papafava palace, which dates to the fifteenth century,
is now home to the British pavilion and the Casanova Museum.*

LEFT

The gothic trifora, *the three-arched window,
is the balcony of Tintoretto's house.*

FOLLOWING SPREAD

*The baroque facade of the Labia palace is an imposing presence
at the corner of the Grand and Cannaregio Canals.*

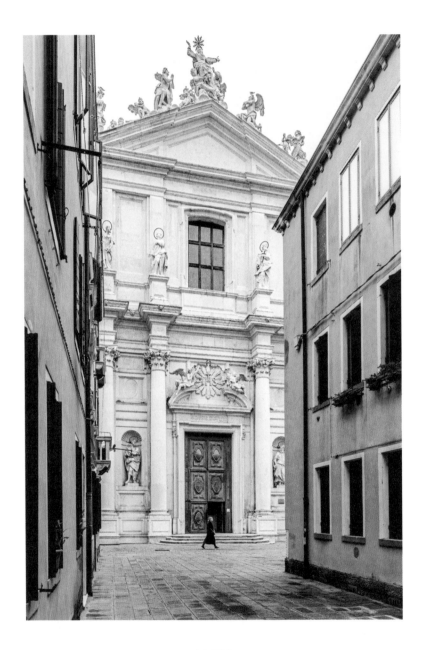

ABOVE

*The facade of the Jesuit church supports eight statues on columns and four in niches,
representing the twelve apostles.*

RIGHT

*The green and white marble and the twisting columns play with the eye to give the
impression of a larger space within the Jesuit church, built between 1715 and 1729.*

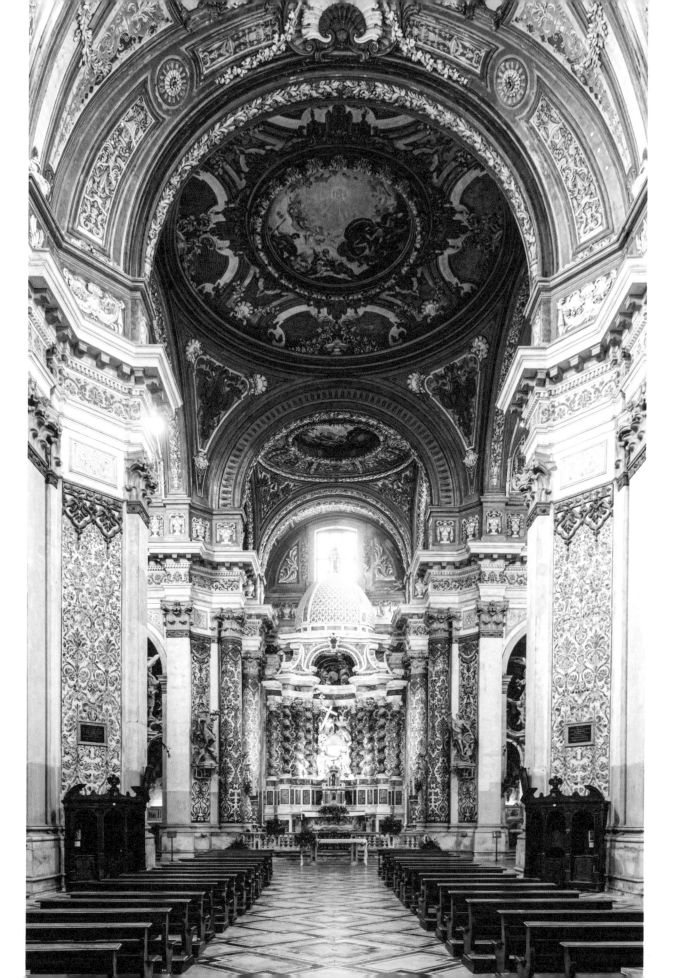

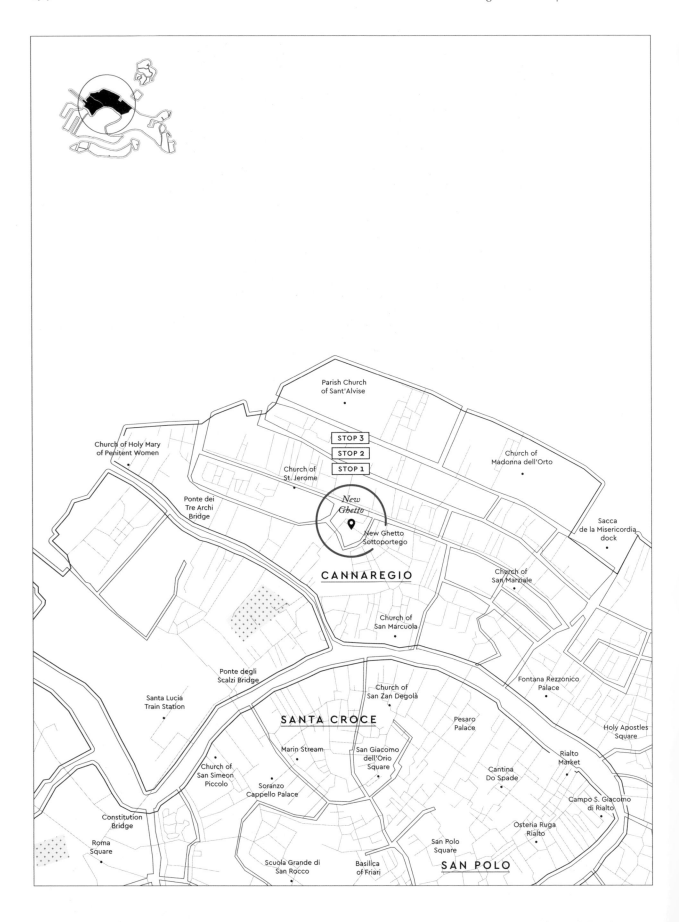

STOP 3

STOP 2

STOP 1

Parish Church
of Sant'Alvise

Church of Holy Mary
of Penitent Women

Church of
Madonna dell'Orto

Church of
St. Jerome

Ponte dei
Tre Archi
Bridge

*New
Ghetto*

New Ghetto
Sottoportego

Sacca
de la Misericordia
dock

CANNAREGIO

Church of
San Marziale

Church of
San Marcuola

Ponte degli
Scalzi Bridge

Fontana Rezzonico
Palace

Santa Lucia
Train Station

Church of
San Zan Degolà

Holy Apostles
Square

SANTA CROCE

Pesaro
Palace

Marin Stream

San Giacomo
dell'Orio
Square

Rialto
Market

Church of
San Simeon
Piccolo

Cantina
Do Spade

Campo S. Giacomo
di Rialto

Soranzo
Cappello Palace

Osteria Ruga
Rialto

Constitution
Bridge

San Polo
Square

Roma
Square

Scuola Grande di
San Rocco

Basilica
of Friari

SAN POLO

THROUGH EUROPE'S FIRST GHETTO

Nestled within several blocks in the heart of the Cannaregio *sestiere*, the ghetto of Venice feels a world apart from the rest of the city. Since its establishment in 1516, the character of this slice of land has been shaped by the history of its various Jewish communities.

STOP 1: CAMPO DEL GHETTO

The term *ghetto* originated in Venice: when authorities decided to force the Jews, who had been present in the lagoon since the tenth century, to live together in one place, they chose the small site of an old foundry, or *geto* in Venetian, as the location. The pronunciation gradually changed to *ghetto*. This term was then adopted all over the world to refer to an isolated minority group. Over the centuries, the Venetian ghetto became a community. It settled first around the Campo del Ghetto, a vast shady square still serving today as the quarter's center. To successfully house a growing population in a narrow space, the houses have an unusual number of floors for those typical of Venice, usually preferring palaces of no more than three or four levels due to the lagoon's continually moving ground. In 1541 and again in 1633, to accommodate communities of Jews arriving from Spain and the Levant, the district was enlarged to the

nearby blocks of Ghetto Vecchio and Ghetto Novissimo. Until its abolition by Napoleon in 1797, the ghetto of Venice was closed at night by guarded iron gates whose hinges are still visible at the entrance to the Ghetto Vecchio.

STOP 2: SYNAGOGUES UNDER THE ROOFS

Hidden behind the window-filled facades around the square are many synagogues. Due to the lack of space, three of the area's five synagogues are housed in preexisting buildings on the top floor. To visit them, you must enter through the Museo Ebraico and take a network of stairs to access the hidden rooms where Jews from the different communities met. Borrowing from the Venetian dialect, the Jews call them *scola*. The oldest, dating from 1527, is the Scola Grande Tedesca, a place of worship for Ashkenazi Jews. There is also the Scola Canton, where painted wooden panels tell the story of the Jewish people, as well as the Scola Italiana. With the expansion of

the ghetto, two new synagogues were built in dedicated buildings, the Scola Spagnola and the Scola Levantina, both of which are baroque in style.

STOP 3: A GOURMAND'S STROLL

The Hebrew presence in Venice has resulted in a unique cultural mix that has given rise to a cuisine borrowing from multiple influences. From northern Europe came the custom of eating goose. With the Levantine, spices were introduced. The Spanish and Portuguese contributed sweet recipes. These foods are now part of the local culture and influence Venetian gastronomy itself, as evidenced by the taste for sweet-and-sour, raisins, and spices. In the ghetto, these gastronomic traditions are still very much present. You only have to stroll down Calle del Ghetto Vecchio to be tempted by pastry shop windows lined with appetizing treats before leaving the neighborhood by way of the *sottoportego*, a covered walkway now open at all hours.

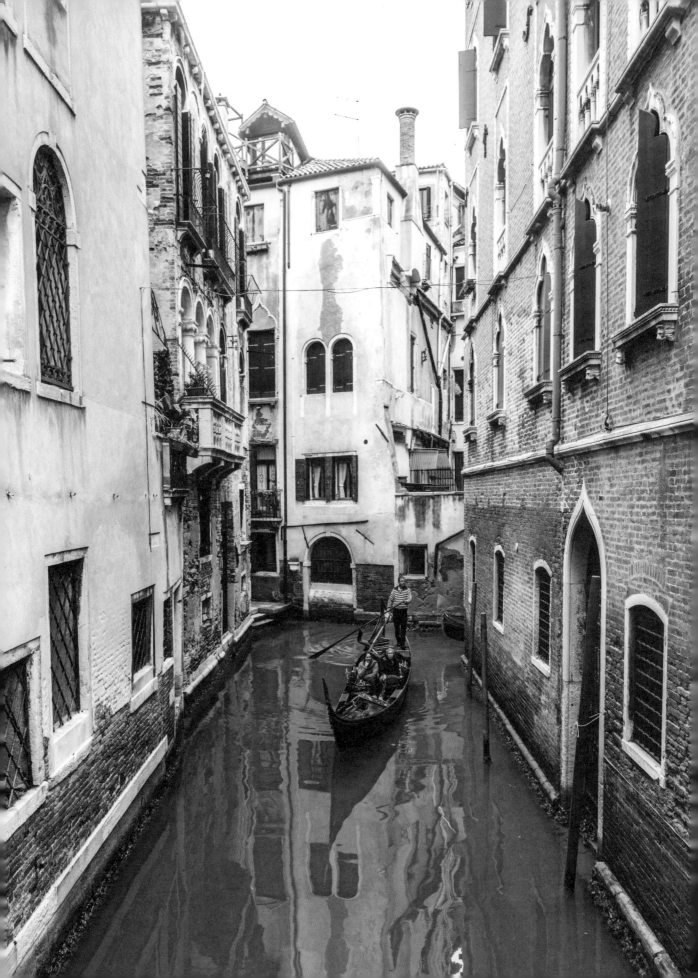

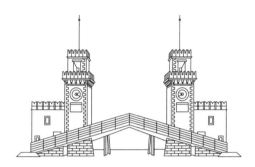

CASTELLO

As a gondola drifts by, a palace's watercolor-like reflection
breaks up into colorful slivers. The movement of the
gondolier's oar blends the brick facade's pinks and ochres
and its white marbles into the green of the water.
In the Castello *sestiere*, the closer you get to the Arsenale,
the calmer the waters, the narrower the canals,
and the more deserted the alleys.

P.196

*Only gondolas and small boats can navigate
the narrowest canals.*

RIGHT

*Ending up by chance at a dead end is not a bad situation.
You often come across nice surprises when you get lost in Venice.*

In Venice, there is an abundance of palaces built by patrician families who wished to live near Saint Mark's. It is difficult to count these wealthy residences with their mix of materials, ample stones, and mosaics of various styles. On the Campo Santi Giovanni e Paolo, the polychromatic marble facade of the Scuola Grande di San Marco presents a trompe l'oeil. Upstairs, the main room welcomes visitors under canvases by Bellini, Tintoretto, and Palma il Vecchio, depicting scenes from the life of Saint Mark.

A few narrow *calle* lead to Santa Maria Formosa, a large winding square where you can stop for a coffee to admire the richly decorated arches in the palace windows. Through the Ruga Giuffa, a narrow passage where musical notes sometimes resonate from the Palazzo Grimani, you gradually leave this aristocratic belt to enter the Castello district with its working-class past.

The quarter then splits into quiet blocks divided around parishes, such as in San Francesco della Vigna or Campo della Bragora. Above the canals from one house to the next, whether on sunny or foggy days, linens are hung out to dry, resembling colored rosaries. Passing under the leaning bell tower of the church of San Giorgio dei Greci inspires thoughts of cosmopolitan Venice with its Dalmatian, Slavonic, Greek, Friulian, and Armenian communities.

The Arsenale, a huge shipyard, contains its secrets behind high crenellated walls, although warships are no longer manufactured there. Every year since 1893, with the alternating Biennales for architecture and contemporary art, the immense buildings of the former Corderies (where ship cables and ropes were made) house works from all over the world. At the exit of the exhibition halls, the Via Garibaldi invites walkers to head toward the Giardini, which continue to the shore. From there, the eye catches the distant domes of the Basilica of Santa Maria della Salute and the peaks of the pine forest of Sant'Elena. Via the Riva degli Schiavoni, bathed in sunshine or illuminated by stars, you return eventually to Piazza San Marco and the Bridge of Sighs.

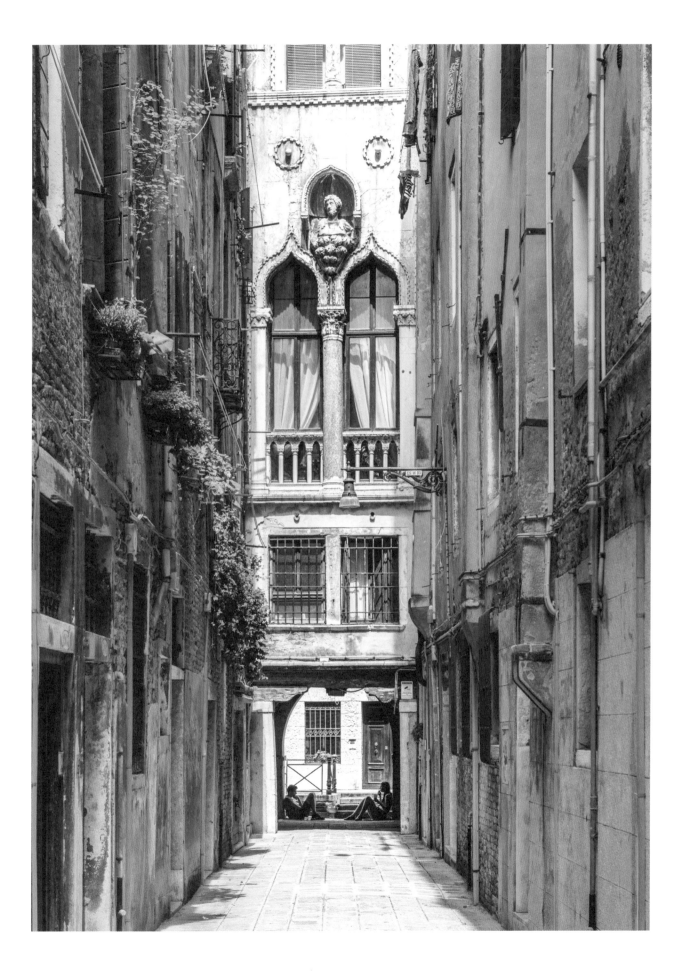

THE ESSENTIALS

VIA GARIBALDI

A wide, lively thoroughfare of the district, the Via Garibaldi is frequented by young people and professionals who come to have lunch in its many small venues.

53

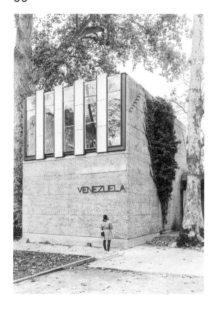

GIARDINI

The Giardini are open during the Biennale and contain the most amazing modern architecture.

54

ARSENALE

The Arsenale, once a heavily guarded naval construction site, is accessible during the Biennale.

55

SANT'ELENA

In the pine forest of Sant'Elena, visitors can stroll, picnic, or take a nap.

56

CHIESA DI SAN ZACCARIA

A veritable dazzle of colors delights visitors in the Chiesa di San Zaccaria.

57

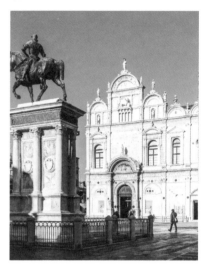

SCUOLA GRANDE DI SAN MARCO

The fascinating marble facade of the Scuola Grande di San Marco hides treasures on its upper floor.

58

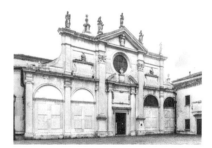

SANTA MARIA FORMOSA

The name Santa Maria Formosa refers to both the sensuously shaped square and the church.

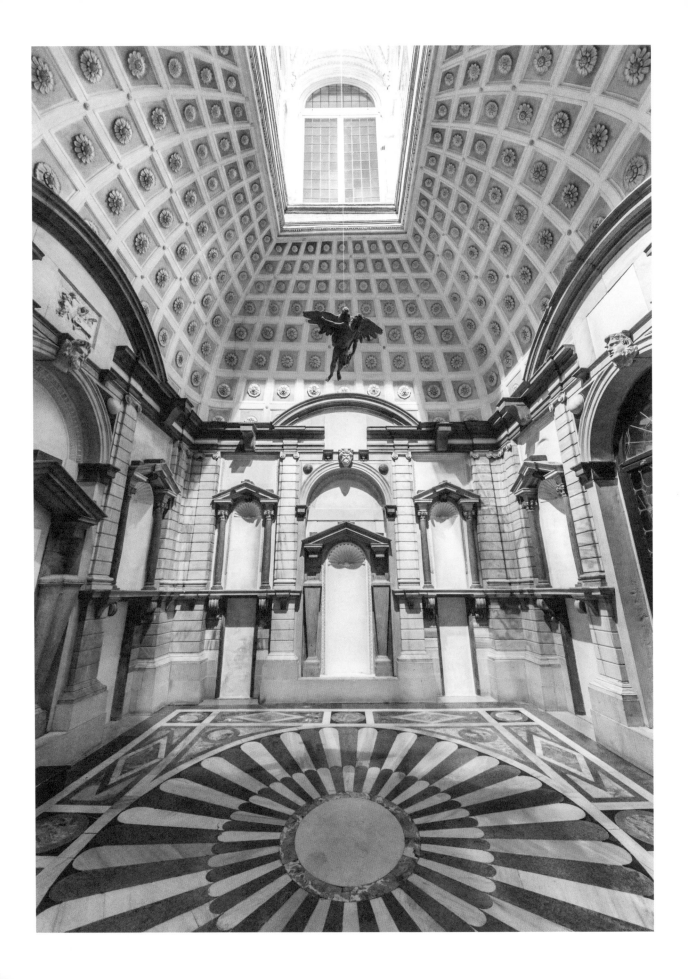

ABOVE

In an alley, the chapel of the Madonna is nestled between palaces.

LEFT

*The collection of antiques and works of art accumulated by the Grimani are a must-see
in their house whose style is surprisingly more Roman than Venetian.*

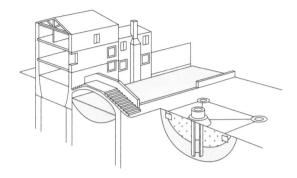

1. A COMPLEX WATER COLLECTION SYSTEM

Because the water in the lagoon is not suitable for drinking, rainwater had to be collected, hence the many water wells found throughout the city.

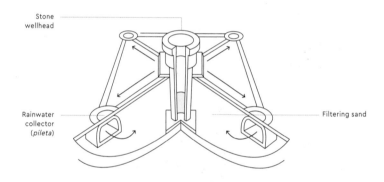

2. IN THE SQUARE

At the four corners of the square, rainwater is collected through openings in the ground.

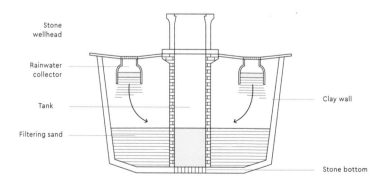

3. IN THE TANK

UNDERSTANDING

THE WATER WELLS OF VENICE

No matter the path you take or in what district, you will find water wells everywhere in Venice. Their beautiful wellheads, the *vere da pozzo*, can be adorned with leaves, birds, or coats of arms.

The largest squares often have several, the small *campielli* have only one, and the palaces and monasteries hide them in their private courtyards. Without them, Venice would have had difficulty prospering and growing amid the salty sea waters. The invention of the water collection system implemented by the Venetians speaks volumes about the creativity and ingenuity of the inhabitants of the lagoon who settled on inhospitable lands where everything had to be invented. Before the construction of the first aqueduct in the nineteenth century, water wells were practically the only way to obtain fresh water.

Strictly controlled, their access was limited, and water was rationed according to available reserves: a half to one and a half gallons (two to six liters) per person per day. To prevent abuse or poisoning of the water, the heavy lids that still close them were locked and the keys entrusted to the head of each parish. Replenished by rainwater, their supplies were sometimes supplemented by deliveries of drinking water by boat from the mainland.

Although there is no comprehensive inventory of them, it is estimated that there are currently about two thousand water wells remaining out of the original six thousand. Many were dispersed and sold to collectors at the end of the Republic in 1797. The decorations of their wellheads offer a discreet journey through time through the artistic influences that inspired their creators, all of whom are anonymous craftsmen. The most ancient are even simple pieces of Roman columns, recovered from the mainland. Beneath each of them is a large clay-lined tank thirteen to twenty feet (four to six meters) deep. Rainwater was collected, filtered, and purified by the sand and finally drawn. There are almost no trees on the squares in Venice in order to prevent their roots from taking over these precious reserves.

From the square Byzantine wells decorated with crosses to the gothic, Renaissance, or baroque wells, Venice once again affirms its attachment to beauty. Here, nothing can be ordinary, not even the most common of urban elements.

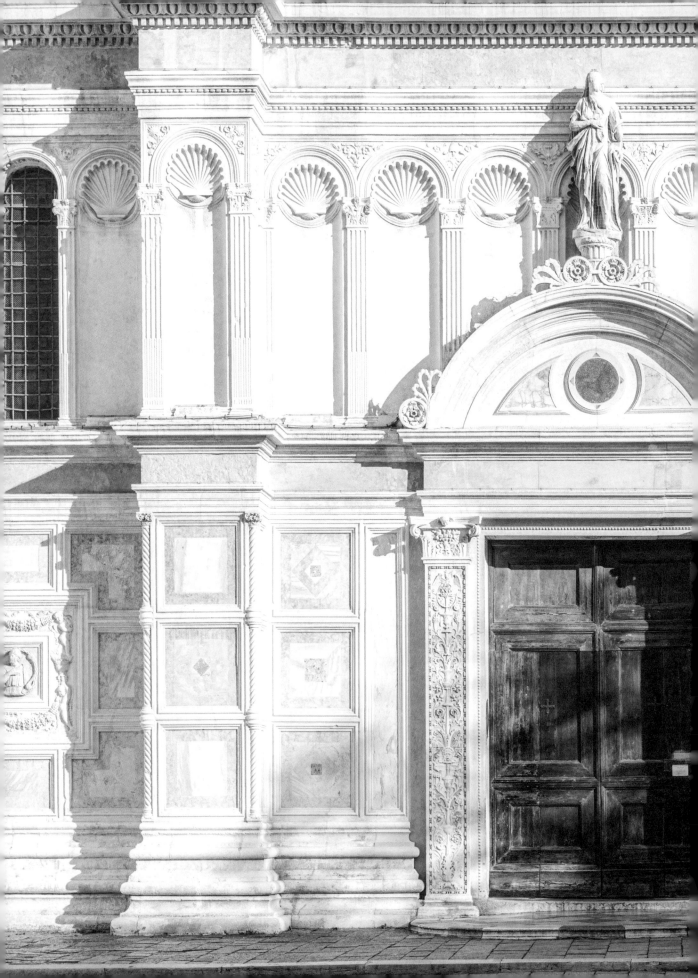

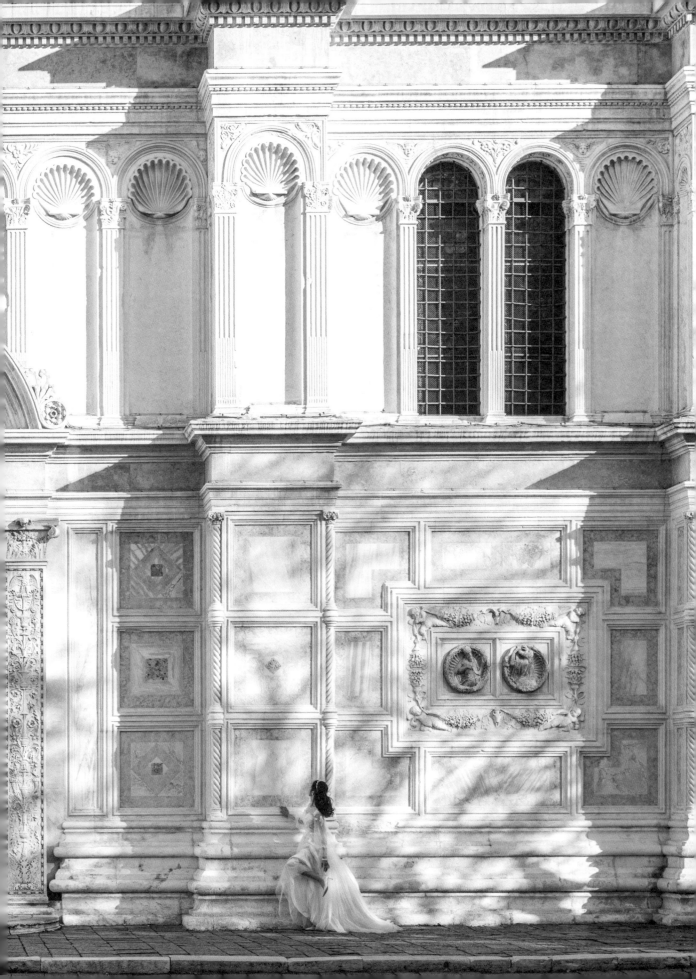

VISITING

THE QUERINI STAMPALIA FOUNDATION

A PATRICIAN'S HOUSE

It is not every day you have the chance to enter the palace
of one of the founding families of Venice. Between contemporary art
and a prestigious library, the Querini Stampalia Foundation is both
casa and *museo*—a place of stories and contrasts.

The origin of the Querini Stampalia dates to the time of the birth of Venice on the Rialtine Islands, an archipelago that now makes up the Rialto district. Having taken part in a conspiracy in 1310, the Querini family could never be elevated to the rank of doge, but their presence and power in Venice are undeniable, with several palaces along the Grand Canal to Castello bearing their name. In 1869, Count Giovanni Querini Stampalia died without leaving an heir. In his will, he asked that his home in Campo Santa Maria Formosa be transformed into a space dedicated to "the service of good studies." The Foundation was thus born, still honoring Count Giovanni's wishes today.

The palace's library contains nearly 350,000 books, and its antique rooms with creaky floors and walls laden with paintings remain open until midnight, making it a privileged place of study for Venetian students. The remaining space is shared between the auditorium and the museum, where temporary or permanent exhibitions are held.

By donating his entire estate, the last of the Querini family allowed the public to enjoy his family's immense collection in the very context of an aristocratic mansion. Thus, neo-Byzantine works and Renaissance masterpieces, such as Giovanni Bellini's *Presentation at the Temple*, are exhibited amid the original furniture and decoration.

In the 1950s, the Foundation turned to contemporary art starting with its architecture. Carlo Scarpa, the architect who best embodied the modern interpretation of Venice, remodeled the rooms on the ground floor. Through an interplay of levels and ducts, he let water penetrate the space through a door on the canal, making the *acqua alta* an element of his architectural style. Architects Valeriano Pastor and Mario Botta completed the Foundation's contemporary appearance, renewing the stairs and patio.

Today, the artists' interventions are integrated into the *palazzo* in a harmonious dialogue between ancient and modern. On the facade, Joseph Kosuth inscribed, in neon, quotes from John Ruskin's book *The Stones of Venice*, confirming the dual role of the Foundation as a place of innovation and conservation.

Researchers, students, lecturers, lovers of
contemporary art or history—the Foundation is a place
where people from all backgrounds converge.

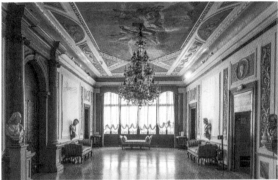

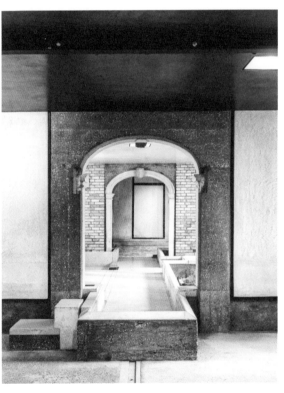

WATERPROOFING

The ground floor, called the Area Scarpa,
was designed to let the *acqua alta*
in and channel it into different levels.

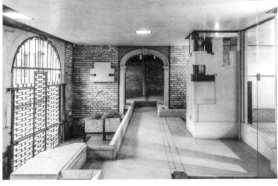

P.206 / 207

*Behind the marble facade of the Chiesa di San Zaccaria are the vibrant colors of figures painted by
Giovanni Bellini: Madonna and child, the three kings, as well as the doge celebrating Easter.*

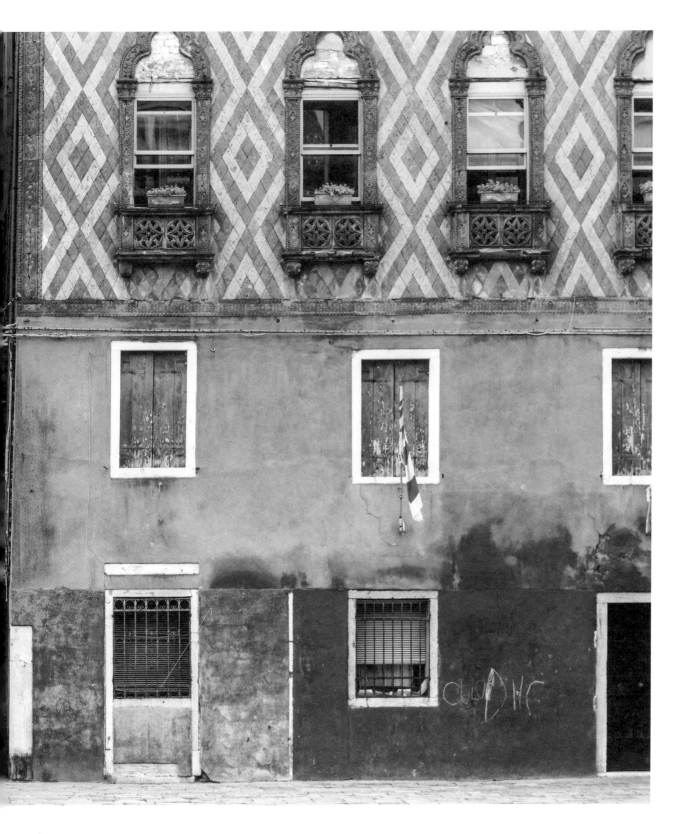

ABOVE

*As is common in Venice, buildings from different eras line the Campo Santa Maria Formosa,
lending a lively spectacle to this wide square.*

LIFESTYLE

DAY-TO-DAY IN CASTELLO

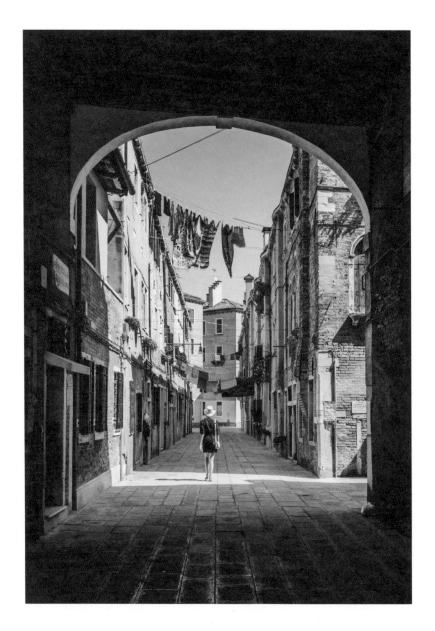

LAUNDRY DAY

Between the houses and up to the canals clotheslines are stretched, ready to
be covered with colorful linens at the slightest appearance of sunshine.

IN THE *CAMPI*

A bench, a small church, and nothing else but the course of daily life.

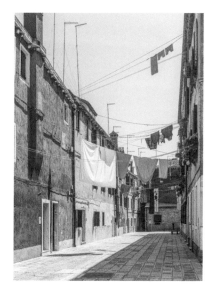

A QUIET PATH

As soon as you leave the main routes, you may find yourself alone on deserted streets.

A BENCH FACING THE LAGOON

From the pine forest of Sant'Elena, the view looks across to Saint Mark's bell tower and the Lido.

SUNDAY ON THE WATER

Venetian families take a day off to enjoy time on the lagoon.

FLOCKS OF PIGEONS

Although the town has made it forbidden to feed pigeons in Saint Mark's Square, you might spot someone feeding them in the smaller squares.

READING BY THE WATER

The garden of Sant'Elena invites a day of reading.

AT THE CAFÉ

In the neighborhood, you can while away the day on café terraces.

EXPLORING THE ALLEYWAYS

Whether you have lived here always or for just a few days, Venice is a continuous wonder.

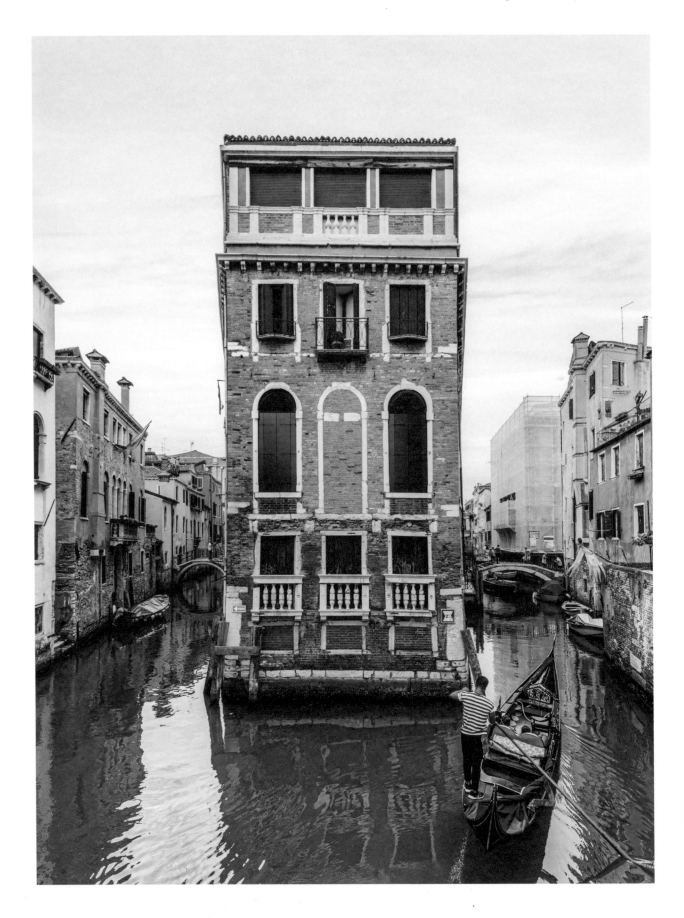

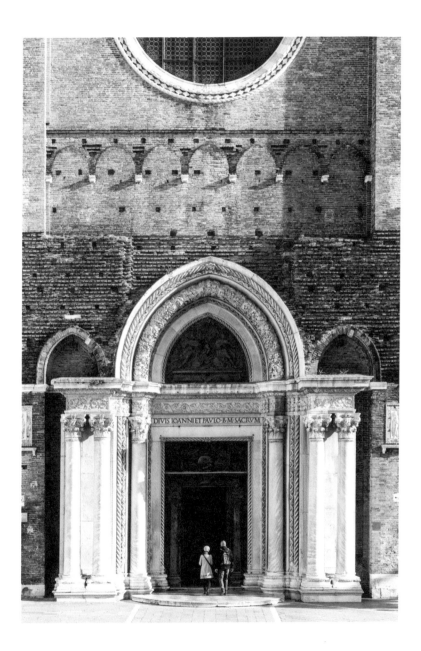

ABOVE

The Church of Santi Giovanni e Paolo, along with the Basilica dei Frari, is one of the largest religious edifices in the city. It is nicknamed the "pantheon of doges." Several tombs are interred in its facade while others of a more monumental status are located inside.

LEFT

Some palaces appear completely surrounded by water, but they always hide a small alley to serve as discreet access for pedestrians.

FOOD & DRINK

ANDREA LORENZON

IMAGINATION IN THE KITCHEN

From a very small kitchen, two cooks and a restaurateur
serve up monuments to Venetian gastronomy. At the head of
this tiny restaurant, Andrea Lorenzon, a young Venetian,
knows how to combine fantasy with excellence.

Andrea Lorenzon spent his childhood around the tables of Mascareta, an *osteria* owned by his father, Mauro, known in Venice for his bow ties and love of wine. Andrea grew up passionate about food and particularly skilled at uncorking bottles. As soon as he was old enough, he became a lover of wine. "It's by drinking that you learn," he says while filling his glass with an unfiltered Prosecco. Eventually he completed his culinary training working alongside great chefs, most notably Massimiliano Alajmo, the current owner of Caffè Quadri in Piazza San Marco.

After gathering experience working in kitchens, Andrea's goal was to open his own restaurant in Venice. In 2009, he realized his dream, opening a tiny space in an alcove in Castello accommodating just fourteen covers. The open kitchen allows diners to observe the skills of the two cooks who prepare fish, meats, and vegetables with a keen sense for harmonizing flavors. Andrea manages the dining room, whose walls are adorned with labels of natural wines. "For me, Venice is the most interesting place in the world for cooking. It is a crossroads where the products from the Adriatic, vegetables from Sant'Erasmo, and spices from the East meet." The products and seasonality are at the heart of his relationship with gastronomy, which adheres to the Slow Food movement, a label guaranteeing the origin and quality of products and know-how. "The development of a dish begins in the market stalls. I'm going to first find quality, seasonal products. Then I look at tradition. What can I convey as an idea? This is where innovation comes from, the ability to interpret traditions." A dish must respect the terroir, yes, but it must also reveal something special, respecting the essence of each ingredient. His version of *seppie al nero*, a dish found on all Venetian tables, is proof of this. Served in carpaccio, cuttlefish rests on a cream of spring peas sprinkled with droplets made from the black cuttlefish ink. This is a seasonal pairing for this fish in season in April, a time when peas are harvested.

At the opening of CoVino, Andrea was the youngest Venetian at the head of a restaurant, instilling a youthful spirit and joyful creativity in the classical repertoire of Venetian gastronomy.

"FOR ME, VENICE IS THE MOST INTERESTING
PLACE IN THE WORLD FOR COOKING.
IT IS A CROSSROADS WHERE PRODUCTS FROM
THE ADRIATIC, VEGETABLES FROM SANT'ERASMO,
AND SPICES FROM THE EAST MEET."

1. ANDREA LORENZON

Standing at the entrance to his restaurant, Andrea greets guests and fine-tunes the wine list.

2. *SEPPIE AL NERO*

Reinventing the classics by following the seasons to spotlight ingredients is CoVino's approach.

3. NATURAL WINE

To understand natural wine, you must drink it. This is why Andrea chooses to feature it.

4. IN THE KITCHEN

When cooking in a tiny space, precision and organization are paramount.

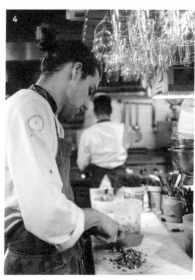

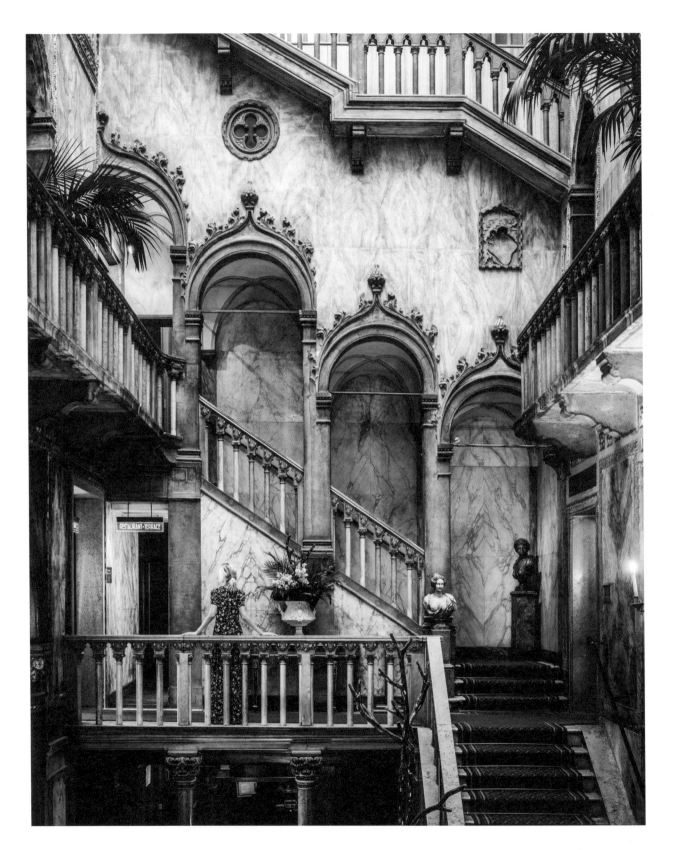

The Hotel Danieli, located in a fourteenth-century palace with a patio decorated in the Moorish style, has fascinated its illustrious clientele since it opened in 1822.

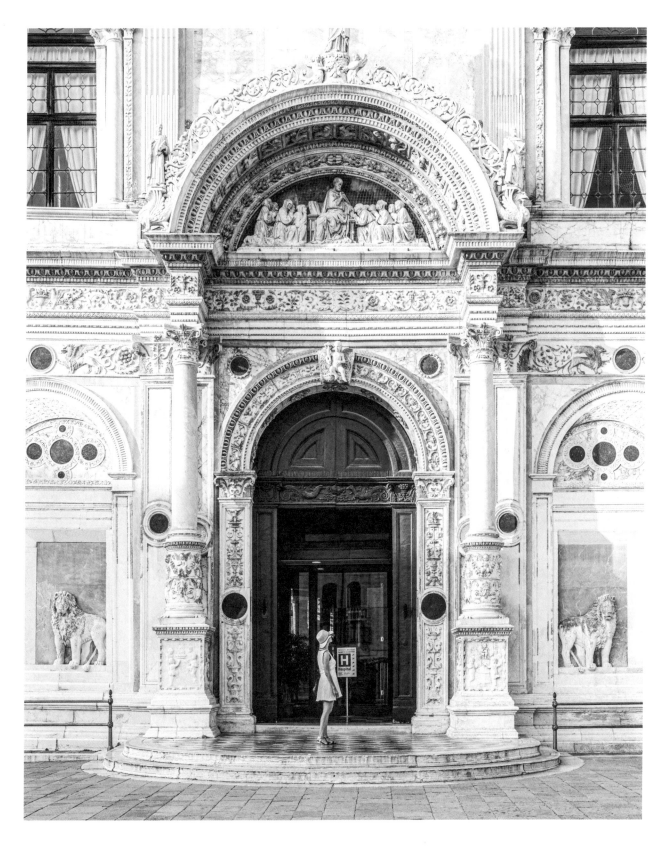

*The city's current hospital sits behind the incredible marble trompe l'oeil facade of the
Scuola Grande di San Marco, a work from the studio of Pietro Lombardo.*

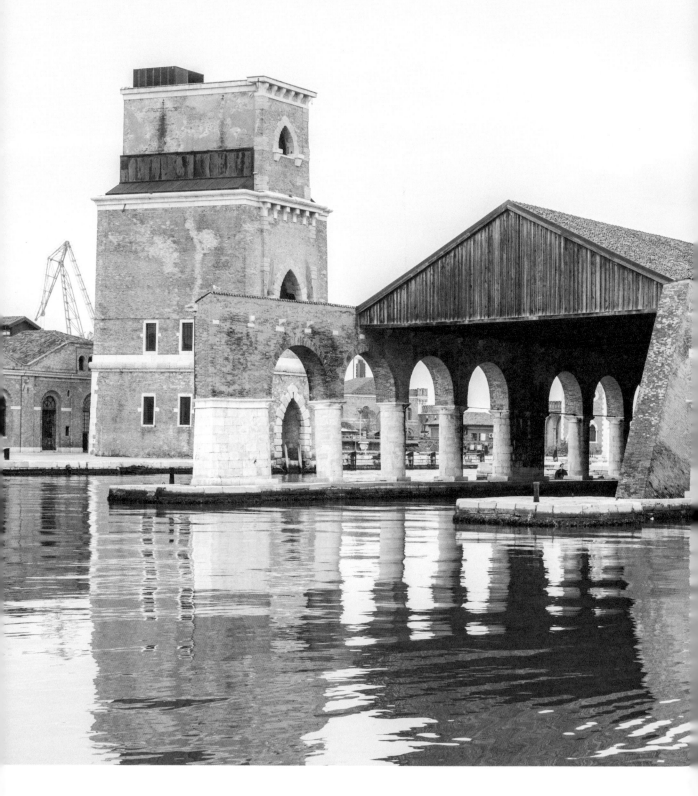

Within the Arsenale, warships of the Republic were constructed. The space is now used to exhibit art or architectural works during the Biennale.

ABOVE

A rare public green space in a city where many gardens are private.
This public garden lends a peaceful atmosphere to the neighborhood.

RIGHT

Whether on clear or gray days, a walk along the banks from Castello
to San Marco always promises beautiful views.

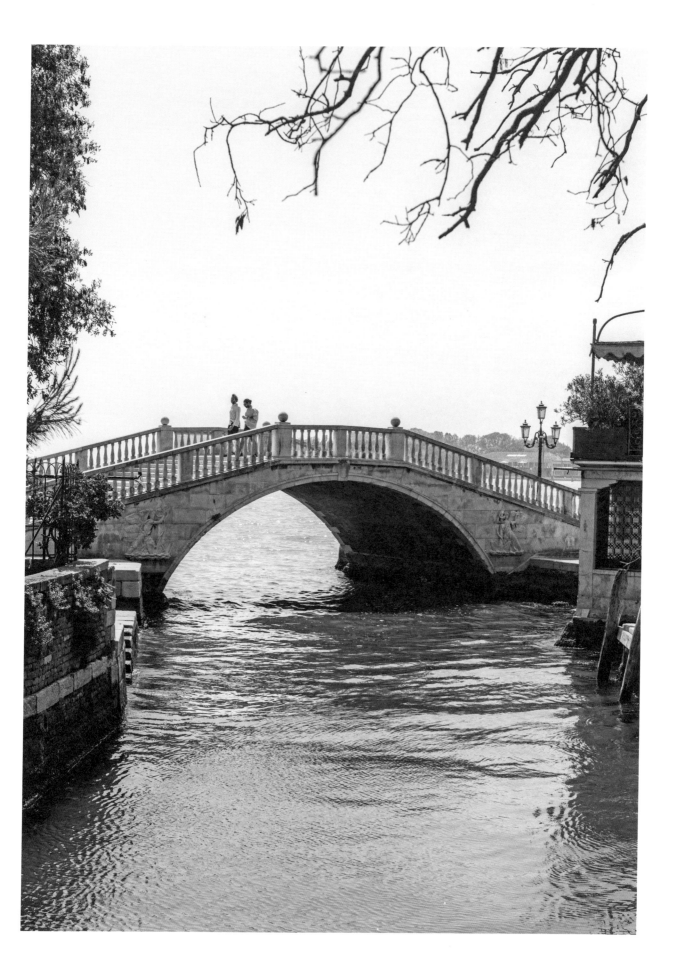

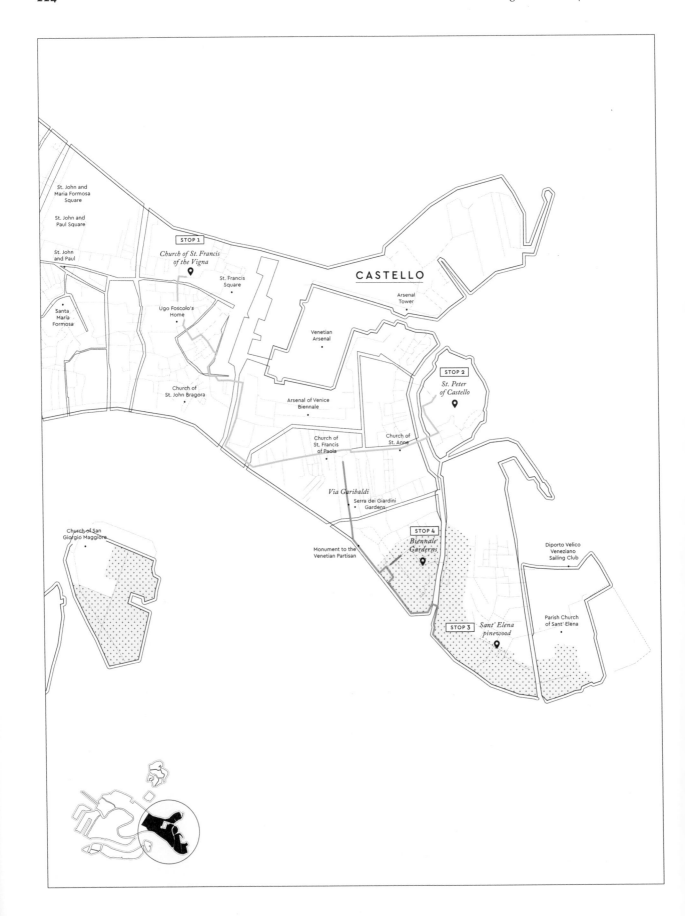

St. John and Maria Formosa Square

St. John and Paul Square

St. John and Paul

Santa Maria Formosa

STOP 1

Church of St. Francis of the Vigna

St. Francis Square

Ugo Foscolo's Home

Church of St. John Bragora

CASTELLO

Arsenal Tower

Venetian Arsenal

Arsenal of Venice Biennale

STOP 2

St. Peter of Castello

Church of St. Anne

Church of St. Francis of Paola

Via Garibaldi

Serra dei Giardini Gardens

Church of San Giorgio Maggiore

Monument to the Venetian Partisan

STOP 4

Biennale Gardens

Diporto Velico Veneziano Sailing Club

STOP 3

Sant' Elena pinewood

Parish Church of Sant' Elena

VENICE IN GREEN

There are around five hundred green spaces in Venice, most of them private,
dotting the islands with surprising oases. These private spaces offer
no evidence of their presence from the streets, except when you might catch
a slight trace of their perfumes escaping over the walls.

STOP 1: AROUND SAN FRANCESCO DELLA VIGNA

Hidden behind the walls of private palaces, numerous secret gardens line the Castello district. Surrounding essential water wells, these lush spaces were used as social gathering places for families who would organize receptions there. During the Biennale, some open their doors to pavilion visitors. Beyond these private gardens, the green spaces of monasteries also help lend a rural sense to the city. The name of the church San Francesco della Vigna provides a hint of the hidden presence of a garden. Since 1253, the vineyard there has been maintained by the monks. From its square where cypresses grow, you realize that to access the gardens you need only to walk through the sumptuous church, whose design is the result of the combined talents of architects Sansovino and Palladio.

STOP 2: THE COUNTRYSIDE AT SAN PIETRO DI CASTELLO

Here, Venice suddenly takes on the appearance of a fishing village. On the edge of the lagoon, the island of San Pietro di Castello is surrounded by a peaceful canal traveled by private boats. At the end of Calle Larga Rosa, a wooden bridge provides access to the island. Its horizon is dominated by its tilted bell tower made of Istrian stone and constructed by Mauro Codussi in 1482. The beautiful church that overlooks the shady garden of the square was, until 1807, the cathedral of the Patriarch of Venice, later moved to Saint Mark's Basilica. Crossing the island takes only a few minutes before leaving it by the second bridge, Calle de Quintavalle. From here, on the Via Garibaldi, you turn onto Viale Garibaldi, a vast shady promenade, passing the greenhouse to stop for coffee, before entering the Giardini, a true city park.

STOP 3: PARCO DELLE RIMEMBRANZE

The idea of a garden as a vast public space open to all was not very Venetian. After the fall of the Republic, Napoleon ordered major urban planning works, carving out several green areas at the cost of destroying churches and historic buildings. Of the sixteen acres (sixty-five thousand square meters) of green space that was built, part of it is still a public park. To get there, you first walk along the shore, passing in front of the *Monument to the Partisan Woman*, a sculpture by Carlo Scarpa which lies exposed to the waves. Then, beyond the Ponte dei Giardini, you enter the pine forest of Sant'Elena, also called Parco delle Rimembranze. Visitors come here to run, play soccer, or read on the grass while looking out toward the Lido, Santa Maria della Salute, and Saint Mark's bell tower in the distance.

STOP 4: THE GIARDINI OF THE BIENNALE

The other part of these gardens built at the behest of Napoleon is now the playground of contemporary artists and architects. In 1895, the first art Biennale was created. Amid the trees, great architects were called upon to create the national pavilions where the whole world comes to exhibit its artists: Carlo Scarpa created the Venezuelan pavilion, the Gruppo BBPR the Canadian pavilion, and the Norwegian Sverre Fehn those for the Nordic countries.

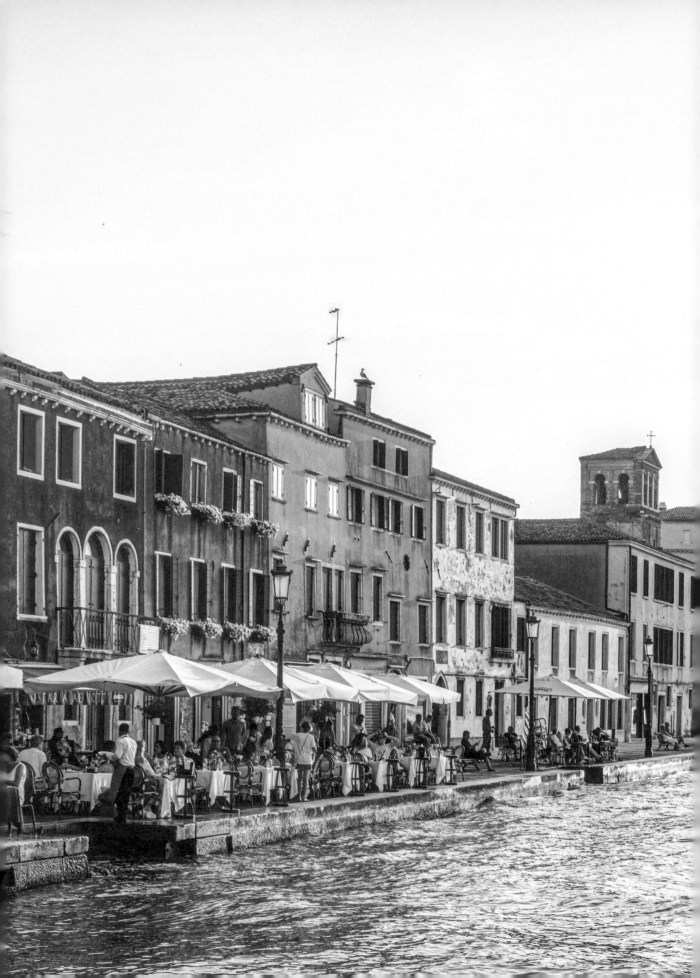

A DETOUR

GIUDECCA

AND SAN GIORGIO

The island of Giudecca is made up of eight smaller interconnected islands
following the outline of Venice. It was once referred to as the
"long thorn," stretching south of the city. At the end is the island of
San Giorgio Maggiore, almost twenty-five acres (ten hectares)
dedicated to Saint George since the ninth century.

P.226

*The pier running along the entire north side of the island offers poetic views of the city.
Restaurants and bars have set up their outdoor patios for dining to the sound of the waves.*

RIGHT

With its neighborhood shops and small churches, Giudecca has the allure of a village.

On this narrow stretch of land along the outskirts of the city are found many contrasts. The story of this land unfolds as you walk along its north side. On the left is the Giudecca Canal, traversed in a constant back-and-forth of boats of all types and sizes, from gondolas to large ships. On the right is a row of low-rise houses, over which gardens overflow their walls, and small shops are nearby. The Molino Stucky dominates the horizon at the beginning of the promenade at the island's western end. Perfectly symmetrical, its brick facade evokes the memories of the industrial past of the island. Here and there, you come across abandoned fireplaces and factories, some now converted into dwellings or artists' studios.

The pier leads naturally to the foot of the staircase of the Church of the Redentore, conceived by Andrea Palladio as a gift from man to Christ the Redeemer for ending the plague. Farther on is the Church of Zitelle, attributed to the same architect, and the front facade of San Giorgio Maggiore, also by Palladio, echoing the same striking design of columns and capitals. At the eastern end of the island, a palace peers outward with its wide eyes. This is the house designed by the painter Mario de Maria and nicknamed by the Venetians the Casa dei Tre Oci, the "house with three eyes." Inside you can visit de Maria's photography exhibitions and survey Venice looking out through its trio of wide windows.

Before returning to board the *vaporetto* at the end of your visit, you can make a few detours to the back of the island, its wilder side, facing the lagoon. The gardens of Villa Hériot, an eclectic home converted into a university, are a reminder that Giudecca is also the place chosen by many wealthy foreigners in search of serenity.

Following the line of a minor canal, you can visit the Junghans district, a modern complex of concrete, as well as catch a colony of ducks sunbathing in front of the old church Santi Cosma e Damiano. The church's cloister, which welcomes visitors, is a sort of residence-workshop for artisans who today use the monks' cells to blow glass, paint, or carve wood.

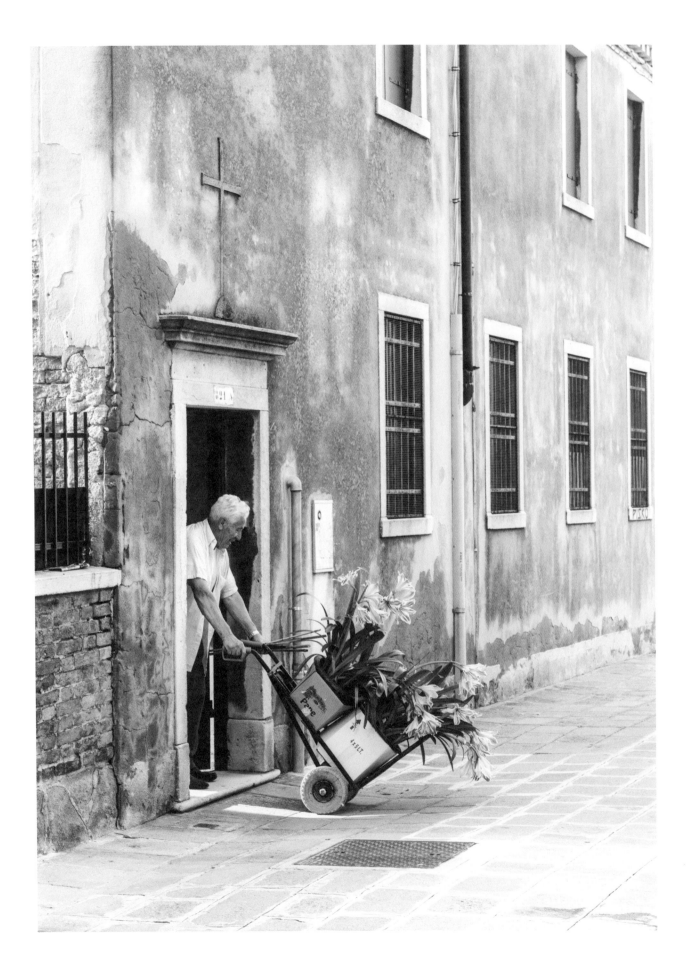

THE ESSENTIALS

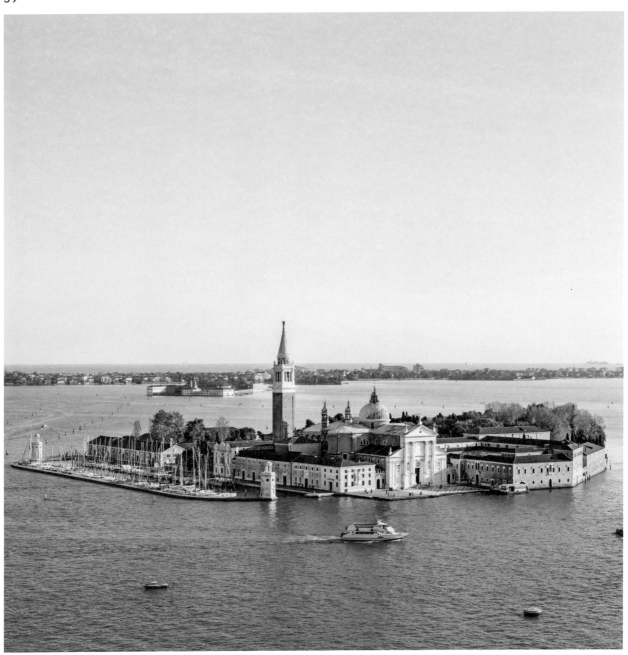

SAN GIORGIO CAMPANILE

The view of the San Giorgio campanile on the Giudecca Canal is ideal at sunset.

60

MOLINO STUCKY

The Molino Stucky is well worth a walk to admire its facade.

61

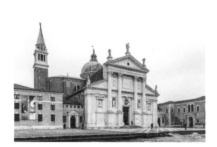

BASILICA DI SAN GIORGIO MAGGIORE

The Basilica di San Giorgio Maggiore displays the purity of its lines.

62

VATICAN CHAPELS

In 2018, at the Biennale, ten architects created the Vatican Chapels in the gardens of the island of San Giorgio.

63

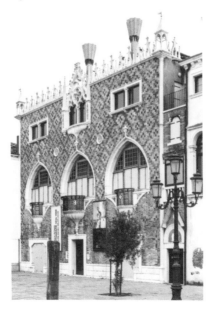

CASA DEI TRE OCI

The unusual Casa dei Tre Oci offers beautiful views of Venice and excellent exhibits.

64

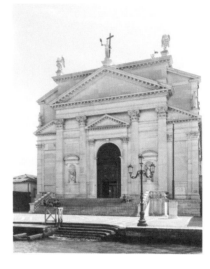

CHIESA DEL SANTISSIMO REDENTORE

This sixteenth-century church is by the great architect Palladio.

65

FONDAZIONE CINI

As a research center, library, museum, and garden, the Fondazione Cini serves multiple purposes.

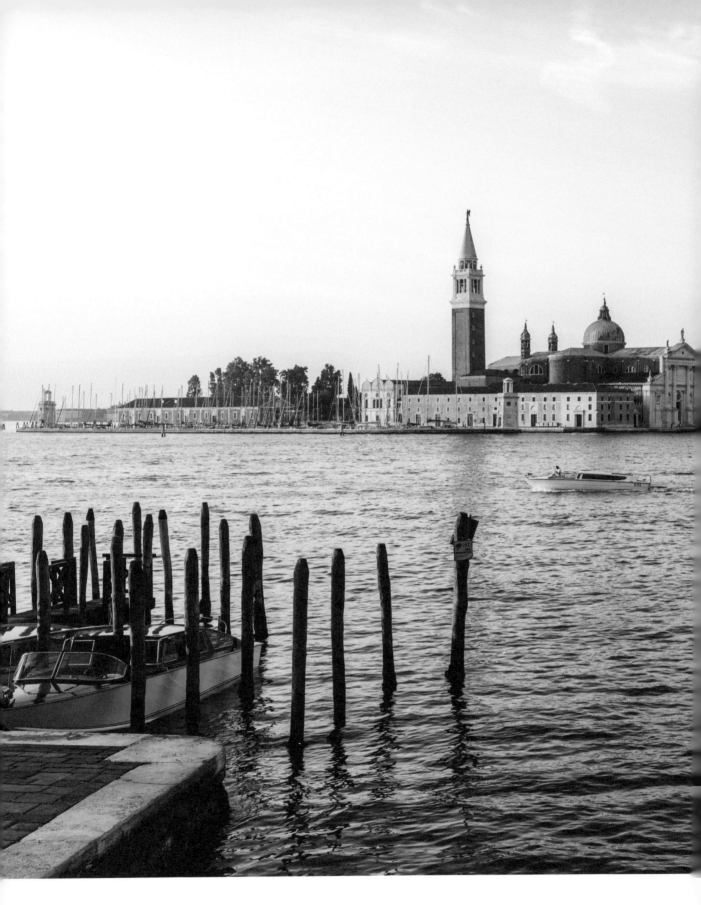

From Saint Mark's Square can be viewed the entire island of San Giorgio, with its church, bell tower, and park space, a garden where exhibitions are sometimes organized.

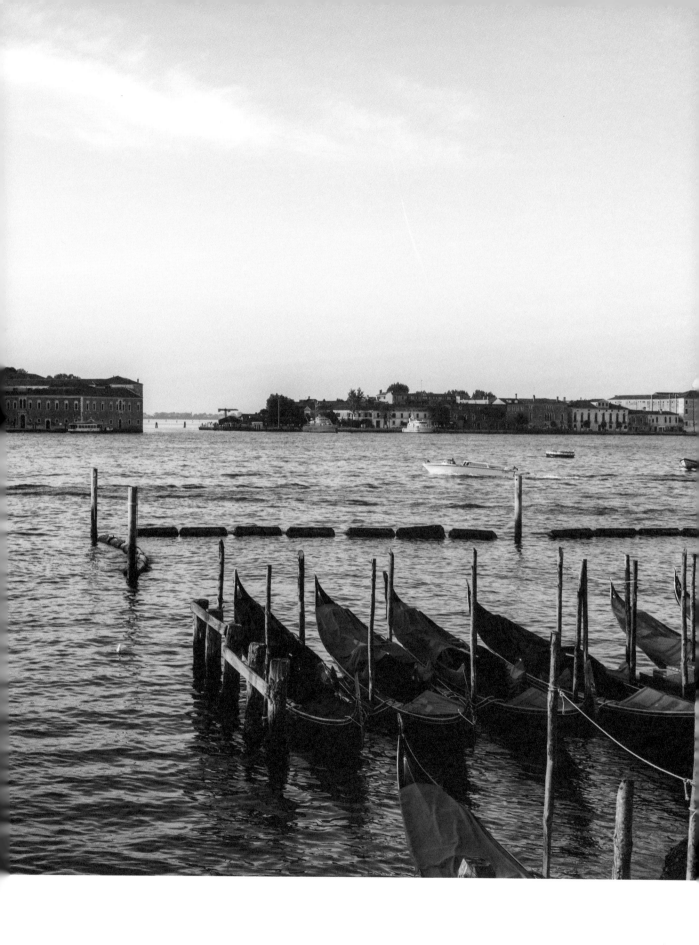

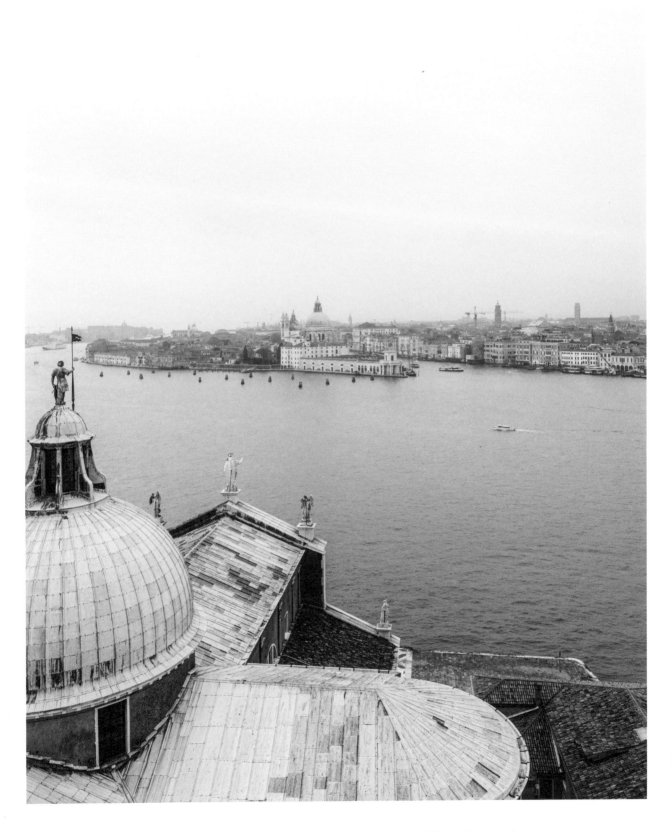

*Even in gray weather, the view from the top of the San Giorgio bell tower is spectacular,
dominating the Giudecca Canal that flows by its domes.*

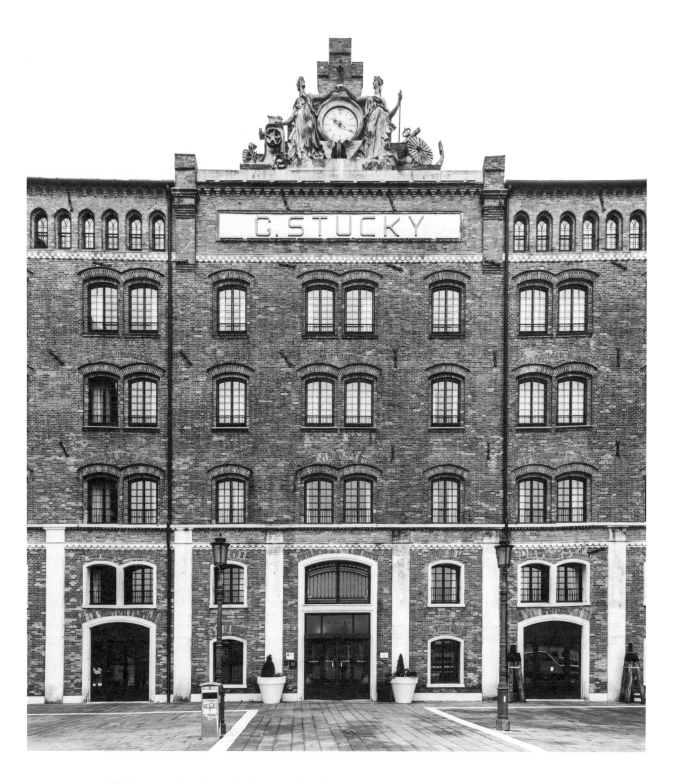

With its neo-gothic industrial architecture, the Molino Stucky makes a statement in the Venetian landscape, evoking northern European design by its German architect, Ernst Wullekopf.

THE GIORGIO CINI FOUNDATION

ISLAND OF THE ARTS

Its bell tower seems to be a duplicate of the one at Saint Mark's,
and its abbey's immaculate white facade reflects the pink light of sunset.
Since 1951, the island of San Giorgio, a former monastery,
has been a flourishing haven for the arts.

Opposite Piazza San Marco, the Giorgio Cini Foundation occupies a privileged position on the island of San Giorgio at the maritime entrance to the city overlooking the Giudecca Canal. It was founded in 1951 by Vittorio Cini in memory of his son Giorgio, who died in a plane crash in 1949 in Cannes.

For eight hundred years, San Giorgio remained a place of peace, prayer, and meditation: a Benedictine monastery was founded here in 982 and lasted until the fall of the Republic of Venice in 1797. The designs of several great architects give it the radiant aspect that characterizes it today.

Giovanni Buora created Manica Lunga in 1508, a long hall with pure shapes where the monks' dormitories were located. His son Andrea built the first cloister in 1526, to which was added a second by Andrea Palladio between 1566 and 1610. Palladio also created the church and the refectory where Veronese painted the *Wedding Feast at Cana*, currently on display in the Louvre. Baldassare Longhena contributed a baroque touch with the monumental staircase, a theatrical ensemble leading to the abbot's apartments. Starting in 1797,

the French, followed by the Austrians, turned the monastery into barracks, using the monks' cells as a prison.

The creation of the foundation allowed the site to be reclaimed and to compensate for the dispossession and damage that occurred after the closure of the monastery. By renewing the original monastic plans of spreading culture, the foundation has allowed various research institutes dedicated to Venice to settle on the island. Thus, the restored spaces of the monastery have been given new uses. The Manica Lunga was transformed into a library by designer and architect Michele De Lucchi. Since 2016, the former shipyard, the Squero, has hosted a glass auditorium where concerts take place with the lagoon serving as backdrop. In 2011, a labyrinth was created in homage to the writer Borges, based on a drawing by the British Randoll Coate, a designer of labyrinths.

In the vast gardens of the foundation, architects Luigi Vietti and Angelo Scattolin used the remains of materials from the construction site to build the Teatro Verde, an amphitheater situated between water and flora.

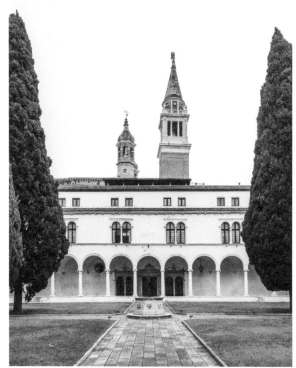

A PLACE OF STUDY

Long before the creation of the current library, the monastery was a place of study and silence.

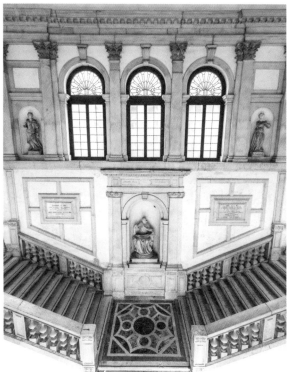

A MEDITATIVE ATMOSPHERE

The various cloisters that were added to the monastery over time were designed to welcome meditation.

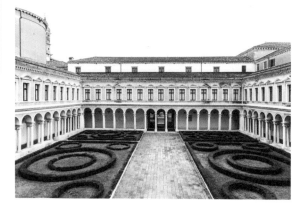

ABOVE

*Religious devotion is expressed not only in churches but also through
the small altars that fill the streets throughout the city.*

LEFT

*Upon landing on the island, you immediately notice the Palladian facade
of San Giorgio Maggiore, whose construction lasted more than forty years.*

FOLLOWING SPREAD

*As elsewhere in Venice, the chimneys of the housing development
Corte dei Cordami were designed to prevent fires.*

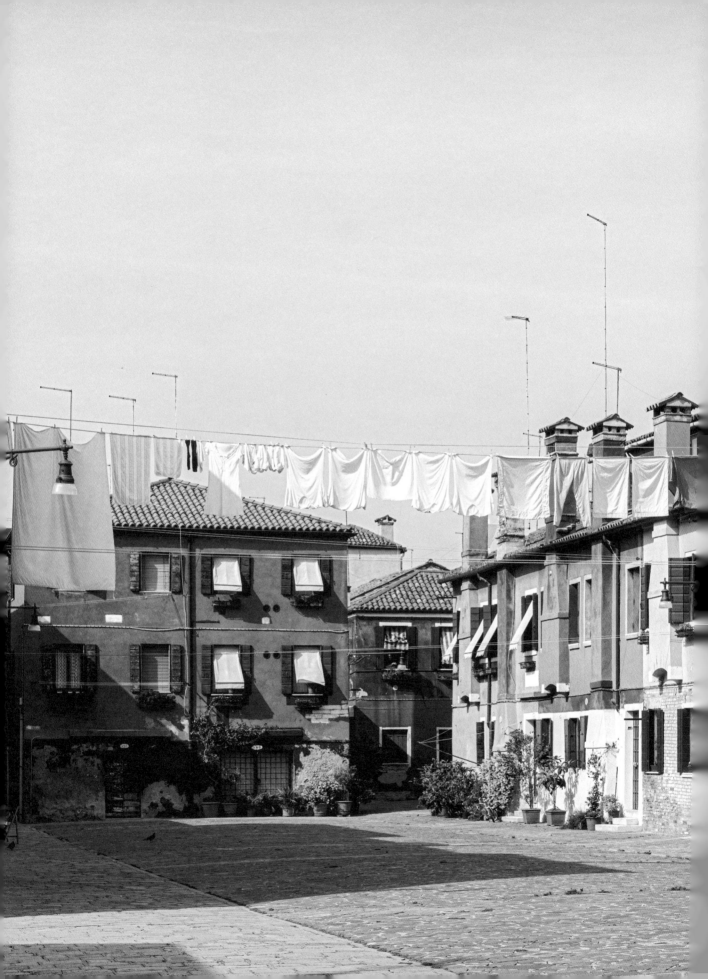

MARIANO FORTUNY

A SPANIARD IN VENICE

His name is displayed in tall letters on the brick facade of
his studio in Giudecca. Mariano Fortuny, an eclectic inventor,
left Venice a legacy of silks, printed canvases, and
exotic objects, spanning painting to theater.

Some relationships between an artist and a city are so prolific they seem destined. This is the case with Mariano Fortuny and Venice, where his home, workshops, and collections can be found. The son of a Spanish painter, Fortuny arrived in Venice in 1889 at the age of eighteen and settled at Palazzo Martinengo in Dorsoduro. Traveling throughout Europe, he made Venice his home, where he installed the family's collection of myriad objects. His character was as ever changing as the waters of the lagoon as he developed a wide variety of talents in which he invented his own creative style.

In the theater, he used electricity and invented a system called the Fortuny dome to illuminate the entire stage with reflected light, a technique he would also use to create various conical and hand-painted silk lamps later in his career.

The theater led him to fabrics. In 1906, the dancers of the Paris Opera wore silk scarves during a private performance at the home of the countess of Béarn.

The colors of his prints were re-created on silk and velvet in a process that is still a secret today. In the design of his fabrics, as spiritual heir to the pre-Raphaelites, he mixed Moorish, Asian, and Greek motifs with his personal taste. The Delphos dress was thus born from inspiration from the Greek islands of the Cyclades. It consisted of two simple pieces of sewn silk folded over the body by hand, freeing women's bodies from the weight of heavily adorned dresses. Sarah Bernhardt, Isadora Duncan, and later Peggy Guggenheim popularized this dress in Paris and Venice.

In 1919, Fortuny moved part of his workshop, previously located at Palazzo Pesaro degli Orfei, where his production was reduced to just a few prints. Next to the contemporary design of the Molino Stucky, he set up a workshop where he produced printed cottons. Popularized in the United States by Elsie McNeill, who took over the company, the Fortuny legacy has been perpetuated over time and continues to produce thousands of marvelous fabrics.

VARIATIONS OF FABRICS

In the showroom, the surroundings are soft and muted.

THE SECRET OF THE WORKSHOP

Only workers can enter the Fortuny factory.

PRINT DETAILS

The eclecticism of styles is reflected in the juxtaposition of fabrics.

PRECIOUS ROLLS

The elegant libraries present classic pieces as well as those from new collections.

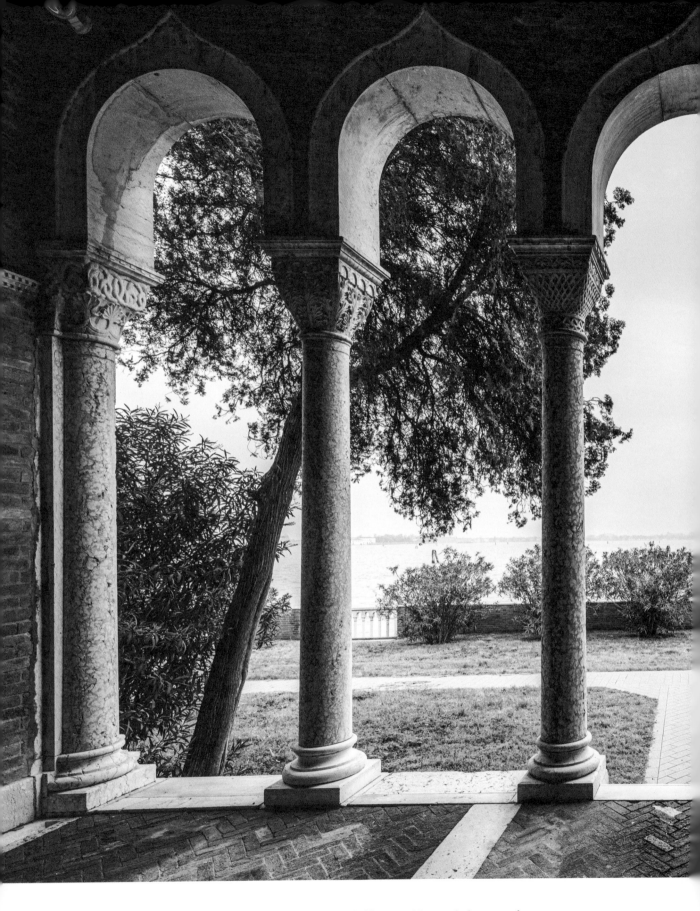

Under the shaded exterior stairs of Villa Hériot, a visitor can look out onto the southern section of the lagoon where the sky fades into the horizon.

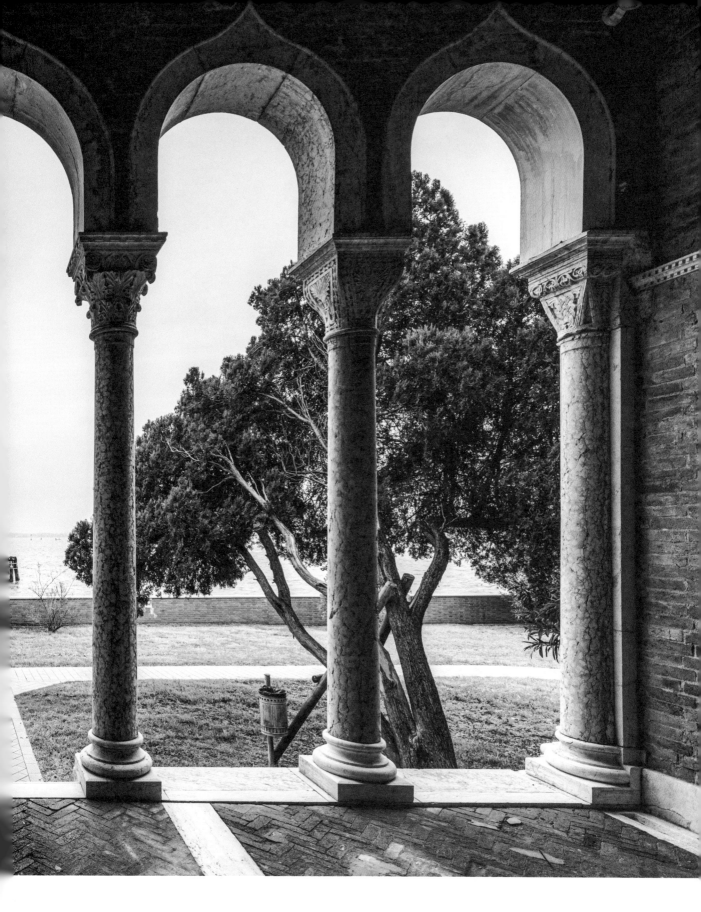

1. THE *BAUTA*

This typical Venetian costume, worn by men and women,
consisted of a black cape, a tricorn, and a mask.

2. FABRICS OF EXCELLENCE

Venetian artisans were master weavers. They mainly produced
velvets, damasks, brocades, and silks.

Cut velvet, 4 scissored cuts

Curly velvet, 4 scissored cuts

Chiseled velvet (cut and curled)

UNDERSTANDING

THE FABRICS AND COSTUMES

OF VENICE

In a city where few resources grow, craftsmanship and the arts still flourish. From the time of the Serenissima to today, the art of fabric and costumes, whether used for Carnival or every day, has been part of Venetian excellence.

The weft of a Venetian fabric tells the long story of an art born from encounters and exchanges—within each pleat and fold of velvets and damasks, if you will. This story continues to be told by the Venetian fabric manufacturers still in operation. At Bevilacqua, the city's last looms are still in operation within a palace set on the banks of the Grand Canal. Another historic manufacturer, Rubelli, has moved its production but not its showroom, a site of wonders hidden in the *sestiere* of Dorsoduro. On the island of Giudecca, Fortuny fabrics are made using a printing technique unique in the world.

Understanding the history of fabric in Venice requires a look at the thread connecting it to the Far East: silk, which arrived in the city as early as the ninth century. Then, in the thirteenth century, it was the Tuscans from Lucca who brought with them the art of weaving. Thus, an industry was born, establishing its guild and its place in the market. The Venetians then invented their own techniques. To silk they added precious gold and silver from which they drew threads that fit into

the weft, otherwise known as brocade. In palaces, velvets decorated the walls, which they used to protect homes from the constant humidity. As you look around, you will see sublime fabrics everywhere in the city, including on the columns of churches, as in Santa Maria della Salute, where gold and purple playfully intersect. In Pietro Longhi's portraits of Venetians, fabric can be found on the costumes of the figures, witnesses of a daily and Carnivalesque Venice, as well as on the walls hanging with red and silver in a room at Ca' Rezzonico where they are exhibited.

Fabrics are everywhere, and not just during Carnival, where they are expressed with the greatest fantasy. Today's designers continue to weave to create design objects or accessories. In the shop windows, one can admire the elegant notebooks of the Polliero bookbinding workshop covered with Bevilacqua fabrics. Sometimes the motifs of Venetian houses can be found in the fashion shows of great designers or on refined accessories, continuing to spread the art of the lagoon to the world.

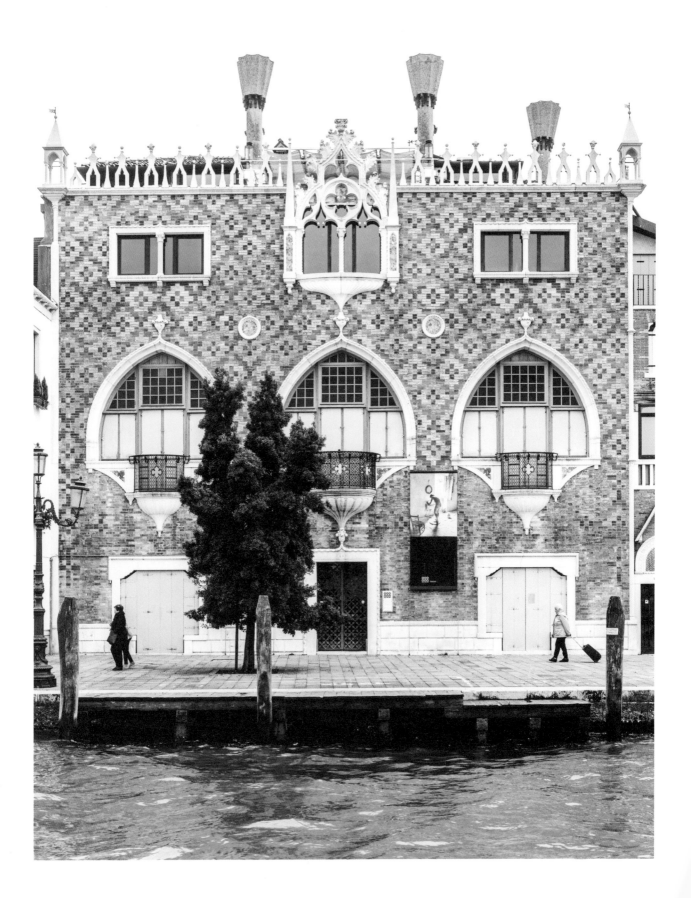

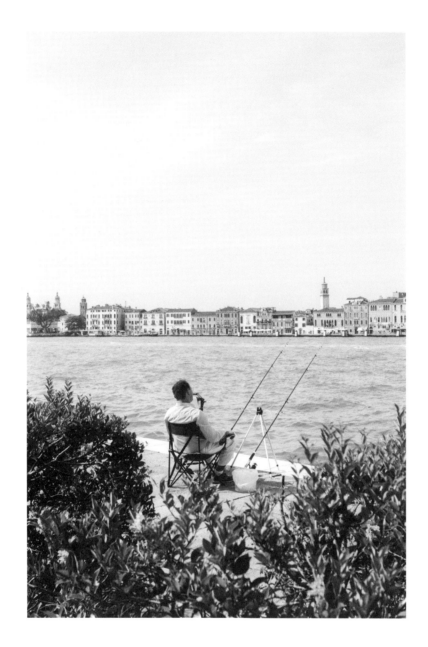

ABOVE

*Depending on the season, you can see cuttlefish, sea bream, anchovy, dorado,
or gobies in the lagoon, which fishermen catch from the docks.*

LEFT

*Behind its three large "eyes" (*oci *in Venetian), the Casa dei Tre Oci,
born from the imagination of the painter Mario de Maria, now houses
a photography museum with impressive temporary exhibits.*

ARCHITECTURE

CONTEMPORARY VENICE

TEATRINO GRASSI

What may be surprising is that Venice is not just a city of ancient palaces.
Contemporary architects have executed many projects throughout the city,
such as Tadao Ando, who created this auditorium in gray marmorino.

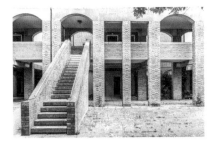

CASE POPOLARE

Community housing from the 1980s, by Gino Valle.

JUNGHANS QUARTER

This neighborhood is designed to promote communal living.

WINDOWS ON GIUDECCA

These modern buildings were designed for residents.

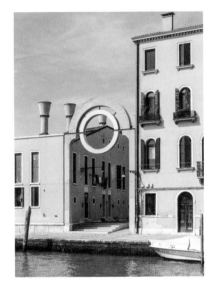

CASE DEL COMUNE

Community housing from the late 1980s, by Franco Bortoluzzi.

SOTTOPORTEGO

This modern walkway is reminiscent of traditional *sottoporteghi.*

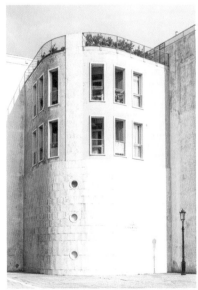

TEATRO JUNGHANS

The Junghans quarter has a theater, used by the Venetian Theater Academy.

JAPANESE INSPIRATION

A Japanese garden updated by Carlo Scarpa for the Querini Stampalia Foundation.

EX-CONTERIE

A Murano glass factory is now used for housing.

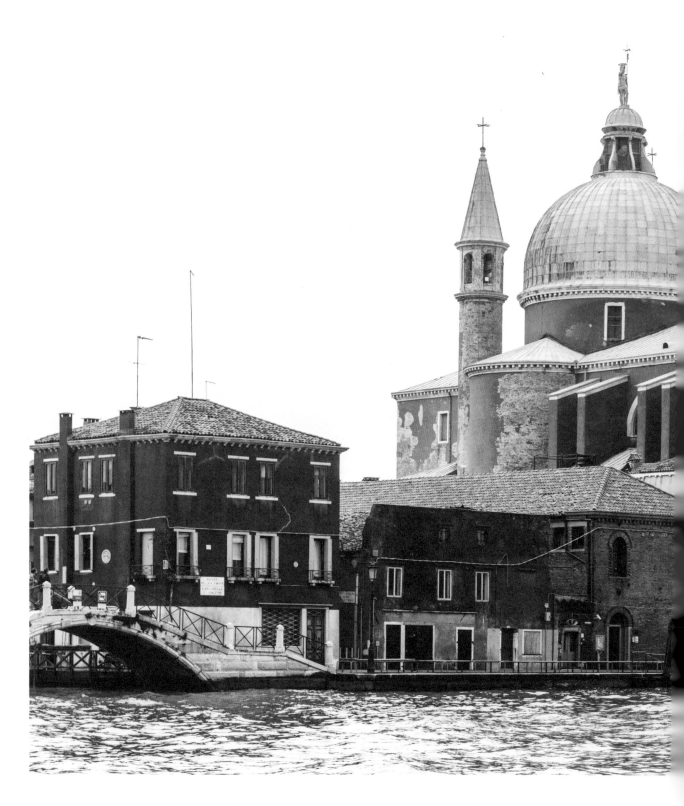

Designed by Palladio in 1577 to thank God for ending the plague, the Chiesa del
Santissimo Redentore was completed after fifteen years of work in 1592.

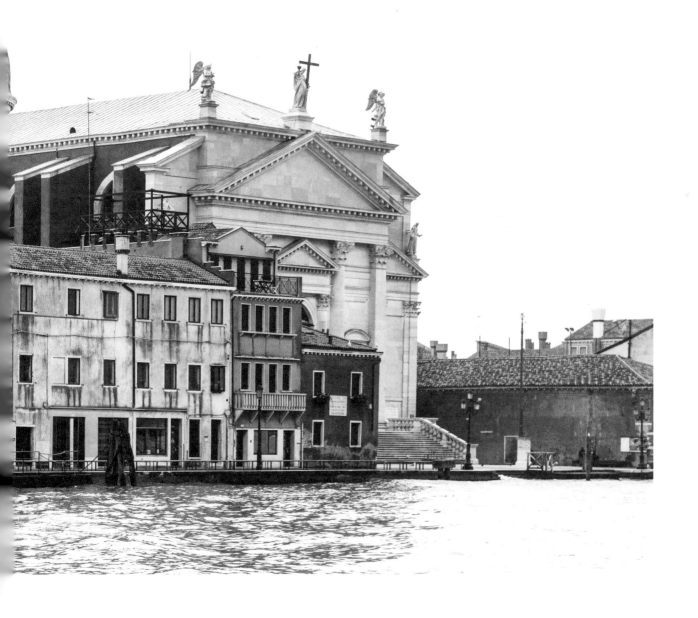

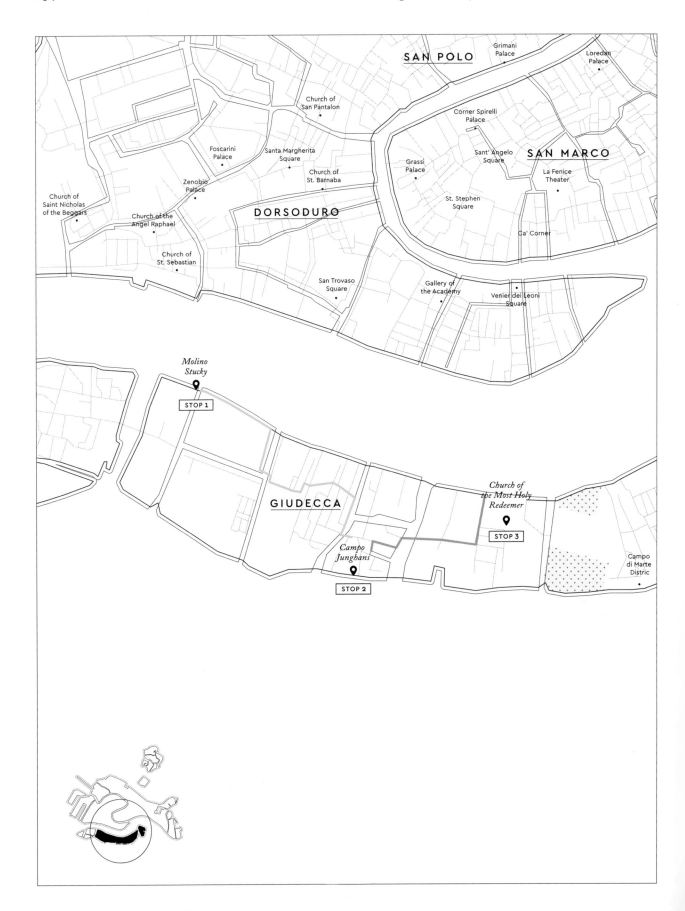

SAN POLO

Grimani
Palace

Loredan
Palace

Church of
San Pantalon

Corner Spirelli
Palace

Foscarini
Palace

Santa Margherita
Square

Sant' Angelo
Square

SAN MARCO

Grassi
Palace

Church of
St. Barnaba

Zenobio
Palace

La Fenice
Theater

Church of
Saint Nicholas
of the Beggars

DORSODURO

St. Stephen
Square

Church of the
Angel Raphael

Ca' Corner

Church of
St. Sebastian

San Trovaso
Square

Gallery of
the Academy

Venier dei Leoni
Square

*Molino
Stucky*

STOP 1

*Church of
the Most Holy
Redeemer*

GIUDECCA

STOP 3

Campo
di Marte
Distric

*Campo
Junghans*

STOP 2

GIUDECCA, THE UNUSUAL ISLAND

Although still in Venice, here you may feel as if you have entered another dimension.
Separated from the historic center of the archipelago by a wide canal just under
a mile (one kilometer), Giudecca is an island of contrasts offering an out-of-the-ordinary
walk, stretching from industrial wastelands to Palladian churches.

STOP 1: MOLINO STUCKY

At the western end of the island, the Molino Stucky tower points high toward the sky. The building's industrial style evokes northern Europe more than the Serenissima, but this is not surprising when you realize the architect, Ernst Wullekopf, came from Germany for its construction in 1895. Commissioned by businessman Giovanni Stucky, it was first a working mill where wheat was delivered by boat. Up to 1,500 people worked there every day milling flour, but in 1955 the factory was closed after a long decline. The mill was renovated in 2000 when the Hilton hotel chain built it into a luxury complex of 379 rooms with a panoramic terrace and a rooftop pool. In this way, the building connects to a part of the history of Giudecca, which once served as a holiday resort for the wealthiest Venetian families. With the Hotel Cipriani and Elton John's villa located close to the Zitelle pier, the island continues to attract wealthy visitors who rub shoulders with a more mainstream set of Venetians, making Giudecca an island of contrasts.

STOP 2: THE JUNGHANS QUARTER

To continue to unravel the thread of the island's industrial history, your steps will take you to the other side of the island, on the lagoon side. Here emerges an amazing contemporary complex, built between 1995 and 2006, a rare example in Venice. The name of the quarter evokes the watch manufacturer that had its factory here from 1877 to the late 1970s, resulting in a century of industrial history under the German brand Junghans, then the world's largest producer of watches. In the 1920s, the Giudecca workshop produced an average of 1,500 watches a day before closing in the 1970s. After falling into disuse, the complex was radically transformed by Cino Zucchi. His urban plan included the articulation of residential buildings, a theater, and student housing.

STOP 3: CHIESA DEL SANTISSIMO REDENTORE

As you return to the north shore, the view of Venice rises again before your eyes. A panorama of profound beauty, with the Zattere and the Doge's Palace appearing on the same horizon. Once a year, these two worlds come together. On the third weekend of July, a floating bridge is set up between the banks of the Church of the Redentore and the Zattere docks. In the evening, boats invade the canals, covered with candlelit lanterns, to watch fireworks. This tradition dates to the end of the plague epidemic of 1575. A church was built in honor of Christ the Redeemer, with the work entrusted to Andrea Palladio. The structure's sobriety inspires piety and humility with its pure forms. The nave, flooded with light, exalts the canvases of great artists like Veronese and Tintoretto. Farther down the pier, another church bears Palladio's signature: the Venetians commonly call it Chiesa delle Zitelle, "the old maids' church," because unmarried girls, often former prostitutes, were taken there. Between its industrial wastelands and the continuing traditions of its Renaissance churches, Giudecca is indeed a world apart within the Venetian landscape.

ABOUT THE AUTHORS

Lucie Tournebize is a journalist, blogger, and author of travel guides. She turned her passion for Italy into a profession, exploring the country from the peaks of the Alps to the beaches of Sicily. Since 2016, she has lived to the rhythm of Venice, a polymorphous and fascinating city that never ceases to amaze her.

Guillaume Dutreix is a photographer specializing in architecture and travels through towns in search of extraordinary places. He posts the photos of his travels on Instagram, publishes in magazines, and exhibits his work in France, Belgium, and Switzerland.

PHOTOGRAPHY CREDITS

All photographs in this book, including the cover, are by Guillaume Dutreix, except:

Page 59: top left, photo Marco Introini, 2011, FAI—Fondo Ambiente Italiano; bottom left, photo Roberto Morelli, 2019, FAI—Fondo Ambiente Italiano; top right, photo Gabriele Bortoluzzi, 2019; bottom right, photo Tristan Robert-Delrocq, 2017

Page 89: photo © Alinari Archives, Florence, Dist. RMN-Grand Palais / Mauro Magliani @ 2019, Éditions du Chêne—Hachette Livre

MAGICAL VENICE. Copyright © 2019 by Marabout. English translation © 2022 HarperCollins Publishers. All rights reserved. No part of this book may be used or reproduced in any manner whatsoever without written permission except in the case of brief quotations embodied in critical articles and reviews. For information address Harper Design, 195 Broadway, New York, New York 10007.

HarperCollins books may be purchased for educational, business, or sales promotional use. For information please email the Special Markets Department at SPsales@harpercollins.com.

Published in 2022 by
Harper Design
An Imprint of HarperCollins Publishers
195 Broadway
New York, NY 10007
Tel: (212) 207-7000
Fax: (855) 746-6023
harperdesign@harpercollins.com
www.hc.com

Distributed throughout the world by
HarperCollins Publishers
195 Broadway
New York, NY 10007

General manager: Emmanuel Le Vallois
Editorial manager: Valérie Tognali
Editor: Franck Friès
Artistic director: Sabine Houplain
Artistic creation and layout: Bureau Berger
Proofreading: Isabelle Macé
Manufacturing: Rémy Chauvière
Photography: Colorway

ISBN 978-0-06-321196-4
Library of Congress Control Number: 2021052109
Printed in China
First Printing, 2022